THE COMPLETE
Photographer

THE COMPLETE
Photographer

Ron Spillman

Designed by Grant Bradford

FOUNTAIN PRESS

Published by
FOUNTAIN PRESS
Fountain House
Gladstone Road
Kingston-upon-Thames
Surrey KT1 3HD
England

© 1996 Second Edition
© 1994 Fountain Press Ltd
© Text by Ron Spillman

Designed by Grant Bradford

Typeset by Rex Carr

Diagrams by Colleen Payne

Cover photographs by
(l to r) Keith Vaughan,
Jill Sneesby, Anthony Wharton,
Laurie Campbell, M.R. Owaisi,
John Gray

Half-title photograph
by Laurie Campbell

Title page photograph
by Ray Walker

Reproduction by Erayscan,
Singapore

Printed in Hong Kong by
Regent Publishing Services Ltd

ISBN 0-86343-307-3 paperback

INTRODUCTION

At one time, it was quite easy to become an amateur photographer. It was fairly easy to choose a camera that suited your purpose and pocket, and to decide whether to use black and white, colour slide or colour print film. From then on, it was up to you how far you wanted to pursue your hobby. The ultimate goal, darkroom work, presented few problems. Textbooks were available, and members of the local camera club were always ready to advise and help. It was taken for granted that you would, at your leisure, learn about such things as depth of field and filters. Among the cognoscenti, this 'gen', this beloved jargon, was half the fun of photography.

Today, cameras have proliferated, not only in types and models, but in a vast number of sophisticated features. The same applies to lenses, flashguns and other accessories. Without guidance, it is almost impossible to make a proper choice of equipment. It is all too easy to spend more than necessary, when less costly items would serve you better.

Perhaps most important of all, guidance is needed in choosing the best pathways, in terms of economy and time, to the goals you set yourself. That is what I have set out to do in these pages. Libraries are full of textbooks on optics and sensitometry, and these are of value to the student preparing for examinations. They are of limited value to the amateur in need of essential information but lacking the leisure of his forbears. At the same time, some popular books on photography fill many pages with step-by-step details on how to mix chemicals for various processes, and how to carry them out. As full instructions are given with every pack of chemicals, I have not gone into such details, preferring at every stage simply to explain, and, where it is helpful, demonstrate the stages involved in photography's many procedures.

In this way, you will be able to make up your mind about the equipment you need, cost and economy, time involvement, and how far you should let your enthusiasms carry you. Finally, let me remind you of the 'instruction booklet syndrome'. So many photographers, handling a new camera or piece of equipment, cannot bother to read the instructions, resulting in spoilt film and frustration, easily avoided by an hour's preliminary reading. Whether you are just starting in this wonderful hobby of ours, or want to extend your photographic experience and skills, may I suggest that you read this book carefully, or at least the relevant parts, beforehand.

I shall be forgiven for adapting an old Irish blessing: may the subjects come up to meet your camera, and your shutter release finger never weary.

Contents

Which Camera

SUBJECT MATTERS ● JARGON ● LET THE SUBJECT DECIDE

E ven if you could afford it, you would not choose a Formula One Ferrari for commuting to and from work every day, but translate this into the field of photography and it is surprising how many novices make a similar choice. Photographers who want to keep a record of family events, outings and holidays, without any intention of ever becoming serious hobbyists, are persuaded to buy the most sophisticated and expensive single lens reflexes. At the other extreme, I receive many letters from people asking advice about such subjects as studio portraiture, motor racing, and extreme close-up natural history photography, which they hope to carry out using the family owned, fixed-lens compact camera.

SUBJECT MATTERS

The most sensible approach, and the one most economical of time, effort and money, for anyone about to buy a camera, or exchange one for a different model, is to decide on the subject matter first. If this will be wholly confined to snaps of the family and family events, a compact camera will suffice. Light in weight, easily loaded, autofocus, with a built-in metering system and flash, such a camera will give truly excellent results with a minimum of fuss or knowledge on the part of the user. If it is intended to visit sports events and air displays, and to take head-and-shoulder portraits with good modelling, zoom or telephoto lenses will be required, and these call for an SLR body. Similarly, the viewing screen of an SLR, free from parallax error and showing just what will be recorded on the film, is needed when focusing on extreme close-up subjects by means of a macro lens or close-up attachment.

Many compact cameras have a dual-focus lens arrangement, giving a modest degree of wide-angle or telephoto effect, usually achieved by means of a supplementary group of elements that slip behind the lens when switched to the telephoto mode. Image quality is usually less good with the supplementary in place. Other compacts have

The eye-catching perspective of this Mauritian scene called for an extreme wideangle lens, in this case 20mm. Only an SLR will accomodate such a lens.

Photo: Peter Roche

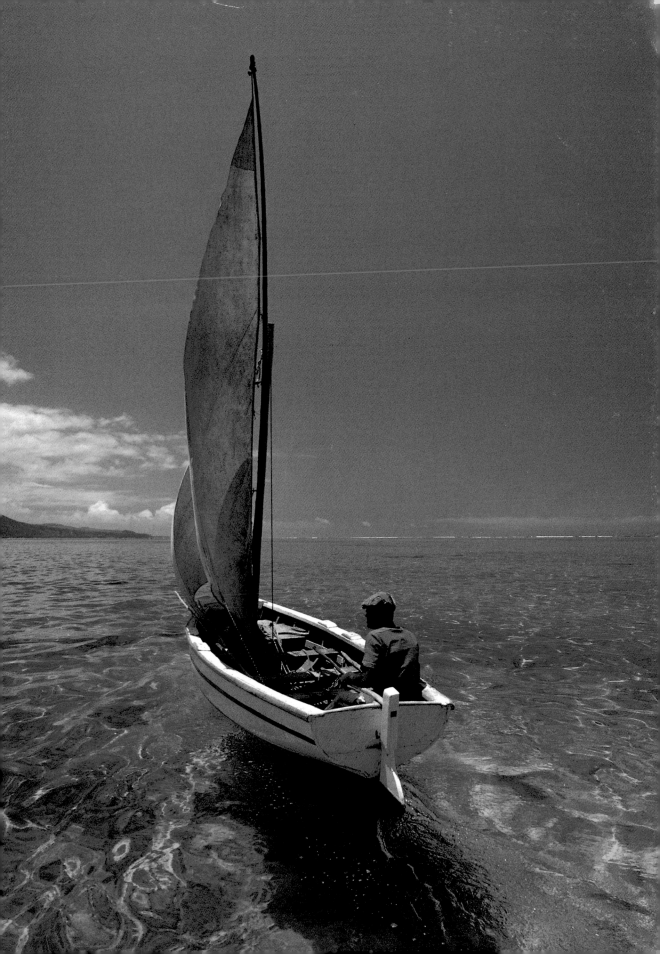

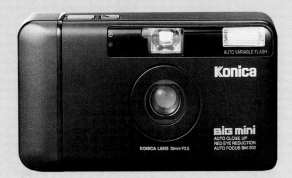

The Konica Big Mini-302 incorporates a pre-flash for red-eye reduction, and gives accurate flash exposures in close-up.

The Pentax Zoom 90-WR covers the focal length range 38-90 mm, and has an infrared remote control.

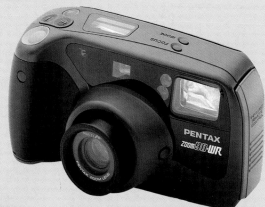

With manual focus and through-the-lens centre-weighted manual metering, this modestly-priced camera is favoured by many who feel no need for further automation.

Polaroid Vision gives instant pictures. No need to send enprints to friends and relatives later.

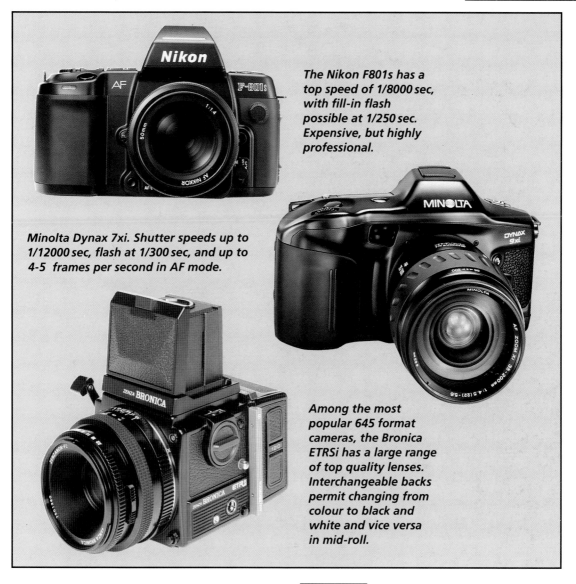

The Nikon F801s has a top speed of 1/8000 sec, with fill-in flash possible at 1/250 sec. Expensive, but highly professional.

Minolta Dynax 7xi. Shutter speeds up to 1/12000 sec, flash at 1/300 sec, and up to 4-5 frames per second in AF mode.

Among the most popular 645 format cameras, the Bronica ETRSi has a large range of top quality lenses. Interchangeable backs permit changing from colour to black and white and vice versa in mid-roll.

a true zoom lens covering the same, or a less limited, range of focal lengths.

Although helpful, most of these cameras are too limited in scope for the amateur aspiring to advanced status. We now have a category of cameras, not so compact, which have been dubbed 'bridging cameras'. They partly bridge the gap between the limitations of the compact and the facilities of the SLR. The Olympus AZ-300, for example, has a zoom lens covering the range from 38mm, which is slightly wide-angle, to 105mm, giving moderate telephoto magnification. The lens of the Ricoh Mirai extends even more, to 135mm, and this would be adequate for many subjects that have to be taken from a distance.

JARGON

Every hobby has its particular language, or nomenclature, which dedicated hobbyists delight in using. Format, depth-of-field, centre-weighted, spot and partial metering, alphanumeric display, auto-bracketing, focus priority, and apochromatic lenses, are just a few of the terms used to describe modern photographic equipment and its attributes.

Unfortunately, the enthusiastic newcomer is often faced with fifty or more unfamiliar terms which, far from being helpful, can cloud the issue and lead to a wrong, and often very expensive, choice of equipment. There is a full list of features and functions in the chapter on specifications.

Photo: Ron Spillman

This effect called for a 28mm wide angle lens on a single-lens reflex.

PICTURE STUDY

Not only do the pictures accompanying this section provide advice on photography in general, they also illustrate the kind of subjects for which the various types of camera are suitable.

Smaller snapshot cameras are defined by their film size, such as 110, disc and ½-frame. However good in its own right, the quality that can be obtained with any of these is less than would be expected from 35mm, the smallest size that should be considered for serious photography. In the chart I have made no category for these smaller formats, and for convenience they may be placed with cameras in the first column. These midget sizes will be dealt with in the next section.

LET THE SUBJECT DECIDE

For the foregoing reasons, this section is devoted to the theme that the subject matter should define the equipment, rather than deciding on the equipment first and hoping it will be suitable for the subjects that interest you. The following two chapters deal with format, which refers to the size of the frame, and specifications of the different cameras. Both subjects are of major importance to anyone aspiring to produce high quality, and especially creative work, over a range of subjects.

To simplify matters, you can refer to the following chart. Cameras have been divided into five types and subjects into nine

Photo: Ron Spillman

The viewfinder of an SLR facilitates composition. After studying a mass of plants, this small area of leaves was selected.

MATCHING CAMERA TYPE TO SUBJECT MATTER

	Fixed-lens Compact	Dual or Zoom Compact	Bridge Camera 38-100-1 35 mm	Single Lens Reflex	Medium Format
Outings, holidays (record)	A	A	A	B	B
Outings, holidays (pictorial)	C	B	B	A	A
½ length portraits and groups	A	A	A	A	A
Head-and-shoulders portraits	C	B	A	A	A
Gardens	B	B	B	A	A
Single flowers and other close-ups	D	C	B	A	A
Sports events (nearby)	B	A	A	A	C
Sports events (distant)	D	C	B	A	C
Parties, weddings	A	A	A	A	A

A denotes excellent for the purpose, **B** means usable but not ideal, **C** will give a 'snapshot' of sorts, and **D** is unsuitable.

Format

Wherever dedicated amateurs gather, usually at camera clubs, you will hear the old, old argument, 35mm v medium-format cameras, the latter using 120 size film to produce negatives and transparencies 6 × 6cm or 6 × 4.5cm. The big question is whether the 35mm frame, which is considerably smaller than medium format, can produce equal quality. The advocates of 35mm insist that it can, while the medium format brigade smile tolerantly.

Common arguments in favour:
1. Finer grained films are available in 35mm size, which compensate for the smaller area.
2. The best lenses on 35mm cameras will render finer detail than those made for larger cameras.

Common arguments against:
1. Adequately fine-grained films are available in 120 size.
2. Good medium format lenses do their imaging on a larger area of film, and can thus produce better detail.

There are some fascinating offshoots to these arguments, many of which amount to special pleading. In political terms, they might be described as being economical with the truth. A straight look at the plain facts will help you decide on which side of the format fence you will stand.

MAGNIFICATION

Although slides may be shown on a screen, negatives, whether colour or black and white, need enlarging if the pictures are to be viewed effectively. It is an unarguable fact that loss of print quality is in direct proportion to the degree of enlargement. Let us look at a few figures.

FORMAT	SIZE (APPROX)	AREA
½-frame	24 × 17mm	408 sq mm
35mm	36 × 24mm	864 sq mm
6 × 4.5cm	56 × 43mm	2408 sq mm
6 × 6cm	56 × 56mm	3136 sq mm

The 6 × 6cm camera is preferred by many professionals. Ideally suited to a picture like this of artist David Shepherd, but a rectangular section is also big enough for quality reproduction.

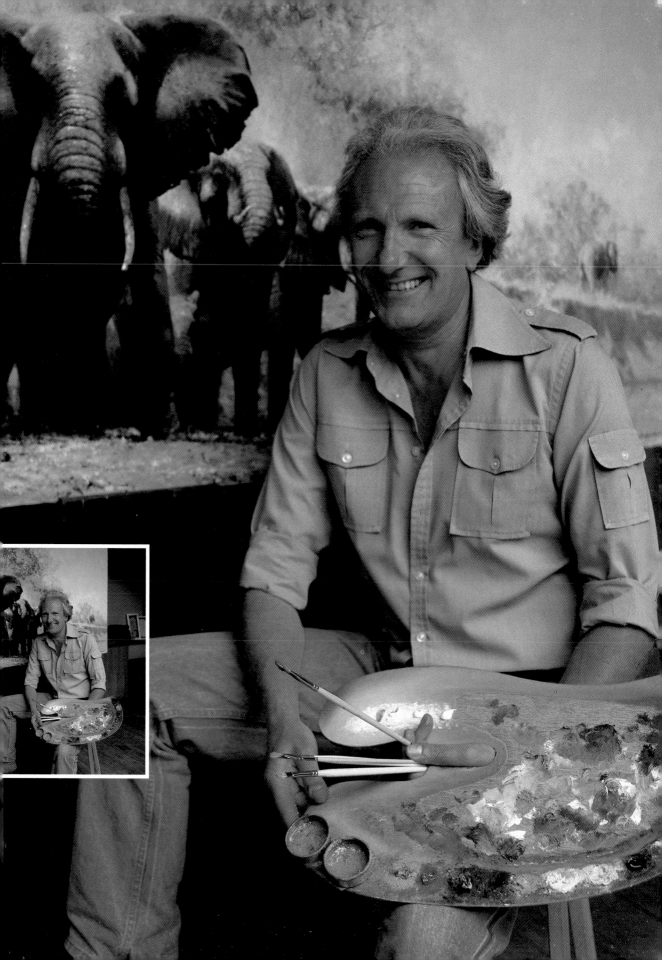

This means that:

½-frame is 0.47 × the area of 35mm;
6 × 4.5 is 2.78 × the area of 35mm;
6 × 6cm is 3.6 × the area of 35mm.

In turn, to obtain an enlargement of 25.4 × 20.3cm, the popular 10 × 8in print, the image needs to be magnified:

from ½-frame 128 × or 10.5 × linear
from 35mm 60 × or 7.0 × linear
from 645 21 × or 4.5 × linear
from 6 × 6cm 21 × or 4.5 × linear

½-frame is attractive but 35mm is the smallest practical size for advanced amateurs and professionals. 6 × 6cm has the advantage that the camera can always be held the same way and used with a reflex hood, but 645 is now the economical medium format choice.

We have already used the phrase 'other things being equal', but photographically speaking, this can be so only in theory, not in practice. For example, when comparing lenses of similar quality for 35mm and medium format cameras, both may be capable of resolving, say, 100 line pairs per millimetre, but the larger format lens images on a larger area of film, and this is only partly compensated for by using a finer grained film in the smaller size.

Perhaps the most important factor in this small v large argument, and the one least considered by amateurs, cannot be stated in technical terms. It is something known to every professional and advanced amateur, and is most often described as smooth gradation.

Regardless of the detail recorded, there is a smoothness of transition across the tonal range which is far more easily obtained (some would say only possible) with the larger camera. It reveals itself not so much in photographs of a technical nature, but in portraiture particularly, and also in wedding, landscape and other pictorial subjects.

A SENSIBLE FORMAT

In practice, a good 35mm camera can satisfy all the needs of the amateur, however advanced his aims. With skill, it is possible even to match the smoothness of gradation so easily obtained with the larger format, and so desirable in many portraits, simply by using

a diffuser in front of the lens, as well as employing a fine-grained film.

In fact, the 35mm camera, especially the SLR, has several advantages that are not immediately apparent when studying lists of specifications. Among the most significant are:

Light weight. An SLR equipped with a couple of lenses may weigh just 3 lb or so, is quite easily carried, and gives wide scope. A similar medium format outfit would weigh twice as much. This is why some users restrict themselves to a fairly limited medium format outfit. The other reason is high cost.

Speed of operation. A 35mm camera can be brought into action far more quickly than a

The SLR with a short zoom, 28-80mm or thereabouts, is probably the most useful combination for general photography.

larger camera. This is all-important when covering such subjects as sports events. Because of its relatively light weight, it can easily be swung smoothly or 'panned' to keep a moving subject centred in the frame.

Lenses. There is a vast array of lenses available for 35mm SLRs. The medium format market tends to be ignored by independent lens makers, while those provided by the camera manufacturers are very expensive. Additionally, lenses of larger maximum aperture are generally available for 35mm

cameras. This is mainly to do with handling weight, but also with the cost effectiveness of the optical/mechanical work. A 50 mm f/2, f/1.8, or f/1.7 lens for a 35 mm SLR might weigh 250g and cost £90, whereas a 75 mm standard lens with a maximum aperture of only f/2.8 could weigh 430g and cost £180. With non-autofocus 35 mm SLRs, the larger apertures give a brighter screen image. Not only does this make accurate focusing easier, it also makes it easier to study the image in detail, though the larger viewing screen of the medium format camera is preferable in this latter respect.

Naturally, medium format cameras also have certain advantages, not always apparent when reading the specifications. Among these are:

Interchangeable magazines. These allow different types of film to be used during the same session. Just the one camera body is required and magazines can be changed at will, without wasting unexposed film. Only one 35 mm SLR, made by Rollei, offers this facility.

Large viewing screen. It is easier to study a subject in detail on the larger screen of a medium format SLR. This usually has a subtle, but definite, improving effect on composition.

Slower in use. Although such items as motorwinds and speed-grips are available for medium format SLRs, they are still rather too cumbersome for fast action work.
More care is needed, so there is less casual snapshotting, and more thought goes into each picture. That is the theory.
As you go through this book, you will realise that truly great pictures can be made with a fixed-lens compact camera. Technically, the results can be every bit as good as those from a good SLR. An exciting or beautiful image can be captured on both. Of course, the compact, largely because it does not have the range of interchangeable lenses, operates within a more limited field than the SLR, but provided it meets all your needs, it could well be the best choice, in terms of convenience and economy.

PRINTS AND ALBUMS

The vast majority of camera owners use print film, and are quite satisfied with the prints that come back from the processor. These are usually about 6 × 4 in, easy to carry in bag or wallet, and mount easily in the albums favoured by most families. They are also quite large enough for easy viewing when handed around. The occasional special shot is selected for enlargement, normally no bigger than 10 × 8 in.

It should be noted that a 6 × 4 in print is not a significant enlargement from a 35 mm negative, so such prints from medium format negatives will not show significantly better quality than those from 35 mm. The expert may detect the difference between 10 × 8 in prints made from the two formats, but this fact is of little importance in anything other than document copying and the like. In fact, by far the majority of large photographs one sees at exhibitions, as well as those that win prizes and earn fees in photographic magazines, are from 35 mm. In the areas of visual journalism, including news and sports work, 35 mm cameras are the order of the day.

In recent years, a few highly sophisticated ½-frame cameras have appeared on the market, and given a boost to this format, popular twenty years ago, but only a minor cult in recent years. Half the size of a 35 mm negative, the ½-frame has to be enlarged much more. Thus, the format will not be chosen by the amateur wanting to get the utmost in quality without going beyond the convenience of 35 mm.

There are still a great many cameras taking even smaller sizes, such as disc and 110. Small prints from these are satisfactory, though clearly not as good as those from 35 mm. They are of no use to the quality conscious photographer.

The rectangular 35mm frame is ideal. when wandering around shows and events. This was taken at the short end of a 35-70mm zoom.

Specifications

Before we can usefully evaluate the specifications of modern cameras and accessories, we should understand the basics. In other words, what all those hi-tech functions are intended for, and why do we need them. The more advanced reader will excuse me if I begin this chapter by explaining to the newcomer just what happens when he or she takes a photograph. And that takes us right back to the beginning.

ANCIENT AND MODERN

The basic principle of picturemaking is shared by the oldest box camera and the latest SLR. They both consist of a light-tight chamber with a lens at one end and a sensitive film at the other. The lens projects an image of what is in front of it on to the film behind it. The image consists of light, intense in the highlights, moderate in the half-tones, and almost absent in the darkest shadows. This image is imprinted on the light-sensitive film, but at this stage remains invisible, or latent. The latent image is revealed later by chemical means.

To obtain a good quality image the lens needs to be focused, so that the image is sharp. This calls for some kind of focusing method. On older cameras this was simply a focusing scale, marked in feet or metres. You set this, usually by guesstimate, and it moved the lens accordingly. These scales still exist on the barrels of modern lenses, but are seldom used. On some cameras focusing was done by observing the image on a ground glass screen, much as we do today when looking into the viewfinder of an SLR and turning the focusing ring on the lens. More expensive cameras of the Thirties incorporated a rangefinder instead of a focusing screen. Two images of the subject were viewed and brought to a single image by turning the lens mount. This method is still used on many compact cameras and a few larger ones.

The film has to be kept in the dark until the moment of exposure. On the very earliest cameras a close-fitting lens cap, lined with

Good colour saturation is a technical term for rich colour. The rule is: never over-expose slide film, never underexpose print film.

Photo: J. Gray

The evaluative or matrix (multi-segment) metering in hitech cameras will compensate for uneven lighting.

velvet, fitted over the lens.

The exposure was made by taking the cap off, with a smooth circular motion that would not cause the camera to vibrate, the correct exposure counted in seconds or minutes, and the cap replaced. This was possible because of the slow films (of low sensitivity to light) of those days.

With the advent of faster films a more precise mechanism was needed, and the mechanical shutter was introduced, capable of giving short as well as longer exposures, and controlled by springs. These were of two main types, lens and focal plane. Lens shutters were placed behind the lens, or between its components. The best of these consisted of blades which opened from the centre outwards, then closed again. Typified by such names as Compur and Prontor, the latest of these are used on most medium format and

Photo: Ron Spillman

Using a camera with centre-weighted average metering, the photographer aimed his lens to the right, away from the bright sky, while metering. This avoided an inflated meter reading, which would cause under-exposure of the people.

larger cameras.

Focal plane shutters, as the name implies, consist of two blinds, or curtains, one following the other horizontally or vertically in the focal plane, immediately in front of the film. The width of the slit between the blinds, and their speed of traverse, determine the amount of exposure. Such shutters are used on many of the best 35 mm cameras made today, though an extremely accurate electro-magnetic version is extremely popular and is incorporated in many cameras.

REFINEMENTS

Those are the basics of a camera and its operation, holding good today just as they did fifty or more years ago. Many refinements were developed to simplify picturemaking. A means of determining exposure was among

the first of these. Starting with simple exposure tables, further developments included a meter containing sensitive paper which darkened when exposed to light. The time taken for the paper to match a standard tint was then translated into a camera exposure time. Then came extinction meters. In the most popular of these you looked through a tube at a circle of numbers, bright at 1 and growing progressively darker. You chose the number that was just visible, transferred this to a dial, and read off the correct exposure. Finally came the photoelectric exposure meter, which we use today. These are built-in to most modern cameras, but separate, or hand-held, ones are used for special purposes, which we will deal with later.

A whole string of refinements has followed, many of which are self-explanatory: double-exposure prevention device; coupled film wind and shutter setting being among the earliest. Later refinements include motor driven film wind and rewind, exposure metering coupled to the shutter giving correct exposure automatically, and that huge step forward for photographic mankind —

autofocus.

From early days there had been reflex cameras, in which the image was composed and focused by looking down on a ground glass screen inside a hood to cut out extraneous light. The image was reflected upwards by an inclined mirror, which was then swung up to darken the inner body of the camera while the image fell on the film at the back. The development which brought photography into the hi-tech era was the pentaprism and instant return mirror. The image is reflected round the facets of the pentaprism to the eye for composing and focusing. When the shutter release button is pressed, the mirror flies up, the diaphragm of the lens stops down to an appropriate aperture, (which will be explained later in this chapter) the shutter makes the exposure and the mirror drops again. The image seen by the eye is blacked out for a mere 1/25 sec or so, just the blink of an eye!

Anyway, that's enough of history. Many later refinements are of very complicated design, even though carrying out a simple function, and it is sometimes difficult for the newcomer to photography to cut his way through the verbiage of the specification, to the function. We can now go on to the list of terms you are most likely to meet in photography, the jargon.

SLR SPECIFICATIONS

AE. Automatic exposure. The camera automatically selects apertures, shutter speeds, or both, for correct exposure.

AE LOCK. Control for holding a particular automatic exposure setting in the camera's memory. Example: skiers in the snow. The snow would inflate the meter reading, causing under-exposure, with dark figures and grey snow. Take the reading from the skiers' clothes, or the blue sky, apply the AE lock, re-compose the picture and shoot.

AF. Autofocus.

AF CONVERTER. An optical converter that allows non-autofocus lenses to operate in the autofocus mode. Note: some cameras and

lenses only.

AF COUPLER. Mechanical linkage between the camera's autofocus system and the lens.

AF ILLUMINATOR. Autofocus assistance in complete darkness. A near-infrared lamp built in to the camera or flashgun sends out a beam of light to project a pattern on the subject for the AF to focus on.

AF LOCK. Autofocus lock, used for holding sharp focus on the subject while re-composing the picture. In most systems, the autofocus measuring area is central in the frame. If two people, for example, are either side of this area, focus would fall on the background unless locked.

ALPHANUMERIC DISPLAY. Any display, on cameras, flashguns and meters, which provides information in letters and numbers.

'A' MODE. Aperture priority mode. You set the aperture, and the camera sets the shutter speed.

AMP. Automatic multi-pattern metering. An automatic metering system on the Nikon FA that takes into account light levels from five separate sections of the picture area, and relates these to the camera's built-in memory. The Nikon F-401's triple zone metering and the Canon EOS's evaluative metering work in similar ways.

APERTURE. Altering the size of the 'hole' in a lens, by means of the multi-bladed iris diaphragm, controls the brightness of the image reaching the film. On some cameras the aperture is altered by an aperture ring on the lens barrel, or by a button in the case of some hi-tech cameras. The user can normally alter the aperture by whole stops, or values, and often by half-stops. Each stop larger or smaller halves or doubles the exposure required.

APERTURE PRIORITY. See 'A' Mode.

AUTO-BRACKETING. A series of pictures taken by the camera automatically, each giving a slightly different exposure. Useful in

Photo: Sylvia Lowe

A lens with macro mode makes this kind of picture easy, while spot or partial metering ensure correct exposure. If a tripod is not used, the camera must be held quite still.

awkward lighting situations where the meter may be misled.

AUTO-FILL (or AUTO FILL-IN) FLASH. A flashgun that can provide the correct balance of flash output to ambient light, whether daylight or artificial.

AUTOMATIC METERING. Any camera metering system which can automatically calculate and set exposure based on information about light level, aperture and/or shutter speed, film speed and (sometimes) exposure compensation. qv.

AUTO REWIND. The ability of a camera to sense the end of a film and automatically rewind it into the cassette. Semi-auto rewind involves the user pressing some kind of rewind control.

'B'. Bulb, or brief time. A setting which keeps the shutter open as long as the release is held down.

BC. Battery check.

BLC. Backlight compensation control. A control to increase the exposure by a given amount. Mainly used to give increased exposure to a backlit subject, which would otherwise be underexposed.

CCD. CHARGE COUPLED DEVICE. Used in autofocus SLRs to measure contrast, so the camera can gauge the distance to an object in the autofocus mode.

CdS. Cadmium sulphide cell. Simple form of light-measuring cell, found especially on older cameras.

CHIP. Slang for integrated circuit (IC). The common ones used in cameras are ROM (read only memory) chip and CPU (central processing unit).

CW or **CENTRE-WEIGHTED AVERAGE METERING.** Most common light-measuring

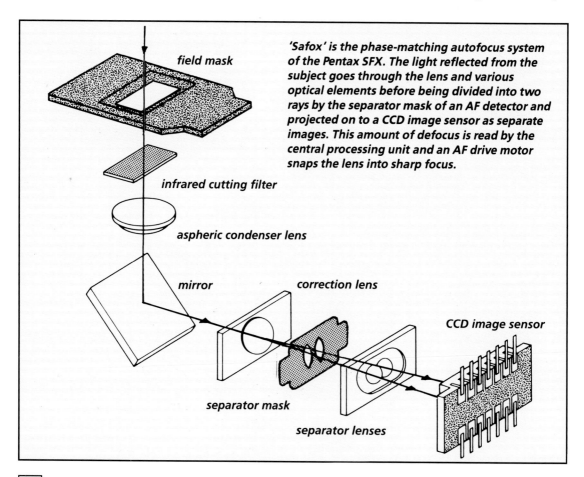

field mask

'Safox' is the phase-matching autofocus system of the Pentax SFX. The light reflected from the subject goes through the lens and various optical elements before being divided into two rays by the separator mask of an AF detector and projected on to a CCD image sensor as separate images. This amount of defocus is read by the central processing unit and an AF drive motor snaps the lens into sharp focus.

infrared cutting filter

aspheric condenser lens

mirror

correction lens

CCD image sensor

separator mask

separator lenses

system found in SLRs. The meter concentrates mainly on the centre half or two-thirds of the frame, where the most important part of the subject is likely to be.

DEDICATED FLASH. System where the flashgun controls some of the camera's exposure functions, the two working together. The simplest dedicated gun would, for example, set the camera to correct flash synchronisation speed and show a ready-to-fire symbol in the viewfinder.

DEPTH OF FIELD. The zone of adequate sharpness on either side (towards and away from the camera) of the point focused on. Fully dealt with in the next chapter.

DOUBLE ENTRY. A function that takes two separate actions to alter. Helps to prevent accidental changing of camera modes.

DX CODING. System in which the camera senses the type and speed of a film, by reading a code on the cassette, and automatically sets the camera accordingly.

DX WINDOW. A clear panel in the camera's backplate, which allows the user to check which type of film is loaded.

ELECTROFOCUS MOUNT. A lens mount using electrical contacts rather than mechanical linkages to receive aperture and/or focusing information from the camera.

ELECTROMAGNETIC SHUTTER RELEASE. Shutter button that works by forming an electrical contact. Gives smooth release. Does not work if batteries are exhausted.

ELECTRONIC INPUT DIAL. Multi-function dial that allows modes, shutter speeds and film speeds to be altered quickly.

ESP. Electro-selective pattern metering. Advanced form of metering on the Olympus OM40, which can take into account the difference in lighting between the main subject and the whole scene, and allow for any difference in light levels.

EV. Exposure value. A value given to an

Extension cord TLA 100 retains dedication when TLA 20 flash is used off the Contax camera.

exposure level, made up of the shutter speed and aperture. An exposure of 1/125 sec at f/8 is the same exposure value as 1/250 sec at f/5.6 or 1/60 sec at f/11, and so forth.

EVALUATIVE METERING. TTL metering information is from a number of cells arranged in a pattern across the film frame. The central processing unit (CPU) evaluates the relative importance of each area, and deduces an appropriate exposure. Also, see ESP and MATRIX METERING.

EXPOSURE. Film and photographic paper are exposed to light via two main variables, the size of the 'hole', or aperture, q.v., and the amount of time the image is allowed to fall on the film, by the shutter. These two determine the amount of light that has reached the film, and together with the sensitivity of the latter (see ISO Rating) determine whether exposure will be correct, over- or under-.

FAST LENS. A lens having a wide maximum aperture, such as f/1.4 rather than, say, f/2, f/3.5 etc. The term is relative, as f/2 is quite fast. The wide aperture lets more light through, thus permitting faster shutter speeds.

FE LOCK. Flash exposure lock.

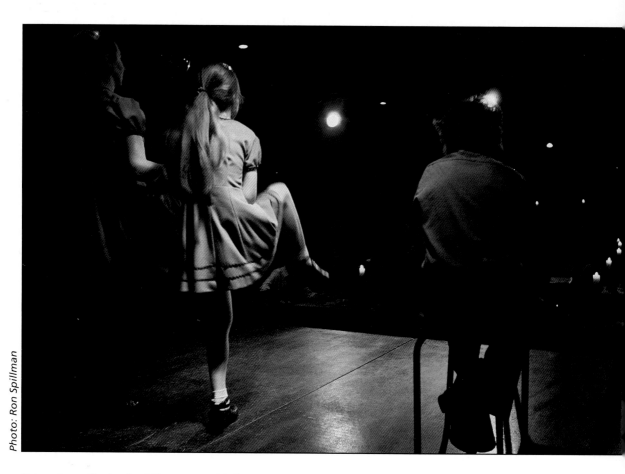

Photo: Ron Spillman

Taken from the back of the stage with fast artificial-light type slide film, a spot meter reading ensured correct exposure of this high-stepping Irish lass.

f/NUMBER, usually expressed as f/1.8, f/8 etc. A number calculated by dividing the focal length of a lens by the diameter of the aperture set. It combines with the shutter speed to determine the amount of exposure given to the film, and also has a bearing on depth-of-field, q.v.

FOCAL LENGTH. The distance rays of light have to travel from the centre of the lens to the film plane when the lens is focused on infinity.

FOCUS AID. A camera's confirmation of correct focusing manually on an autofocus or focus assist camera. Green light confirmation.

FOCUS MODE. The focusing status of a camera, for example, manual focus, autofocus, continuous AF or trap focus.

FPS. Usually in lower case, following a number, e.g., 5fps. Frames per second, refers to the rate at which a motor drive or power winder will operate.

FOCUS PRIORITY. Method on autofocus SLRs for preventing the shutter from firing until the picture is in focus.

FOCUS HOLD. Method of locking the distance setting on an autofocus SLR. See AF Lock.

GaSP. Gallium sulphur phosphide, an advanced form of light sensitive cell.

GPD. Gallium photo diode (as GaSP).

HIGHLIGHT CONTROL. Exposure compensation button that produces correct exposure for light or bright objects in the scene.

HOT SHOE. A direct connection between flashgun and the camera on which it is

mounted, permitting the flash to be fired in proper synchronisation, and without a connecting cable.

INTERVALOMETER. Function that controls the timing between camera exposures, sometimes built-in to a special camera back.

ISO. International Standards Organisation. Widely accepted rating of film speeds.

JCII. Japan Camera Inspection Institute.

LCD. Liquid crystal display. Computer-style display used in camera top-plates and viewfinders.

LED. Light-emitting diode. Used to illuminate and indicate viewfinder information, and as external check on self-timer operation.

LONG-EYEPOINT VIEWFINDER. A design which allows the whole viewing screen to be seen with the eye slightly away from the eyepiece, useful for spectacle wearers and favoured by some sports photographers.

MANUAL AUTOFLASH. A feature found on many hi-tech SLRs with TTL flash facility. The user can set shutter speeds slower than the normal synchro setting, for creative results, and set any aperture. The flash is automatically quenched if over-exposure would result, and a warning of under-exposure is also given.

MATRIX METERING. The Nikon system of multi-pattern metering. Also, see ESP and EVALUATIVE METERING.

ME. Multiple exposure, several intentional exposures, on the same frame of film. A device resets the shutter without winding on the film.

'M' MODE. Manual exposure mode. The user chooses both lens aperture and shutter speed.

MODE BUTTON. The control that allows a camera's functions to be altered. Normally changes the exposure modes, perhaps to speed (wider aperture, faster shutter

speed) to depth (smaller aperture, slower shutter speed).

MOTOR DRIVE. Method of transporting the film through the camera at speed, normally 3.5 fps or faster. Automated rewind is also a feature of many motor drives.

MULTIMODE. A camera that provides several methods of producing an exposure, such as manual, where the user sets shutter speed and aperture, shutter priority, where the user sets the shutter speed and the camera sets the aperture, and aperture priority, where the reverse is the case. Also programmed modes, which let the camera set a suitable combination of aperture/shutter speed. A multimode may also include flash modes which control flash output, and possibly shutter speeds and apertures.

OTF. Off the film. A metering system which measures light directly off the surface of the film. One of the most accurate forms of exposure control.

OVER-EXPOSURE. A dense negative or thin transparency, caused by too slow a shutter speed or too wide an aperture.

PARTIAL. Metering mode in which light is measured from a central area of about 12 per cent of the whole frame. It lies midway between centre-weighted and spot metering.

PENTAPRISM. The glass prism at the top of an SLR, which permits the scene to be viewed right way up and right way round at eye level.

PHASE DETECTION. The principle behind an SLR's autofocus system. The image of a subject is split into two and read by a row of sensors. When they are in phase the subject is in focus.

PICTOGRAPH. Information displayed on LCD panels in the form of pictures.

'P' MODE. Program mode. The camera sets a combination of aperture and shutter speed for correct exposure. Modes include high speed programs which provide a faster shutter speed and wider aperture for action

work (also called P Hi, tele or action program). There are also wide programs which set a smaller aperture and slower shutter speed for greater depth of field. These programs are normally moved to from the normal program.

POWER WINDER. Method of automatically transporting the film and winding the shutter ready for the next shot. May be a separate attachment or built-in. Will have single shot and continuous modes.

PROGRAM. Auto-exposure mode, with the camera setting both aperture and shutter speed.

PROGRAM BACK. Highly advanced form of data back. Some extra features such as autobracketing and multi-spot metering may be offered, as well as normal data imprinting, such as time, date, and sequential numbering.

PROGRAM FLASH. The camera is left on program and controls flash exposure.

PROGRAM RESET. A 'panic button' which resets the camera to full auto.

PROGRAM SHIFT. Controls movement between programmed modes. See 'P' Mode.

SECOND CURTAIN SYNCH. Flash mode that allows moving subjects to be sharply lit by flash at end of longish shutter opening which records lights trailing back from the subject.

SERVO MODE. Continuous autofocus, also called follow-focus. Keeps a moving subject in focus until an exposure is made.

SHADOW CONTROL. Exposure compensation control, that ensures blacks are reproduced as true blacks, not as greys.

SHUTTER PRIORITY. Exposure mode where you set the desired shutter speed and camera sets the appropriate aperture.

SLOW SHUTTER AUTO FLASH. The ability to set shutter speeds slower than the normal X-sync speed.

SLR. Single-lens reflex. Has facility for

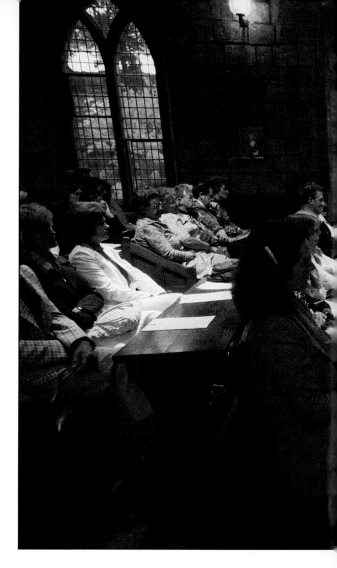

interchangeable lenses. A mirror reflects the image up to a focusing screen, usually under a pentaprism, q.v., and the mirror flips up out of the way during exposure.

'S' MODE. Shutter priority mode, q.v.

SPD or SPC. Silicon photo diode, or cell. Advanced form of light metering cell.

SPOT. Metering system where light is read from a small area of the subject.

STILL VIDEO COMPATIBLE. An SLR capable of accepting traditional film and still video floppy discs.

STOP. Lens aperture setting.

STOPPED-DOWN METERING. Exposure mode where the camera selects the correct

Photo: Ron Spillman

shutter speed with the lens stopped down to its taking aperture.

ST. Self-timer, sometimes called a delayed action device.

TRAP FOCUS. Focusing system with which the camera will fire only when an object moves into the zone of sharp focus.

TTL. Through-the-lens. TTL metering incorporates sensors inside the camera body which read light passing through the lens.

UNDER-EXPOSURE. A thin negative giving a dark print, or a dense transparency, caused when camera or user selects too fast a shutter speed or too small an aperture.

VIEWFINDER. General name for the area where the photographer views the image,

The photographer knew that the TTL-metering would balance the daylight from the window with those dark shadowy areas, providing correct exposure for players and audience. Taken at Shrewsbury Castle during a music festival.

including any focusing and camera status information.

VIEWING SCREEN. Etched glass or plastic on which light is focused for viewing. A standard screen may have a split-image rangefinder spot surrounded by a microprism ring, the rest of the screen being matt. Special-purpose screens are available for some SLRs, in some cases interchangeable by the user, but sometimes needing factory service.

X-SYNC. A shutter speed setting which gives correct synchronisation with an electronic flashgun.

Choosing Lenses

UP FRONT ● ABERRATIONS ● FLARE ● LENS COATING
BARREL DESIGN ●FIXED FOCAL LENGTH LENSES
FIXED VERSUS ZOOM ● CREATIVE CHOICES ● LOW LIGHT LENSES
FINE POINTS ● THE POPULAR 35 – 70MM ZOOM ● AUTOFOCUS

To describe the function of a modern camera lens as projecting an image on to the film is rather like saying that a car's function is to take you somewhere. Both statements are true, but they say nothing about quality and application. The ideal lens would give a pin sharp image from corner to corner of the frame, would have good contrast, total freedom from flare (unwanted light rays affecting the image), a large maximum aperture and light weight. Unfortunately, in spite of the enormous progress that has been made in optomechanical engineering, this perfect lens does not exist. There are fast lenses and technical lenses, lenses designed specially for macro work, and a majority of lenses of compromise design for general photography.

In order to make a suitable choice of lenses, it is not necessary to know everything about lens design and manufacture, but this is a case where a little knowledge can be very helpful. Older lenses suffered from a variety of optical aberrations, spherical and chromatic, coma, astigmatism, curvature of field and distortion. The job of the designer, then as now, was to reduce the aberrations to a residual minimum, resulting in a good quality lens. As a result of computer aided design, aided by new types of glass, we can today make better lenses in larger numbers and at lower cost. But small residual aberrations and other problems remain, and we should go quickly through some of these before discussing more general properties.

ABERRATIONS

Distortion is a word often misused in photography to describe the unusual acute perspective when a subject containing straight lines is photographed from a close viewpoint with a wide-angle lens. The well-corrected lens is doing its job properly, presenting a view which is unusual simply because we do not normally view with our eyes from such a close viewpoint.

An extreme wide angle lens emphasises the foreground, while relating it to the background.

Photo: Roger Reynolds

33

Distortion, in fact, affects photographers only when it causes pincushion or barrel distortion. It does not affect the sharpness of the lens. It tends to be present to a small degree in camera lenses of a single focal length but more so in zoom lenses. Normally, pincushion or barrel distortion go unnoticed in general photography, but can be revealed when photographing a rectangular object dead in front of, and square to, the camera. If the borders of the subject, say, a map or a sheet of printed paper, align with the edges of the viewfinder screen, the subject borders may be seen to curve inwards or outwards in relation to the screen.

At its worst in zoom lenses this kind of distortion is seldom of great consequence to the amateur unless accurate copying forms a significant part of his hobby. In that case, he may obtain a special macro lens for the purpose.

Perhaps more important in an age where colour films have been brought to a state of near-perfection, is chromatic aberration. This is the inability of a lens to focus all colours of the scene in exactly the same plane. The red part of the image focuses farther from the lens than the blue image, with other colours sharp at varying distances between the two extremes. Some very ancient camera lenses suffered badly from chromatic aberration, but were all right for use with non-panchromatic black and white film. Only the very simplest and cheapest of today's lenses may have a significant amount of this aberration, which is masked anyway by general optical inferiority.

FLARE

What we call flare is scattered non-image forming light in the camera distributed more or less evenly over the film. It has the effect of reducing image contrast, the shadow tones especially being compressed. It comes from a variety of sources but lens flare proper is the result of multiple reflections at glass/air surfaces in the lens, the light thus scattered eventually entering the camera. Other non-image forming light can come from imperfectly blackened surfaces in a lens mount or camera body.

Quite often non-image forming light is localised on the film and gives rise to ghost images. The effect can be seen in spectacular form on television when the camera with a zoom lens makes a panoramic sweep across a scene taking in the bright sky or sun. A long line of coloured shapes, ghost images of the lens aperture reach towards the camera from the source of light and disappear as the traverse proceeds beyond this point. The same effect can occur in some of our still photographs.

Lens flare proper is reduced to an absolute minimum by the practice of coating or blooming lens surfaces. This is done by vacuum deposition of a thin coat of perhaps magnesium fluoride which has the effect of reducing reflections at glass/air surfaces. Modern practice is to apply seven or more layers which have the result of reducing flare dramatically. Such multiple coating can do nothing to reduce the level of non-image forming light caused by reflections within a lens mount or camera body.

LENS COATING

When light reaches a glass surface, most of it gets through, but some is reflected back. In a lens this light loss is progressive, occuring at each air/glass surface. In old, uncoated lenses, the loss was as much as 5 per cent at each surface, and in a lens with, say, six elements arranged as two singles and two cemented pairs, the eight air/glass surfaces could account for as much as 40 per cent. Light loss was not the only problem, as the image reaching the film would lack contrast. The degraded image would be particularly noticeable with colour film.

As some zoom lens designs, especially early types, had as many as twenty or more air/glass surfaces, they had to stay on the drawing board, marked 'optically good but impracticable'. This state of affairs persisted until coating techniques were applied

To fill the frame, the photographer doubled a 500mm lens to 1000mm by means of a 2X converter. The very shallow depth of field blurs the background, which adds extra apparent sharpness to the subject.

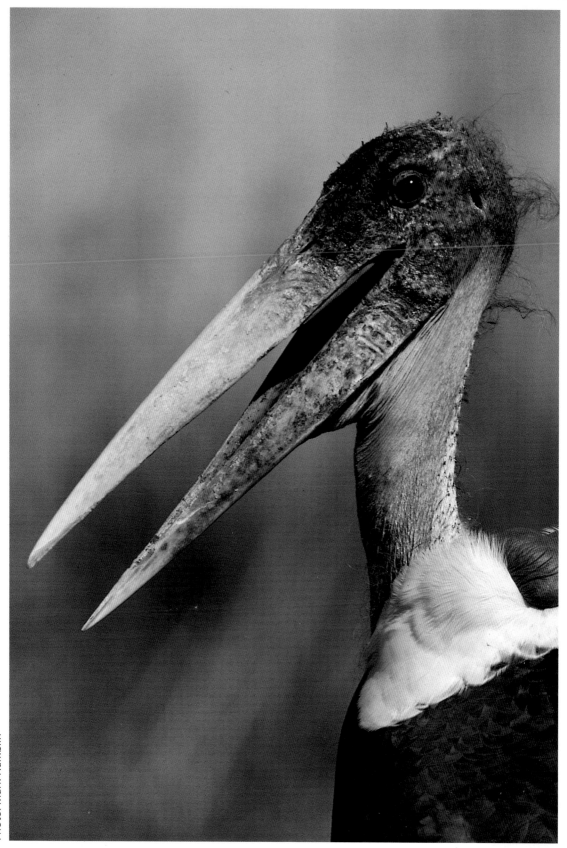

Photo: Mark Hamblin

28mm

50mm

135mm

From the same
viewpoint, the longer the
focal length the greater
the magnification. Long
lenses often reveal
pictures not noticed by
the naked eye. 28mm,
50mm, 135mm, 300mm.

300mm

to lenses.

The greatest advance was the introduction by Pentax of applications of up to seven layers per surface. Every top lens maker now uses a form of multiple coating, with light loss at each surface reduced to about 0.02 percent, or practically nil.

Naturally, multiple coating helps in the formation of an image with good contrast and, in conjunction with good colour film, produces brilliant, well-saturated colours. It is the main, but not the only factor, in the reduction of flare. Keeping the surface of the lens clean also helps, as does the use of a lenshood.

BARREL DESIGN

The barrel of the lens does far more than hold the glasses in the right place. The revolving and sliding parts for focusing, zooming and aperture setting, need to be smooth but positive and without slackness. The interior design must help reduce flare, and this is achieved in several ways. First, the exposed inner wall is baffled, with a matt-blackened pattern of concentric ridges. Non-reflective spacers are used between groups of elements to shade the wall from stray or reflected light rays. This reduces the possibility of such rays reaching the film by reflection from the wall. Stopping the lens down gives additional shading, which explains why image contrast increases as the lens is stopped down, and is least good at full aperture.

In some lenses, such as the Canon FD 28-85mm f/4 and the Minolta MD 28-85mm f/3.5, further protection is given by the use of a 'flare stopper', a roughly rectangular mask at the rear of the barrel. This device is very effective.

FIXED FOCAL LENGTH LENSES

Such a lens has a single focal length, as opposed to a zoom, which covers a range of focal lengths. In general, lenses with a fixed focal length have less elements, and a less complicated optical configuration, than zoom lenses. Among the least complicated of lenses are telephotos of modest maximum aperture,

such as a 200mm f/4 or a 300mm f/5.6, which accounts for their relatively modest cost. On the other hand, a wide-angle lens has a more complicated optical design within a small compass, which calls for precision construction and assembly. By way of comparison, the Canon FD 200m f/2.8 has 7/6 (seven elements arranged in six groups), while the Canon FD 24mm f/2.8 has 10/9.

Similarly, the popular zooms covering a range of about 70-210mm may need as few as ten elements, while a shorter zoom, such as a 28-85mm may require twelve or more. Because the groups within a zoom have to move in relation to each other, and yet maintain focus and freedom from aberrations while zooming, they are more difficult to make. For years after their introduction, an argument raged among amateurs, and to some extent still does, as to whether a zoom can perform as well as a lens of fixed focal length.

FIXED VERSUS ZOOM

If every photograph taken was of a lens testing chart, it could probably be shown that in most respects single focal length lenses give a better optical performance than zooms. In this case we cannot introduce that wonderful phrase 'other things being equal', as the two types of lenses, fixed focal length and zoom, are so different. In fact, over the years, zoom design has improved so vastly that the difference cannot be seen in general photography. Naturally, we expect better performance from an expensive zoom, just as we do from an expensive fixed focal length lens, and it is not unusual for a quality zoom to outperform a lens of fixed focal length of modest cost, and vice versa. Optically, then, when we consider zooms from the most reputable and better known makers, the old argument becomes meaningless, or at best academic.

This does not mean that practical differences do not exist, and you may take some of these into consideration when choosing an optical outfit. As far as zooms are concerned, the most obvious advantage is that one lens replaces several. A 28-85mm zoom, for example, replaces 28mm, 50mm

and 85 mm lenses. It is far quicker to zoom than to change lenses. Some would argue that pictures can be lost while switching from one lens to another, though this may be of practical concern to the action photographer rather than the pictorialist. It is also easier to decide on a suitable degree of magnification by zooming, rather than by changing from lens to lens.

Against these fairly obvious advantages there are certain drawbacks to be considered. A 70-210 mm lens at 210 mm may be hardly bigger or heavier than a 200 mm lens, but used near the shorter end, say, at 100 mm, it is much more cumbersome, and thus more difficult to hold still, than a 100 mm lens. This ties in with the question of maximum aperture. The 70-210 mm zoom set to 100 mm may have a maximum aperture of f/3.5, while the 100 mm or 105 mm lens would commonly have f/2.8 or f/2.5. Imagine that you are concentrating on shooting pictures of a child indoors near a window in good light. With the fixed lens at full aperture you may manage a comfortable 1/60 sec, and with the zoom only 1/45 sec or 1/30 sec. Not only can you rely on getting a shake-free picture with the smaller and lighter lens, but the viewfinder image will be that much brighter and focusing easier and perhaps quicker.

Most zoom lenses now have a macro mode, permitting close-ups to be made at less than the normal minimum focusing distance. On some zooms the macro mode comes into play at the shorter end, on others at the longer. If at the shorter end, the lens may be brought to within a few inches of the subject, and the perspective effect will be acute. If at the longer end, the perspective will be more natural but with the same degree of magnification.

In either case, this is usually not a true macro mode, and should really be described as just a close focus mode. Lenses for general camera work are computed to give their optimum performance at infinity. As they are focused closer, residual aberrations start to increase, though they do not become noticeable, except to the expert, at distances shorter than a few feet. This is why true macro lenses are made, giving their optimum performance at very close distances, down to

life size or half life size. It must be pointed out, though, that an ordinary lens, or a zoom with macro facility, gives a very creditable close-up image, which is perfectly acceptable for all but technical applications. Similarly, true macro lenses perform satisfactorily at long distances.

Among the more expensive there are lenses which have a 'floating' group of elements, which shifts its position in relation to the other groups as the focusing is altered, thus keeping any residual aberrations at a low level and maintaining optimum quality.

Perhaps a minor factor, but one which irritates many a perfectionist, is the problem of lenshoods on zoom lenses. Ideally, a lenshood should be deep enough to avoid just cutting into the cone of image-forming light rays in front of the lens. Thus, a lenshood for a telephoto lens, which has a narrow angle of view, can be quite long, whereas a lenshood for a wide angle lens, which has a very wide angle of view, must of necessity be short. On extreme wide-angles, in fact, parts of the lenshood are cut away, so as not to vignette the corners of the frame. This is shown in the illustration on page 44.

Naturally, no-one in his right mind would keep a series of lenshoods of different lengths and swap these around when zooming between different focal lengths. For convenience, most zooms are provided with a short lenshood, ideal when the shortest focal length is in use, but becoming progressively less effective as the focal length is increased. The problem is cleverly overcome by some makers, who fit a long lenshood to the outer barrel, inside which the body of the lens retracts and advances as it is zoomed. In the wide-angle mode the front element of the lens is shielded by just the front end of the hood. In the telephoto mode, it retracts and more of the hood comes into play.

A problem with some retracting zooms is the difficulty of fitting filters, especially polarisers, which have a larger mount, as these may foul the outer barrel. This problem does not exist with fixed focal length lenses, provided the user has the patience to remove and replace a lenshood when fitting or removing a filter.

CREATIVE CHOICES

In the left-hand picture, focus is on the rose at a wide aperture, so the background is out of focus. The right-hand picture shows how a small aperture brings the background into focus. Dynax 7000i.

A choice of lenses should be related to creative potential rather than mere degrees of magnification. Before buying any lens, go to a shop and try one out. It doesn't matter if it is the make you intend to buy or another, provided the focal length is the same. Take it to the doorway and study the effects when focusing on near and far objects. Then, decide whether that particular focal length matches your requirements and aspirations. It is a fact that some photographers prefer photographing nearby objects and like acute perspective effects, while others are inspired by the flattened planes of a distant subject seen under magnification, as through binoculars. Most of us are excited by both, but artistic preferences exist.

You may find it helpful to study the effects obtained at different distances and with different focal lengths. Make your decisions in the light of which effects appeal to you most.

A very good choice, which will cover a great variety of work from wide-angle to telephoto would be just two zooms, a 28-85mm and a 70-210mm. If you find that

you are discovering the most exciting images at about 100mm focal length (twice the magnification of a standard 50mm lens, which will include the same subject matter, albeit with less acute perspective, from twice the distance) and seldom have need for 28mm, you may best be served by a 35-105mm rather than a 28-85mm zoom.

If your enthusiasm often inclines towards wide-angle imagery, you might decide to add a 24mm lens, giving 24mm; 28-85mm; 70-210mm.

If you find yourself constantly seeking pictures on the far horizon, and hardly ever excited by wide-angle viewing, you might add a 1.4 × or 2 × tele-converter, giving 28-85mm (or 35-105mm); 70-210mm; 140-420mm (with 2 × converter).

You may even decide to drop the shorter zoom altogether, which, with your standard 50mm lens, would give 50mm; 70-210mm; 140-420mm (with 2 × converter).

There are many variations on this theme. I, for example, find that the 28-85 mm zoom stays on my camera practically all the time, though I do carry other lenses for occasional use.

LOW LIGHT LENSES

Press photographers, and anyone shooting sport in less than perfect light, need a long lens with a large maximum aperture. This is where lenses of fixed focal lengths come into their own, in the shape of 200 mm and 300 mm f/2.8 lenses. Very long zooms are available, such as 75-300 mm and 100-500 mm, but with maximum apertures of f/5.6 to f/8 at the long end, there is no question of hand-holding for action shots. Shutter speeds would not be fast enough.

The same applies in other situations. The portrait or child photographer wanting the freedom to move around his subjects and shoot by natural light indoors, is restricted by the modest maximum apertures of mid-range zooms. For him, lenses such as 100 mm f/2.5 and 85 mm f/2 permit faster speeds and focusing, easier study of pose and expression, with lighter weight.

FINE POINTS

Lens designers have techniques and materials at their disposal which make it practicable to construct very wide-range zooms.

For example, some makers now include a 28-200 mm zoom in their lists. Naturally, this appears quite exciting to the novice. Why, he reasons, should he carry both 28-85 mm and 70-210 mm zooms, and have to change from one to the other, when a single zoom will cover the whole range and may stay in position on the camera, always ready for action? I can think of several reasons why not.

A representative zoom of this range has 18 elements arranged in 16 groups, a maximum aperture of only f/5.6 at the long end, takes a 72 mm filter, and weighs 720 g. A representative 70-210 mm zoom has a 12/9 optical construction, a maximum aperture of f/4.5 at the long end, takes a 52 mm filter, and weighs 650 g. The latter gives a brighter

Photo: Ron Spillman

The picture on the left was taken from a distance with a 100 mm lens, and the perspective appears normal. For the picture on the right a 16 mm lens was used and the camera brought very close to maintain image size.

image, permits faster shutter speeds, certainly has a better optical performance, doesn't cost the earth for filters, and is easier to hold. In such a case, it is definitely worthwhile to handle the intended purchase first, just to make sure you find it manageable.

The light-transmitting power of many zooms reduces as the focal length is increased, and this is expressed in stops, such as f/3.5-4.5 and, in the case of some extra-long zooms, the loss may be as much as 1½-2 stops. The TTL metering in an SLR takes care of this, but it has to be allowed for when using a separate exposure meter, or when using studio or non-TTL flash.

With auto, non-TTL flash, you set the lens aperture indicated by the flashgun for the distance, which is fine if the light transmission of the lens remains a constant. When this varies, as it does with many zooms, it can be a

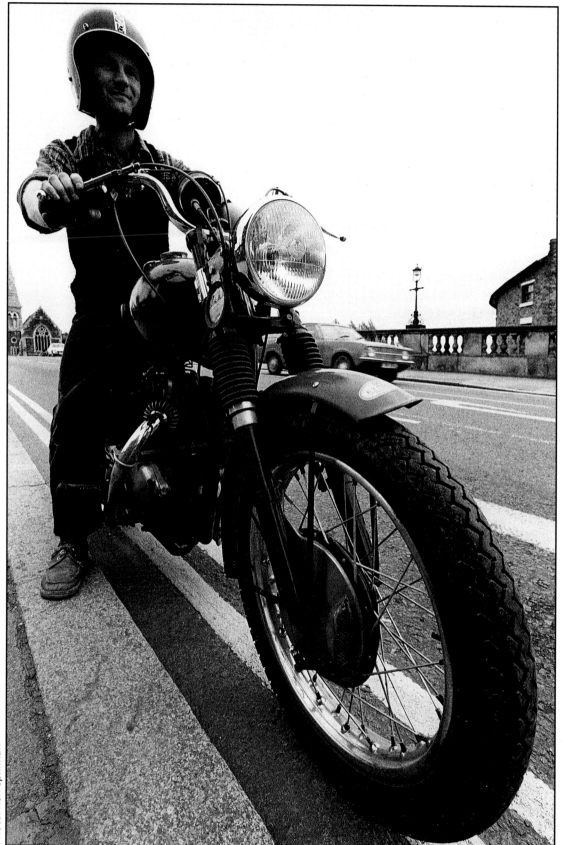

Photo: Ron Spillman

nuisance. It is even more of a nuisance when working with multiple studio flashes, when a flash meter is required. In such cases it is best to restrict yourself to just three focal lengths, the shortest, the longest, and one in the middle. At the shortest end, where light transmission is greatest, just set the lens to the indicated aperture. At the middle focal length, open the lens half a stop more than the indication, and a full stop more at the long end. Thus, with a 28-85mm f/3.5-4.5 zoom, and a flash indication of, say, f/8, you would use f/8 at 28mm - f/8-5.6 at 50mm f/5.6 at 85mm.

THE POPULAR 35-70MM ZOOM

Many SLRs are fitted with a 35-70mm f/2.8 lens as standard. It is one stop slower, and the screen image correspondingly less bright, than a standard 50mm lens. Nevertheless, its relatively simple construction ensures a very good performance. The lens has a great appeal to those requiring only a small shift to wide-angle or telephoto, and will go on acting as a useful 'standard' if wider aperture and longer focus or zoom lenses are added at a later date. Two further advantages of the 35-70mm, and its more recent sister the 28-70mm are modest cost and light weight.

AUTOFOCUS

Most good compact cameras now have an autofocus system. Provided a small area at the centre of the viewfinder screen is centred on the subject, the camera will automatically bring it into focus. Autofocus, usually of a more sophisticated nature, is also used on the flagship compacts of the big SLR makers.

On simpler autofocus cameras, if the AF spot falls on the background, the foreground subject will be out of focus. This commonly happens when the picture is of two people, standing either side of centre. This is why cameras are equipped with focus hold. The camera is moved so that one of the two figures is in the centre of the frame. The first pressure is then taken on the shutter release button, which locks focus at that point. Without releasing finger pressure, the subject

A standard 50mm lens gives natural modelling to a half-length portrait at about 5ft.
To preserve good modelling on a head-and-shoulders, a 90-100mm lens can be used from the same distance.

is now re-composed, after which the release is pressed all the way down to make the exposure.

Autofocus becomes even more sophisticated when trap focus is introduced. Here, the camera will fire only when the subject has moved into the preset area of sharp focus.

Pressmen will use autofocus with confidence for those subjects which are easily centred in the viewfinder but not for sports such as football where there is no time to ensure that a key figure is occupying the focus spot. Too many sharp pictures of the crowd in the opposite stands would result!

The best autofocus mechanisms work fast. As an example, here are the times taken from the closest focusing distance to infinity, with three AF lenses on the Minolta 7000 camera:

Very wide-angle lenses have the hood cut away to prevent vignetting at the corners of the oblong frame. This is the Sigma 24mm Super-Wide II.

AF lens	Autofocus speed	
28mm f/2.8	1m-Inf	0.15sec
50mm f/1.7	0.45m-Inf	0.60sec
70-210mm f/4	1.1m-Inf	1.20sec

These speeds would be much faster if the lens operated from a mid-point on the focusing scale. One method of obtaining ultra-fast autofocusing, is to preset focus at the shooting point for a rapidly approaching subject, and preferably just in front. By this method you can even ensure sharpness of a long jumper hurtling towards the lens. Many an experienced pressman would, however, switch from auto to manual focus with such subjects, and rely on his old skill at pre-focusing and firing just before the subject reaches the point of focus. Firing slightly in advance is necessary, due to the time taken for the SLR's mirror to rise, which is about 1/25sec.

Advanced autofocus systems will work in either the single shot or continuous mode in similar fashion to a motordrive. In the single mode, focus is held on one spot. In the continuous, or follow-focus mode, a moving subject will be kept in sharp focus provided it is centred in the viewfinder.

Autofocus is a boon to those with failing eyesight, and to those shooting candid or action shots of the kind where the subject is easily followed. All the same, there are occasions where a switch to manual focusing is necessary. I well remember a conversation I had with one of Minolta's Japanese designers, who was enthusing about the autofocus on their famous 1000 series of cameras.

'Suppose I am using a wide-angle lens very close to a face, which I want to fill one side of the frame. I want sharp focus on the eye of the subject which is nearest to the lens, but need a wide aperture so that the background, which is central, is out of focus. What do I do?'

'Ah', came the smiling, and quite predictable, reply, 'Move the camera to centre the eye, hold focus on it, swing back and re-compose, then take the picture.'

'But the lens-to-eye distance is a mere twelve inches, and by swinging back to re-compose I could be altering this distance by an inch or two. What about sharp focus then?'

'Well, in that case, you had better switch to manual focus.'

This, in fact, is what any skilled photographer would do, composing the image but carefully focusing off-centre without moving the camera, and shows that autofocus, while being a great boon, is not always the best method of focusing.

Passive autofocus systems such as are found on SLR cameras will focus quite happily through glass provided it has no deposits on it that have enough contrast for the camera to focus on. In the case of an active infrared autofocus system such as is found on most compacts, shooting squarely through a window may result in the scanning infra red beam being reflected straight back to the sensor of the camera and the focus will be set on the surface of the glass. The autofocus will work properly however if the camera is pointed at about 45° to the surface of the glass so that any reflection is away from the camera direction.

A true fish-eye lens, in this case a 7.5mm lens fitted to a Canon T90, gives a 180deg circular image. Other 'fish-eye' lenses give 180deg, but on the diagonal, which fills the rectangular 35mm frame.

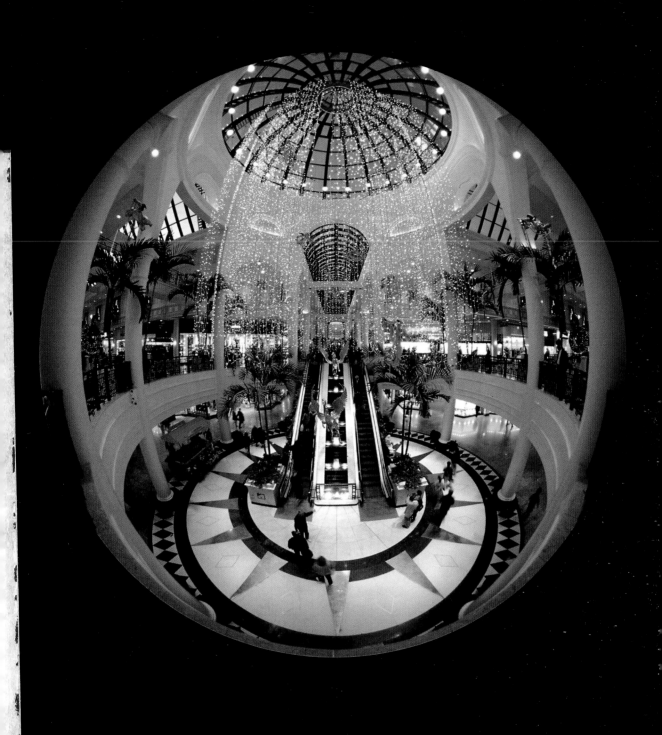

Shutters

FOCAL PLANE ● **SYNCHRO SPEED** ● **COMPACT SHUTTERS**
FLASHBULBS

T he shutter on a camera is something we tend to take for granted. After all, what is it but a device to control the exposure the film receives? This is true enough, and modern shutters can be amazingly accurate, but there are other aspects of shutters, and their design, which are worth looking into.

TYPES

There are three types of shutters, one of them at the front and usually built into the lens itself, which we call a front-lens shutter. The other two are focal plane, that is, they are placed just in front of the film. The traditional focal plane shutter, now brought to near-perfection, is used in the majority of advanced 35 mm SLRs, and consists of two springloaded blinds, or curtains, one of which follows the other across the film. The speed of traverse and the space between the blinds, determines the actual exposure. The third type is an electromagnetic variation in which metal blades traverse the film.

The front-lens shutter consists of a number of concentric springloaded blades. When tripped, these blades open from the centre, are fully open at the perimeter of the lens then close again. While they are opening, the blades are working in similar fashion to an iris diaphragm, or lens opening. That is, they form an aperture, which increases in size, then diminishes. In effect, when the shutter begins to open, the aperture is small and letting in relatively little light. Light transmission increases with the size of the aperture, then falls off again. For this reason, the exposure is the sum of a continuous range of intensities and not, as with a focal plane shutter, a precise exposure given to each part of the film at the same level of brightness.

The top speed of most lens shutters is 1/500 sec, though with use this may drop to as low as 1/400 sec without the slower speeds being affected. For this reason, press and sports photographers prefer the high speeds obtainable with focal plane shutters. Nevertheless, the lens shutter is favoured for medium and large format cameras, the

The crowd of Liverpool football supporters make an exciting backdrop for the flag waver in this 400 mm shot. The limited depth-of-field indicates the wide aperture needed to obtain a sufficiently fast shutter speed.

Photo: Howard Walker

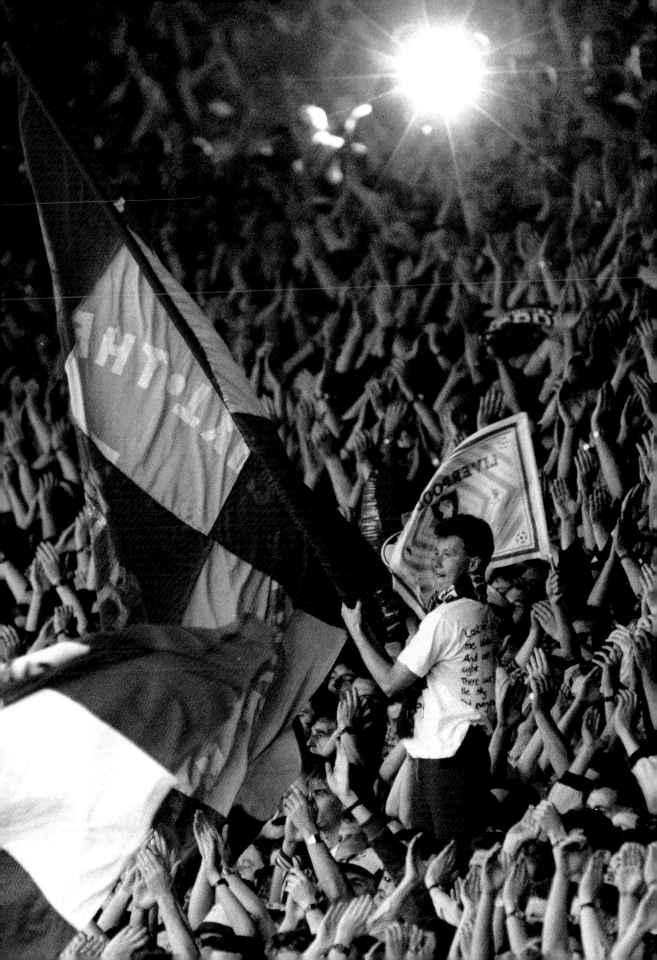

medium format SLR in particular. This is partly because of the size of the mirror as compared with that of a 35 mm SLR. It requires quite strong springing to lift it quickly, and the same applies to the springing in a focal plane shutter of that size. Together, the two could cause enough vibration to spoil the definition of a good lens.

Even more important, is the problem of flash synchronisation with a large focal plane shutter, the top synchro speed often being as low as 1/30 sec.

The medium format SLR is used very often for indoor work in conjunction with studio-type flash units, for which the lens shutter is ideal. It is easily connected by a long flash lead to its coaxial socket, and synchronises at all speeds.

Although each exposure is the total of a range of light intensities the lens shutter gives satisfactory results. Even though the marked 1/500 sec may actually be about 1/400 sec, this has virtually no significance. The permitted tolerance for exposure meters, for example, whether separate or built into the camera, is 1/3 stop, though most are more accurate than this.

FOCAL PLANE

At one time, 1/1000 sec was the fastest shutter speed obtainable with conventional focal plane shutters, though 1/2000 sec, 1/4000 sec and even 1/8000 sec are now common. The beginner to action photography may be excused for presuming that faster is necessarily better, which isn't the case at all. In fact, a great many skilled action photographers seldom use a shutter speed faster than 1/1000 sec, from preference.

This is because a very fast shutter speed can freeze action to the point where there is no impression of movement in the picture. Using a slower shutter speed, and keeping the moving subject centred by smoothly swinging the camera (panning), gives a far better impression of speed. This can be seen in many professional shots of track events, especially car and motorcycle racing. The camera is set to 1/500 sec, or even as slow as 1/250 sec, and panned with the moving vehicle. Because its image is stationary relative

A subject needing a shutter speed of 1/1000 sec or faster. Action photographers release the shutter fractionally before the point of peak action, to allow for the rise of the SLR's mirror.

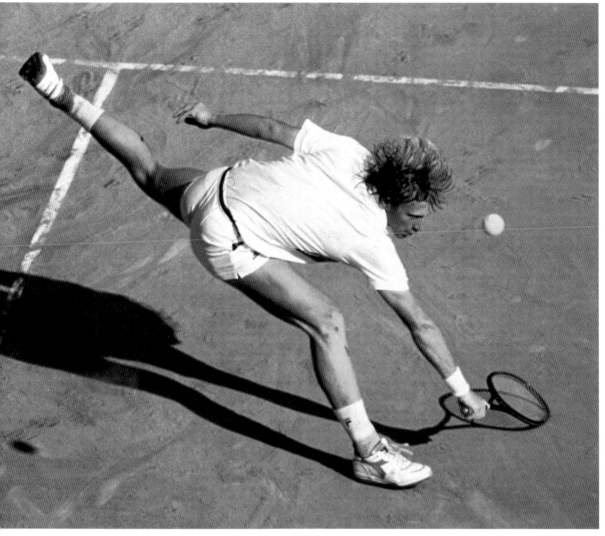

Photo: Russell Cheyne

to the film it comes out quite sharp in front of a background which is horizontally blurred. You can see the effect of different shutter speeds in the illustrations.

On some occasions the faster speeds, such as 1/2000 sec and 1/4000 sec are useful, and may even suggest creative ideas not previously possible. Certain action subjects do not benefit from the blurred background effect. Take, for example, the case of an athlete doing the high jump or pole vault, and caught from below. At the peak of the movement he is not moving very fast, but a fast shutter speed will capture much desirable detail, such as facial expression, tautness of muscles and so on. The background here will be the sky or part of the top of the stands, and there is no benefit in blurring either.

What about shutters that go up to 1/8000 sec? This speed is hardly likely to be wanted except for action work. In this you would almost certainly be using a fast film. Seldom could sunlit conditions be bright enough to enable such a speed to be used, and then only with a fairly large lens aperture. At a smaller aperture, which would be preferable in the interest of depth of field, an exposure would not be possible without reducing the shutter speed.

SYNCHRO SPEED

Perhaps half of the 35 mm SLRs on the market have a top synchro speed of 1/60 sec, adequate for most indoor flash work, but somewhat limiting if flash fill-in is required outdoors. If the subject moves too much,

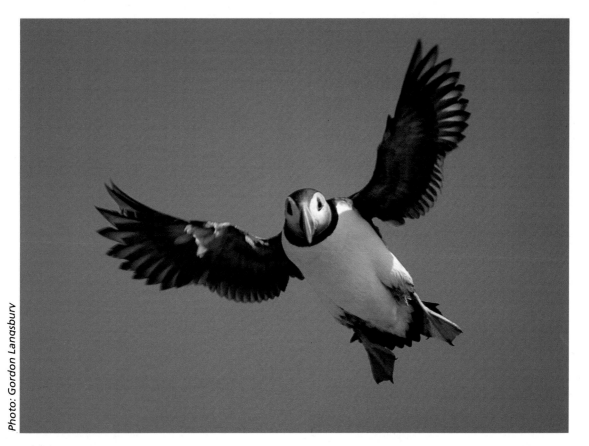

Photo: Gordon Lanasbury

there will be a double image, one from the flash, the other from the daylight. The same applies indoors if the ambient light is bright enough to make an impression on the film. Even with portraits, a sudden laugh or quick movement of the head can result in a double image.

In some cameras the focal plane blinds run vertically down the film's short side, instead of horizontally along it, and the shorter traverse permits a faster synchro speed, up to 1/125sec or even 1/250sec, which can be less limiting. For the sake of the novice it should be explained that when an electronic flash unit is triggered, the flash reaches its peak almost instantly, lasts a very short time, usually between, say, 1/600sec and 1/10,000sec, and dies out instantly. For this reason triggering is set to occur at the moment the first shutter blind is fully open, and before the second blind has begun to make its traverse. Any shutter speed slower than the top sync speed may be used, but at faster speeds the blinds will not be fully open, and some cut-off of the image will occur. The faster the speed the greater the cut-off.

In the picture above a fast shutter speed reveals every detail of the puffin. For the picture on the right a slower shutter speed around 1/60-1/125sec, gives a sharp body with blurred wing movement to suggest movement.

The Olympus Super FP system, as used on the Olympus OM4Ti, overcomes synchro limitations in a novel way, provided the camera is used with the Olympus F280 flash. This flash unit will deliver a 'long burn' flash at the faster shutter speeds. It works this way. Before the shot is taken, the camera registers the level of ambient light on the scene, and knows roughly what shutter speed to use in conjunction with the aperture you have chosen. If fill-in flash is required, as soon as the release button is pressed the camera measures the combined ambient/flash light falling on the film's surface and, if necessary, slows down the flash. Thus, the flash will expose all parts of the film as the slit between the shutter blinds makes its traverse. Thus, you can have fill-in flash with the Olympus OM4Ti, at shutter speeds up to 1/2000sec and,

Photo: Roger Reynolds

similarly, up to 1/4000 sec with the Nikon F90 and appropriate Nikon flashgun.

TO SUM UP

The lens shutter, typified by the names Compur and Prontor, is most popular on medium and large format cameras, partly because a large focal plane shutter needs very powerful springing to make a fast traverse, and this can cause jerk, or camera shake. The lens shutter, with a marked top speed of 1/500 sec which may, in fact, be more, is satisfactory for general subjects, but is not ideal for action work. It will, however, synchronise at all speeds.

Focal plane shutters are fitted to 35 mm SLRs, and the latest will synchronise up to 1/250 sec. For anyone who intends to do much outdoor portraiture, the question of sync speed, which will be dealt with fully in section 7, is of more importance than a shutter which reaches 1/4000 sec or 1/8000 sec.

COMPACT SHUTTERS

With some exceptions, the best of modern compact cameras employ a special kind of electro-magnetic shutter behind the lens, in which a single set of metal blades serves as combined shutter and iris diaphragm. The exposure time is controlled by the speed at which the blades open and close, and the lens aperture by the extent of the opening. Thus, a reciprocal relationship between shutter and aperture is maintained, usually between 1/500 sec at f/16 in the brightest light, down to 1/8 sec at f/2.8.

Even handheld speeds of 1/15 sec or so can yield sharp pictures, provided you lean against a wall or rest your hand on a chair top, and squeeze rather than jab the shutter release. This picture inside the squatter's cottage at Blists Hill, Ironbridge, was taken with a 28mm lens at f/2.8 and 1/15 sec. Ilford HP5 Plus.

The trend nowadays is to employ a stepping motor, which has no springs. As it rotates, it sets the autofocus lens, adjusts the aperture, then opens and closes the shutter, after which it reverses direction to open the aperture and reset the AF mechanism.

Most of these compacts have built-in flash. On the Canon Sureshot Supreme, for example, the flash cuts in automatically when the light level falls, providing perfect fill-in flash, which lightens the shadows without destroying the natural lighting effect. Flash also cuts in when the camera's metering system detects a backlit subject.

FLASHBULBS

Expendable flashbulbs, some as big as household lamps, are still made for professionals who may need to illuminate a large area, such as a factory, with a multiple lighting set-up. A dozen or more flashbulbs, complete with slave triggers that need no trailing wires, weigh very little, and the individual bulbs in reflectors are easily put into place, even on high rigs. To obtain the same amount of light from electronic flash would call for gear weighing hundreds of pounds, difficult to position, and even more difficult to hide from the camera.

Some smaller and older cameras use

Photo: Paul France

flashcubes, while some Polaroid and other cameras use a flashbar consisting of ten bulbs, back to back in fives, and firing sequentially. On a shot-to-shot basis flashbulbs are more expensive than electronic flash, but are a viable proposition for the camera owner, now rare, who gets through only four or five films a year. For him or her, the cost is small compared to the initial purchase of the electronic unit and the waste, through age, of batteries.

Getting inside the action often calls for a long lens, and camera shake becomes a critical factor. To overcome this, a wide aperture permits a fast shutter speed to be used.

Metering

T he owner of an auto everything, point-and-shoot camera has few worries about exposure. The camera takes care of it, and in ninety-five out of a hundred cases, the negative or slide will be properly exposed. As for the few which are too light or too dark, well, they aren't really that important. Unless, as can happen, those few are of that unrepeatable wedding or that miraculous slate sky over a gleaming field of yellow rape. Yes, it happens with maddening frequency that the most important shot on the film is the wrongly exposed one, probably because the appeal was in the unusual lighting.

There is absolutely no need for this to happen. No reason why every shot you take should not be a correct exposure. All that is called for is a little knowledge on your part, so that in those few situations where the light or conditions are awkward, you can use your knowledge to override the camera's automatic response. Remember, camera meters can measure the light, but they cannot think. You can.

METER MAGIC

Different types of film have different degrees of sensitivity to light, described by the ISO (International Standards Organisation) speed number shown on the carton or the 35mm cassette. This was formerly shown as an ASA (American Standards Association) rating, which need not concern us as the numbers are the same. The most popular rating is ISO 100. The whole question of film characteristics and choice are dealt with in Section 8, and for the moment we need concern ourselves only with exposure.

Correct exposure simply means that the shutter opens and closes just long enough to allow the image projected by the lens on to the film to make a proper impression. This is determined by three things (a) the brightness of the subject, (b) the aperture of the lens, and (c) the sensitivity, or ISO rating, of the film.

This is effective because the runner is in silhouette. As no detail was wanted in the runner, a straight reading was taken from the sky.

Photo: Ron Spillman

To ensure correct skin tones when using a separate meter in the reflected mode, which measures light reflected from the subject, go close but be careful not to cast a shadow.

The white dome of a meter used in the incident light mode, must face the camera from the subject position, or (under open sky) anywhere along the subject/camera axis. An incident reading is always right for skin tones. When using a separate meter, allow for the fact that some zooms have a smaller effective aperture at the longer end.

The subject itself is composed of many bright, medium and dark areas - the sky, the trees, the dark earth. Each part is reflecting more or less of the light falling on it. The meter's light-sensitive cells integrate these varying brightnesses, and produce a single reading. Based on that reading, the meter indicates a mid-tone exposure. This produces a negative or slide of correct density and colour, neither over- nor under-exposed. In an automatic camera, it is this exposure information which is passed to the lens and shutter. It is called an average reading, because the meter has averaged the various brightnesses reflected from different parts of the subject. Its success depends on there being an average range of brightnesses.

The five per cent of failures occur when the subject is not of average type. Some examples: a figure in very dark clothes against a black background, the only important tone being the light face; a skier against a large expanse of white snow; a portrait of a person in the shade with a background of bright sky. A few of the latest SLRs have metering systems sophisticated enough to cope with such subjects. See ESP and EVALUATIVE METERING, page 27. With other cameras,

however, the user can modify the indicated exposure.

With the above examples, the modifications are as follows:

1. A figure in dark clothes against a black background. Left to itself, the meter would be averaging a large, dark area, with the light face occupying only a very small area. The meter would read this as an all-over dark subject and indicate extra exposure to reproduce this as a mid-tone. The result, the dark clothes and black background would appear grey, and the face over-exposed and chalky. To correct this, you would give perhaps two stops less exposure, or take the reading from the face alone.

2. A skier against a large expanse of white snow. Here, the meter would do the opposite, and indicate less exposure to reproduce the predominant snow as a mid-tone. The result, the snow grey (with colour film, usually a dirty green) and skier's face and bright clothes under-exposed, and therefore too dark. To correct this, you would give perhaps one or two stops extra exposure, or take the reading from the skier alone. In practice, all you need do is take the reading from the deep blue sky, which is a mid-tone.

3. A portrait of a person in the shade, with a background of bright sky. The meter will be influenced by the very bright background and give an inflated reading, correct for the background, but under-exposing the portrait, which will be full or semi-silhouette. You can give a couple of stops more exposure to correct the portrait, but the background will then be over-exposed and its aesthetic value, if any, lost. The answer is to expose for the background but use just enough fill-in flash to lighten the portrait. This function, giving a correct balance between flash foreground and natural background, is performed automatically by many cameras, compact and SLR, used in the program mode with a dedicated flashgun.

METERING PATTERNS

The first through-the-lens metering SLR was the original Spotmatic, introduced by Pentax in 1964. Apart from a very few of the initial models, in which the metering area was confined to a small central spot, hence the name, metering was evenly distributed over the entire frame. This is known as average metering, and is quite independent of the average brightness range discussed in the last section. It is still used on some SLRs. The skilled photographer examines the scene in the viewfinder, and decides whether there is an even distribution of light, dark and mid-tone areas. Usually there is, and the exposure indication can be trusted. If there is, in the photographer's opinion, a preponderance of light or dark areas, he will override the meter, and give more or less exposure in such cases.

Many camera manufacturers have concluded that a higher proportion of accurate exposures results by restricting the metering to roughly the centre two-thirds of the frame, or at least making it more sensitive in that area, and this is called centre-weighted metering. Many advanced amateurs and professionals, myself included, prefer this form of metering.

Spot metering is restricted to an area of just a few degrees, defined by a circle shown at the centre of the viewfinder screen, and is useful in awkward lighting situations, enabling the exposure to be balanced for a selected part of the subject. Spot metering is provided in addition, and as an alternative, to the average or centre-weighted metering in a camera. It requires considerable knowledge to decide just which area of the subject should be read by spot metering, so beginners are prone to error when using it.

A useful extra metering mode is partial metering, reading from an area midway between centre-weighted and spot. It would be extremely useful, for example, when photographing a live subject, occupying roughly the centre half of the frame, and moving constantly in front of a succession of light and dark backgrounds. Also, for a close-up of a light coloured flower against dark foliage.

It is worth noting that when TTL metering was first introduced, many skilled professionals were constantly modifying the exposure in the light of past experience, only to discover to their chagrin, that the metering was right more often than they were !

a

b

c

Normal program sets a balance between aperture and shutter speed. Variable shift program gives a choice; larger aperture with faster shutter speed, useful for action, especially with telephotos, or to put the background out of focus. Or, smaller aperture with slower shutter speed, to increase depth of field. These three pictures were taken with a Canon T90 using (a) Tele-3 Program, (b) Standard Program, and (c) Wide-3 Program.

MODIFIED EXPOSURES

It has been explained that non-standard subjects, those with very uneven lighting or tones, or with a preponderance of very light or dark tones, call for modified exposures. This can be effected in three different ways.

AE (auto exposure) lock. This is the most convenient method. The camera is turned away from the subject until an evenly-balanced area, or a subject of middle tone, fills the screen. The exposure lock is then pressed and held in place while re-composing and taking the picture. Some exposure locks are incorporated in the shutter release button. Take the first pressure to apply the lock, then continue the pressure to take the picture. An alternative is a separate EL lever adjacent to the release button, which can be depressed with the middle finger while the index finger rests on the release. The advantage of these types of exposure lock is that they are self-cancelling, that is, directly the pressure is lifted, you are back to normal exposure for the next shot.

Exposure override/modification dial. This is provided on many SLRs, and consists of a dial with half and whole stop settings between −2 and +2. It is directly linked to the meter and is applied manually to alter the exposure over the range −/+ 2 stops. It works, but has three disadvantages over the AE lock. First, it is set in arbitrary steps, and thus lacks the continuous versatility of the AE method. Second, it is slower in use. Third, some, but not all, cameras with this feature, include a viewfinder warning that it is in use, but when concentrating on a subject it is easy to forget to cancel it, which results in some or all of the following shots being over- or under-exposed.

Speed setting. Some compacts and a few of the simpler auto-only SLRs lack either of the above means of modifying the exposure. Provided there is a means of setting the speed rating of the film, this can be used to modify the exposure. To give extra exposure, an ISO number lower than that of the film in use is set, and to give less exposure, a higher number. Thus, when using an ISO 100 film, a setting of 200 will give half the exposure, while a setting of ISO 50 will double it. Some point-and-shoot models respond only to the DX coding on the film cassette. Lacking the manual setting, they cannot be used in this way.

GENIUS METERING

The design departments of the big Japanese camera makers have worked for years to develop more and more foolproof metering methods. Until recently, this was best described as an effort to reduce, not to completely eliminate, the possible number of failures in non-average conditions. Now, however, metering methods have been devised which virtually ensure correct exposure under all conditions.

Canon's evaluative metering. The system is incorporated in the EOS models and basically the metering pattern is distributed over several areas of the field. As can be seen in the diagram, the centre circle A delineates the size of the central subject, around which is area B, which determines the difference in brightness between the main subject and the surrounding area. C1-4 are used to determine the brightness of the background, while the black areas have no sensitivity. Basically, the system is geared to the principle that most often, correct exposure is required in the part of the subject wanted in focus. In the EOS, autofocusing is in the centre of the frame, so automatic exposure compensation is based on the brightness of this central area.

The clever part is in how the metering reacts to subjects in non-average lighting. For example, it recognises that if the centre A is darker than B, this constitutes backlighting. The greater the difference between A and B, the stronger the backlighting. The brighter those outer C areas, the greater the exposure compensation needed. C being brighter than B also indicates backlighting or a very bright subject. As the illustrations show, the system is hard to beat.

Nikon's matrix metering. This system is incorporated in the remarkable Nikon F-801 camera, which is 80 per cent centreweighted to a 12mm circle shown at the centre of the screen. The camera can be switched to matrix, or multi-pattern, metering, in which the sensor readings are of five separate areas,

This Canon EOS metering sensor is divided into six segments, consisting of three main areas: the centre (A), the intermediate ring (B), and the rest of the sensor (C1 - C4). A: this area determines the size of the centrally placed subject. B: determines the brightness difference between the main subject and the surrounding areas. C: these four fields are used to best determine the brightness of the background. The black areas are not sensitive.

Sensitivity bias in metering patterns.
Top, centre-weighted average metering.
Above, partial metering.

as can be seen in the diagram. Each area is measured for brightness and contrast and, from its own memory banks, the camera decides whether the combination constitutes frontal, side or back lighting, and to what degree. It also uses the information to decide where the main subject is in the frame, then computes all the data to give the best possible exposure. It can also decide whether the important parts of the subject occupy more than one position, and balance the resulting data.

Matrix metering can also take additional flash fill-in into account. Outdoors, for example, it will provide just enough flash on the foreground subject, while giving the correct exposure for the ambient light on the background, however lit. It is a more sophisticated system than ordinary program flash, partly because of the foregoing, and partly because it encompasses a far greater range of aperture, shutter speed and flash

duration combinations. Full flash dedication requires the use of the Nikon SB24 flashgun. Other makes may be used, but these may not interface fully with the system.

Perhaps the most useful design feature of the matrix system is that it ignores those extreme brightness levels, such as the sun or inky shadows, which are in any case beyond the ability of the film to record.

HAND-HELD METERS

Although camera metering has been brought to such a level of perfection, there are still uses for the separate, hand-held exposure meter. These advantages apply only for some photographers, sometimes, and you will easily decide whether any or all of them are of benefit to you.

1. A photographer may find himself in a

Confining the exposure to the girl, brightly lit by late evening sun, the sky has remained dark and stormy. If the sky had been metered as well, more exposure would have resulted, giving too light an effect overall. Spot metering

position where it is inconvenient to use the camera's meter. The camera may be on a tripod in an awkward position, and a change of light may necessitate a new reading. It is far more convenient to use a separate meter, without disturbing the camera. This applies in portraiture indoors, with the camera on a tripod. The separate meter will quickly give a new reading from the subject position.
2. Incident light. By sliding a white hemisphere over the receptor cell of the hand-held meter, it can be aimed towards the camera from the subject position. It will integrate light from various sources and the exposure will be balanced. This is an incident light reading. When a meter is pointed

Photo: Ron Spillman

Average metering would take account of both the bright statue and the dark background. With a centre-weighted system, care should be taken not to include only the statue, as this would result in under-exposure of the seated figure.

towards the subject, as with camera meters, this is a reflected light reading.

3. Although some medium format SLRs have alternative metering prism heads, some photographers prefer to use the standard reflex head, and a separate meter. This is particularly so in the case of square format cameras. Looking down into a hood, at a bright, laterally reversed image, projected upwards on to the large viewing screen by way of a 45° mirror, has one main advantage which is not obvious in the specifications. It makes composition easier. The photographer is studying an image in a square frame, just like the final picture. Being reversed, it is at once further removed from the actual scene, so the photographer tends to view with more detachment than when looking through a pentaprism.

4. A good point for the careful worker, is that use of a hand-held meter slows the operation of picture-taking, and promotes more care.

Definitely not of use to the action photographer! Of course, there is no reason why the photographer should not take equal care when working with TTL metering. It is all a matter of discipline.

THE GREY CARD

These are available from Kodak and other suppliers, and consist of a sheet of strong card, usually 10 × 8 in, one side matt grey with 18-per cent reflectance, the other side matt white. If the card is held in the subject position, facing the camera and angled 45° towards the main light source, a reading taken from it by TTL metering, which works in the reflected light mode, will be equal to an incident light reading. This is because the grey card has integrated the various light intensities.

In studio work, the card would always be held at the subject position, as the light level would be different at the camera. Outdoors, with the sky as illuminant, the card can be held at any point between subject and camera, provided it faces the camera and is angled 45° towards the sky.

A grey card can be extremely useful when copying artwork, especially where this consists of drawings or typing on white paper, or perhaps the reverse, with white or coloured lines on a dark ground. The grey card is laid over the artwork to obtain a mid-tone reading with the camera's TTL metering. An incident light meter would, in theory, give the same result, but most types have the cell at one end. Standing it up to face the lens, the cell may be disproportionately closer than the artwork to any lamps being used.

The white side of the card has 90 per cent reflectance. Originally, it was intended that the reading should be taken from this side when the light level was low, and the exposure multiplied by five to match the 18 per cent reflectance of the grey side. Modern exposure meters are so sensitive that this method is all but obsolete.

A straight meter reading would have been inflated by the light sand, causing under-exposure of the boules player. Half a stop more exposure than indicated by the meter added some detail to the figure, but without spoiling the high contrast effect.

Photo: Robert Ashby

Flash

BASIC FLASH ● AUTOFLASH ● MULTI – RANGE AUTOFLASH
DEDICATION ● TTL FLASH ● RECYCLING TIME ● BATTERIES
BOUNCE HEADS ● STUDIO FLASH ● POWER CHOICE

T he duration of the flash in the simplest on-camera electronic flash units is between about 1/600 sec and 1/1000 sec. When fired, the flash reaches its peak almost instantaneously, and drops away just as fast. The shutter of the camera has to be open long enough for this brief burst of illumination to reach all parts of the film. Hence the need for synchronisation. Quite simply, the electrical contacts for the flash are set to meet when the first shutter blind is fully open and the second has not yet begun its traverse. On most 35 mm SLRs the fastest shutter speed at which this full synchronisation can take place is 1/60 sec, 1/125 sec or 1/250 sec.

Indoors by ordinary room lighting, or outdoors at night, the ambient light will be too weak to have an effect on the film, so the exposure will be made entirely by the flash. However, the brighter the ambient light, the more useful it is to have a faster synchronisation speed, as this will avoid the possibility of a faint secondary, or ghost, image on the film.

BASIC FLASH

The most modestly-priced flash units have a relatively simple circuit. It works this way. The energy required for electronic flash is in the form of a high voltage stored in a capacitor or condenser. Direct current is required for charging this and is supplied by perhaps four 1.5 v alkaline dry cells connected in series to give 6 volts. This is raised to a high voltage by an oscillating transistor circuit and a transformer, the transistor producing pulses of energy that the transformer treats as alternating current. The high-voltage output of the transformer is rectified to change it back to direct current which is fed into the main capacitor.

Ideally, this Thai dancer might have been taken with fast artificial-light type film, not always to hand when you are travelling. Ceiling and walls were too far away for bounce-flash, so direct flash was the only alternative. However, it does show excellent detail.

Like other hitech cameras, the Minolta 9xi interfaces with its 5400xi or 3500xi electroflash, which incorporates an LED autofocus illuminator. When the release is half pressed, a light pattern is projected on to the subject (top). The AF sensors in the flashgun are able to focus on this pattern (bottom) and pass information to the autoflash metering system, which controls flash duration in all exposure modes.

The output of the capacitor is connected permanently across the flash tube but the resistance of the latter is too high for the energy to flash through the tube. To trigger the flash a high voltage pulse has to be applied to a third external electrode of the flash tube, consisting of a few turns or a strip of wire or ribbon on the outside. The trigger voltage is provided by a pulse coil which is a high-ratio induction coil. A low voltage tapped off from the capacitor charging circuit is switched to the primary winding of the pulse coil when the trigger circuit is closed and the resulting high tension pulse ionises the inert gas in the tube and the capacitor-stored energy discharges through it in a few milliseconds. The trigger voltage applied to the primary of the pulse coil is switched by the camera's flash contacts but the energy involved is so small that there is no risk of damage to flash contacts or electric shock to the photographer.

Full flash power is expended each time the gun is fired, and in the specification it will state, for example, forty flashes per set of fresh batteries, probably 2-4 alkaline manganese AA size, such as the well-known Duracell MN 1500.

These simple flashguns are usually of fairly low power, which is expressed as a guide number, or GN. Quite simply, you divide the GN by the distance between flash and subject, to obtain the right aperture to be set manually on the lens. GNs may be based on either feet or metres, nowadays generally the latter, and are usually stated for a film speed of ISO 100. Thus, for a gun of GN28, the correct aperture at 10m would be f/2.8, or f/5.6 at 5m, f/11 at 2.5m, and so on. The correct aperture would be one stop smaller with a film of ISO 200, two stops smaller with a film of ISO 400, or one stop larger with a film of only ISO 50.

A basic flashgun can be bought for just a few pounds, and would be an economical purchase for the photographer who intends to use flash just a few times a year and then only for recording family occasions.

AUTOFLASH

An auto flashgun has a sensor which measures the amount of flash falling on the subject, and switches off the flash when the film is fully exposed. On older types of auto flashgun, and lower-priced modern ones, the unwanted part of the flash is diverted to a quench tube inside the unit. Better guns incorporate a circuit which stores the unwanted power for further use, giving far more flashes per set of batteries.

A calculator on the gun tells you what aperture to set on the lens relative to the film speed. After that, the flashgun will control the output, more or less according to distance. At extremely short distances the flash duration may be as short as 1/30,000 sec, increasing to 1/600 sec at the maximum working distance. The faster speeds are useful for some natural history subjects, such as close-ups of insects.

Some auto flashguns are provided with a remote sensor, one which can be unclipped from the body of the gun. The sensor is inserted in the camera's hotshoe, so that it will always be aimed at the subject, and the flash can be positioned away from the camera, to provide better modelling, or aimed at the ceiling or wall, from which it will 'bounce' back to give a natural lighting effect.

Better guns incorporate a 'sufficient power' feature. This works with direct flash-on-camera, but is most useful when the flash is bounced. The test button is pressed to fire the flash, and a diode lights if the output is sufficient for the intended exposure.

An incidental advantage of working in the autoflash mode is that off-camera operation does not require a special off-camera dedicated lead. A simple extension lead of 1m or more can be bought from any dealer, and it is only necessary to ensure that the sensor is aimed at the subject and the lens aperture set according to the calculator. A cord adaptor is available for cameras which have only a hot shoe.

MULTI-RANGE AUTOFLASH

All but the lowest powered autoflashes now have two or more distance/aperture ranges that can be chosen to suit the shooting conditions. For example, you might find a three-range gun with GN32, and set to ISO 100, offering a choice of;

0.7-4m at	f/8
0.7-8m at	f/4
0.7-16m at	f/2 (f/1.8, f/1.7)

For convenience, the ranges will be colour-coded. If all your pictures were to be taken at a party, at distances of just two or three metres, f/8 would be the obvious choice, and so on. Most of the more powerful guns have infinitely variable range selection, and many permit a form of depth-of-field control by selecting a desired aperture at any given distance within the power capacity of the unit. Such guns incorporate a power switch, allowing output to be reduced in steps between a half and sixteenth power.

DEDICATION

A dedicated flashgun controls some of the functions of the camera, where such facilities exist. At its simplest, inserting the gun in the hot shoe sets the camera's synchro speed and a 'flash ready' light will glow in the viewfinder. A ready light already exists on the

Photo: E. Janes

Ernie Janes used two synchronised flashes to take this pin-sharp portrait of a Tawny owl with prey.

Flash-on-camera gives a stark, flat image. For this shot taken in the Ogof Flynnon Cave, South Wales, the photographer used an Olympus OM-1 with two flashes, one from the camera position, the other at the rear and triggered by a slave unit.

back of the flashgun, and as this is no more than an inch or two from the viewfinder eyepiece, the signal in the viewfinder is not very important. On the other hand, it is surprising how many beginners forget to set the right synchro speed, usually indicated by a different colour or a lightning symbol on the shutter speed dial. Use of too fast a speed will cause some cut-off of the image, as the second shutter blind will already have started to traverse the film when the flash goes off.

With some cameras it is necessary to set the speed dial to Auto, to enable automatic switching. Other cameras, when set to the shutter priority mode, will control the aperture automatically if used with an appropriate flashgun. In this case, the aperture is set on the flash, not on the camera. The latest and most sophisticated cameras can be used with a special dedicated cable. This enables the flashgun to be used away from the camera without losing any of the dedicated functions.

Multi-dedicated flashguns from independent makers deserve a special mention. The main gun may be fitted with a module dedicating it to a particular camera, and modules are available for cameras from all the big names Canon, Pentax, Minolta, Nikon, Yashica/Contax, Olympus and Ricoh. Thus, when changing makes, or buying a second camera of a different make, it is necessary only to add another module to the flashgun. Some of the latest hi-tech cameras, though, offer full dedication only with their own matching flashguns, so you should check first.

Photo: Ron Spillman

Comedian Les Dawson was photographed in a theatre dressing room, with a flashgun on a short lead, held in the photographer's left hand and directed at the wall on the left. An interesting sidelight comes from the mirror. The camera was held in the right hand.

TTL FLASH

As with ordinary measurement of daylight or any continuous light source, TTL flash metering is done through the lens of the camera. The flash sensor is built in to the body of the camera and measures the light as it enters, then sends appropriate exposure signals back to the flashgun. In its most advanced form it combines with the camera's metering system to measure the combined flash/ ambient light, reflected from the surface of the film. This is known as OTF, or off-the-film flash metering.

It is the easiest possible way of securing correct fill-in flash exposures, where the main and background exposure is from the ambient light, while the flash provides enough illumination to lighten the heavy shadows. It is useful both for cutting contrast in bright sunlight, and for brightening the subject on an overcast day.

RECYCLING TIME

A purely manual flashgun expends the same power at any distance, so the recycling time remains the same. With fresh batteries this may be 6-10 sec or so, extending to about 25-30 sec as the batteries become exhausted. Longish recycling times can be a nuisance when a large number of flash exposures have to be made in a hurry, which is why the thyristor flashgun has such an advantage. The closer the distance the briefer the flash, the less energy expended, and the faster the recycling time. This could vary from a fraction of a second close-up to perhaps ten seconds at maximum shooting distance. A secondary

The shutter speed was slow enough for the headlamps to streak. Top; the flash fired just before the second shutter curtain closed. Bottom; the flash fired just after the first shutter curtain opened. This is known as second and first shutter synchronisation, or sync for short.

benefit is the greater number of flashes per set of batteries.

Very short recycling times allow four or five rapid sequence flash pictures to be taken with a motordrive.

BATTERIES

Always read the instructions with a flashgun before using it, and preferably before purchase. Some can be used with either alkaline manganese batteries, which are replaced when exhausted, or nickel cadmium (nicad) rechargeable types. Not a few instruction booklets, though, state that nicads should not be used with the particular flashgun, as they could damage the circuit. Always follow the advice given. A set of alkaline manganese batteries usually gives more flashes than a fully charged set of nicads.

A universal charger for nicad batteries, taking sizes AAA, AA (standard for flashguns), 9V square, C and D, can be bought quite cheaply. These can be recharged about 1000 times, the AA size taking 6-14hr, depending on the type of charger. Nicads are most efficient when used constantly, and fully exhausted before being recharged. This is because they have a 'memory'. If the potential output is, say, forty full-power flashes, but the number actually used stops at twenty or so, the batteries will eventually deliver less than the potential, in spite of full recharging. To overcome this, if the flashgun is not in regular use, it should be fully discharged perhaps every month or two, and then recharged.

A photographer covering a function and knowing that a large number of flashes will be needed, should carry spares. For some camera/flash outfits a special battery grip is available. This attaches to the camera, and the flash is inserted in a shoe on the grip. The grip contains extra batteries, and a very much larger number of flashes is available before changing or recharging. Another advantage is that the flash is farther from the axis of the lens, and in a dimly-lit room sitters are less likely to suffer from red eye, where the flash enters the dilated pupils and reflects from the blood vessels of the retina.

Some nicads contain special sintered cells,

which permit a much higher charging rate, a full recharge being effected in anything from fifteen minutes to three hours. The charge rate is specified on the casing, and a special charger is required. An ordinary, long-charge nicad must never, even in an emergency, be charged on one of these.

BOUNCE HEADS

The scope of a flashgun is vastly extended if it has a head that will swivel upwards, and preferably also sideways. The lighting obtained by having the flash reflect back from a wall or the ceiling looks much more natural, gives far better modelling, and gets rid of those heavy black shadows which join subject to background and are characteristic of direct flash.

Some of the more advanced models have additional features. One is a beam adjuster, which can be set for wide-angle, standard, or telephoto use. The telephoto setting usually matches the angle of an 85mm lens or thereabouts, but works with lenses of longer focal length, as the sensor measures only that part of the light which actually reflects from the subject. Other features include an interchangeable bare-bulb head. Here, there is no casing or reflector around the flashtube, and this provides a combination of direct and bounced light.

Many flashguns are supplied with, or have as an optional accessory, clip-on wide-angle diffusers, giving even coverage when a 28mm or even a 24mm lens is used. Also available are sets of clip-on colour filters.

STUDIO FLASH

For most amateurs, an improvised studio is a living room, and all aspects of this will be covered in Section 12, on portraiture. Full-size flash units on stands are used, with a variety of accessories. These include barn doors to control the light, honeycombs and diffusers, white, silver and gold umbrellas, snoots to give a spotlight effect, and various reflectors.

It is all too easy for the novice to fall prey to studio fever where every shot is attempted with the aid of three or more lighting units, to

Photo: Malcolm Mackay

Studio flash does not have to be harsh and oversharp. Here, a large diffused flash was used at the front and high, with a reflector at the left and a diffused hair light from the rear.

provide modelling, fill-in, rim and background lighting. All these may serve a purpose, and often do in the large professional studio, but the amateur can do very fine work with one or two lamps and a reflector at most. The picture on this page was made this way, using the very popular and reasonably priced Courtenay units.

One flash is connected to the camera by means of a long flash lead, and any further unit is fired cordlessly by built-in slave when the first one fires. All units have to be connected to the mains. It is not possible to use studio flash in the TTL mode, so exposures are arrived at by experiment or, much more accurately, with a flashmeter. This may be of the type supplied by the maker of the flash units, or an independent.

Such studio units have a rapid recycling time of just a second or so, and more power than the clip-on type of flash. Most

important, they have a tungsten modelling lamp, so that the lighting effect can be arranged and studied. Most can also be switched to reduced flash power, the modelling lamps following suit.

POWER CHOICE

Before leaving this chapter, a few words on the subject of power, as expressed by the guide number. The beginner is sometimes misled into thinking that any product that is faster, or more powerful, is by definition better, which is not necessarily so.

A hammer-style flashgun with GN60 is a professional tool, required by an amateur only for special work, such as long-range nature photography, or as the centre of a portable multi-flash set-up. Such a flash is heavy, does not fit easily into a gadget bag, so is often likely to be left at home. A good clip-on type of gun, dedicated and with GN36, has adequate power and is far more convenient.

And here is a reminder of some of the terms used:

ALKALINE MANGANESE. In AA size, most commonly used expendable batteries for flashguns.

AMBIENT LIGHT. The normal daylight or artificial light on a subject.

AUTO FLASH. A sensor on the flashgun measures the flash or flash/ambient light reflected from the subject, and regulates the energy output accordingly.

BOUNCE. The flash is aimed at wall or ceiling to provide a more natural lighting effect.

COAXIAL SOCKET. On camera body. Accepts coaxial plug of flash lead.

DEDICATION. The flashgun combines with the camera to give an extra facility. May be simply a 'flash ready' light in the viewfinder and auto-setting of the camera's synchro speed (q.v.), up to full TTL flash (q.v.).

DURATION. Of the flash. Usually from about 1/600 sec at full power, to 1/30,000 sec in auto mode at close range.

FILL-IN. The flash used to lighten the shadows in an ambient light picture.

FLASHMETER. Used with manual or studio flash to determine the exposure.

GHOST IMAGE. In a flash picture, a secondary, usually blurred, image caused by the ambient light.

GUIDE NUMBER (GN). Flashgun's power rating, normally in metres with ISO 100 film. Divide the distance into the GN to obtain the right aperture.
Thus, GN 28 at 5 m = f/5.6.

HOT SHOE. Fitting on camera for flashgun, with one or more electrical contacts.

IR BEAM. In dim light, or in the dark, the dedicated flashgun projects an infrared pattern on to the subject, enabling the autofocus sensors to 'see'.

MULTI-RANGE. You have a choice of two or more apertures, each of which covers an indicated range of distances.

NICADS. Nickel cadmium rechargeable batteries.

OFF-CAMERA LEAD. Flash lead inserted between camera and flashgun, allowing use of flash away from camera.

OFF-THE-FILM (OTF) FLASH METERING. Sophisticated system measuring flash and/or ambient light reflected from the film itself. Very accurate form of measurement.

OUTPUT. Refers to energy of flashgun (see Guide number).

PROGRAM FLASH. Flash works in conjunction with camera's program mode, providing balanced flash/ambient light exposure (see Fill-in).

RECYCLING TIME. Time taken for flashgun to recharge to full power after a flash has been fired. Gets longer as batteries become exhausted.

RED EYE. Flash reflected from retina of eye causes red pupil.

REMOTE SENSOR. A sensor (q.v.) used at a distance from the flash, usually on the camera.

SENSOR. On the flashgun. Measures the flash reflected from the subject, and regulates the output accordingly.

SUFFICIENT POWER (OR FLASH OK) CHECK. Press the test button and a diode lights to indicate that the flash is powerful enough for correct exposure.

SYNCHRONISATION. Adjustment of contacts, so that the flash fires directly the first shutter blind is fully open, and before the second blind begins its traverse.

SYNCHRO SPEED. The fastest shutter speed at which a particular camera can be used with flash.

TRIGGER VOLTAGE. The voltage reaching the camera's hotshoe or coaxial socket when a flash is fired.

TTL FLASH METERING. The flash is metered through the lens.

Photo: Laurie Campbell

The Right Film

SHARPNESS ● SUITING THE SUBJECT ● PRINTS OR SLIDES?
CHOICE OF COLOUR FILM ● GOING FASTER ● AND EVEN FASTER
SLIDE FILMS ● BLACK AND WHITE ● XP2 ● T– MAX AND DELTA FILM

When choosing films, whether print or slide, or black and white, it is all too easy to think only in terms of granularity. Nowadays, it is not always true that fast films are grainy, medium speed films have the most useful balance between grain and speed, while slow films give the finest grain of all. Things have changed rapidly in recent years. New emulsion technology has given us faster films with finer grain and, as some of the pictures in this chapter show, the gap has narrowed sharply between the quality that is obtainable with 35 mm and larger formats. As we shall see, this is particularly so in the case of black and white film.

The question of granularity, in fact, no longer occupies the waking hours of so many photographers. Granularity is remarkably fine with films of all speeds, and is accepted as a fact of photographic life. We have come to a more mature appreciation of it, and can even make it serve our purposes. We can choose a film to give pronounced graininess, and thus emphasise a sense of roughness, urgency, or action. We can choose a grainless film to show every tiny detail and tonal nuance in foliage, or to emphasise the smooth skin of a child. The finest grained film is not necessarily the best for all subjects. This section should simplify the choice.

SHARPNESS

Oddly enough, increased film speed does not destroy the impression of sharpness, but it may break up the smoothness of gradation, especially in mid-tones. Even this may be quite unimportant in enlargements of moderate size. Images may be pin sharp and have very good colour saturation on a 12 x 8 in print, but at 20 x 16 in the clumping of grains breaks up the image to an unacceptable extent, and the colours desaturate.

The colour red is notoriously difficult for colour film to render, and detail is often swamped by high colour saturation. Here, the glancing light and dew help reveal texture.

Photo: Robin Macey

Kodachrome 64 is faster and generally more useful than Kodachrome 25 but is virtually as sharp and fine-grained.

It could be argued that an ISO 400 film would enlarge better than an ISO 1600 one. True, but at the low light levels calling for such films, the ISO 1600 film would give an exposure of, say, 1/60 sec at f/2.8, whereas the ISO 400 one would require 1/15 sec at f/2.8 or, at best, 1/30 sec at f/2. Getting a sharp picture would then be a matter of sheer luck.

Fast films permit fast shutter speeds, which in turn ensure sharp images. It is a psychological fact that the human eye constantly seeks a point to focus on. When we look at a really sharp print, our eyes can focus instantly, and come to rest while we appreciate the picture. If a picture is blurred, or not quite sharp, our eyes go on seeking and find - the granularity. So, in an odd way, it can be said that a faster film can actually reduce our reaction to granularity.

SUITING THE SUBJECT

Before deciding on the speed of the film, a choice has to be made between colour and black and white. For most photographers this is no problem, for in the public mind colour gives a more lifelike representation of nature and is therefore, by definition, 'better' than black and white. In fact, as you can see by comparing the colour and black and white illustrations in this book, each film type suits a different class of subjects, and even the approach to the subject matter.

From a purely technical point of view, there is no point in using the black and white medium to photograph a few red berries on a green bough, as both red and green will reproduce as the same grey tone, and the berries become invisible. On the other hand, in colour the small spots of red can make a delightful accent against the green. In an opposite situation, it is pointless to use colour film to photograph a white page with black type. In fact, the colour film could only produce a black and white image.

Those, however, are purely technical reasons for using colour or black and white, and there are better reasons for the imaginative photographer to choose one or the other on different occasions. In general, the person who is attracted mainly to subjects because of their coloration, strong or subtle, should work mainly with colour film. Others are attracted more by the shapes and contrasts of the things they see, and for them the most satisfying choice could be black and white. With such subjects, in fact, any colour present may be irrelevant, and even detract from the image the photographer has previsualised. An example would be a gnarled old tree raising bare branches to the sky. The appeal is almost entirely in the shape, and a blue sky might lessen the contrast, and therefore the impact of the image.

Amateurs sometimes tell me they are going to try a roll of black and white film,

Photo: John Pyatt

Fujichrome Sensia 100 is one of the best general purpose films, used widely by amateurs and professionals.

and I am always careful to point out that merely loading the camera with monochrome film does not automatically ensure a choice of suitable subjects. Decide on your kind of subject matter first, then decide whether it is best served by colour or monochrome. Black and white photography calls for a different way of looking at things, a careful previsualisation of the kind of photograph you are aiming for, and the technique that will give that result. Filters give you considerable control over the way colours will reproduce in monochrome, and this is dealt with in the next section. Further controls are possible in printing, and the methods are described later. Print film is best

PRINTS OR SLIDES?

if you want pictures that can be displayed; slide film if your interests lie with slide shows and lectures. Slide film is also universally preferred by magazine editors, though quite a few publications can now reproduce perfectly from good, glossy prints.

It is possible to make, or have made, extremely good prints from colour slides, and these are in no way inferior to prints made from negatives, though usually more costly. Equally, slides can be made from colour negatives, and though these are good enough for demonstration and lecture

Photo: Hugh Milsom

purposes, they do not quite match the quality of an original slide shot in the camera.

CHOICE OF COLOUR FILM

Fuji, Kodak, Konica and Agfa are now making films with better colour saturation, better sharpness, finer grain and more exposure latitude than ever before, and film users are now taking for granted regular improvements that, only a short time ago, would have set the photographic world alight. In answer to the question, 'Which is the best print film?' or 'Which is the best slide film?' I can honestly reply that there isn't one. It all comes down to taste, to which film gives the results that please you best. That, you cannot discover with a single roll of film, or perhaps even on a single occasion. In dull weather, for instance, no film can give the colour you expect on a sunny day, and this is a poor reason for changing to a different brand. However, rather than take refuge in generalities, I will try to indicate the characteristics of some popular films, which may help you to narrow

Although used mainly for press and action photography, Ilford HP5 Plus is also used extensively by pictorialists, owing to its excellent tonal gradation.

your preliminary choices.

Two important factors should be born in mind. First, except for special films made for scientific purposes, film makers do not try to give you the truest possible rendering, but the most pleasing. They are not necessarily the same thing. When I asked a Fuji scientist how they settled on the best colour balance for their films, he told me they check with their employees returning from vacation, on what they like and dislike about the results they have obtained with the Fuji films they have been using. Any modification of the films' colour response is made partly in the light of these findings. Secondly, human response to colour is subjective, so my comments on different films are also subjective, and should be treated as such.

There is no doubt that Kodak Ektar 25 is by far the finest grained print film on the market. It will also resolve finer detail than other films, will give rich colour and, at the same time, is

Photo: Lloyd Wright

Fuji Neopan 1600 enabled Lloyd Wright to use a 180 mm lens at full aperture of f/2.8 and 1/60 sec for this atmospheric shot of David Bowie.

other films will give rich colour and, at the same time, is able to differentiate between subtles shades. It has, in fact, virtually eliminated the quality gap between 35 mm and medium format. On the other hand it is quite slow. A photographer who appreciates its fine qualities will often be prepared to use a tripod, on occasions when great depth of field is required. It could certainly be used handheld in bright light, often at larger than usual apertures, but that kind of usage would hardly exploit the film's finer points. Ektar 25 has less latitude than other print films, and must be exposed as accurately as slide film. All in all a wonderful film for still life, tripod work and portraiture by flash.

The superior quality of Ektar 25 is only apparent when a large print is placed side by side with one of the same subject shot on a faster film. In fact, print films of ISO 100 will give a grainless and satisfyingly sharp enlargement up to about 12 x 8 in. Exhibition prints on 20 x 16 in matt or lustre paper look just as sharp and free from granularity when viewed from a proper distance of three or so feet. My own exhibition prints are made from ISO 100 Fujicolor Super G Plus negatives, simply because this particular film suits my taste. Other photographers are equally happy with Kodacolor Gold 100, Ektar 100, Agfacolor HDC 100 or Konica VX100.

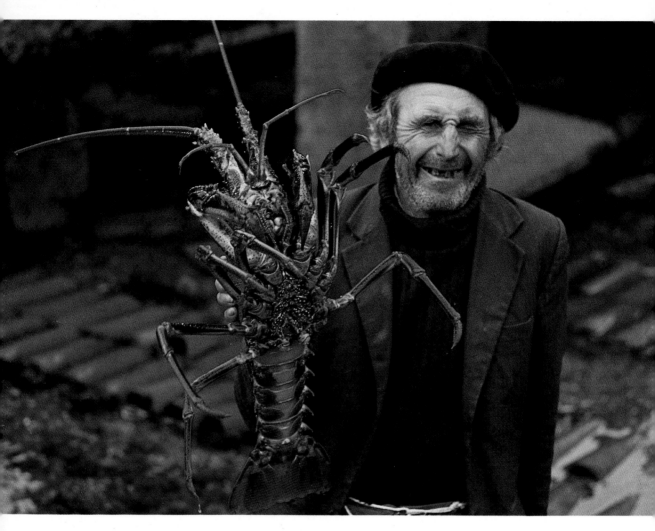

Choice of colour film is eventually a matter of taste. Some prefer neutral colours and clean whites, others a touch of warmth, or high contrast This was taken on Agfachrome CTX, a 'cool' slide film, on an overcast day.

GOING FASTER

There are occasions when a faster film, ISO 200 or 400, could be an advantage. This would apply in the case of sports or action work in less than perfect weather, or when the maximum aperture of a zoom or telephoto is not large enough to allow fast shutter speeds with a slower film. If your biggest enlargement is seldom above 12 x 8 in, with a very occasional 16 x 12 in, the ISO 200 films will give results almost identical with those obtained from ISO 100 films. In fact, there should be no discernible difference in 6 x 4in prints. The new ISO 400

films are very sharp, but on enlargement there is a more noticeable break-up of image quality. As these films are normally used for action subjects, the less smooth gradation from tone to tone will not matter, and will in any case be in keeping with the subject matter. On the other hand, it is far from the ideal choice for portraiture, especially if you want to flatter.

AND EVEN FASTER

Ultra-fast print films offer two great advantages. They make action photography possible indoors or in very poor light outdoors. Certainly, these ISO 1000, 1600 and 3200 films are much grainier than ISO 400 types, but this becomes objectionable only with great enlargement. In any case, coarse grain is in keeping with low light,

often gritty, subjects. An extra advantage is that they can be used with a blue conversion filter in tungsten light, and still have enough speed for handholding. These print films are balanced for daylight, and would normally give a yellow print when used by tungsten light. The 80B filter cuts light transmission by $1^2/_3$ stops, thus reducing the effective ISO rating of the film. Fuji's HG 1600, for example, becomes ISO 500, but this is adequate for picture-taking indoors in ordinary room lighting, or in such places as aquaria and the animal houses at zoos.

On test by the technical staff of some photo magazines, not all these superfast films came up to the stated ISO figure, so after your first roll of film you may decide to lower the rating a little. There is, however, enough exposure latitude to give good prints, even with some under-exposure.

SLIDE FILMS

All slide films are now compatible with Kodak E6 processing, and the traveller in former Soviet Bloc countries should avoid the one or two non-E6 brands which may still be on sale. Processing is no longer available. Kodachrome has a more complicated structure and processing sequence than E6. Kodachrome 25 has been for many years, and still is, the finest grained and sharpest slide film available but, like the print film Ektar 25, is best suited to tripod work and photography of still or slowmoving subjects in good light. Kodachrome 64 is almost its equal, as is ISO 50 Fujichrome Velvia.

As with print film, though, the most popular slide films are in the ISO 100 category. They have enough speed for general use, yet the grain, sharpness and colour characteristics are more than adequate for magazine reproduction and for projection in large halls. Ektachrome, Fujichrome, Agfachrome and Konica Chrome are all excellent films and, in general photography, the choice between them will be a matter of individual taste. In fact, the old adage about a change being as good as a rest applies here, and some photographers will enjoy the stimulus of switching brands from time to time.

As with print films, the same factors apply when choosing between the various ISO speeds of slide film. It should be kept in mind, though, that slide film has much less latitude than print film, and must always be correctly exposed. On the other hand, E6 films can be push- and pull-processed. To 'push' means to expose at two or three times the film's speed and give extra development. Conversely, to 'pull' means to reduce both the film speed and development time. This reduces contrast, particularly useful when duplicating slides, to prevent an increase in contrast. These speed-modifying techniques will be described in the section on colour processing. The Kodachrome enthusiast needing faster film will switch to Kodachrome 200.

Of even more importance is that slide films are made in both daylight and artificial light versions. The faster ones are ideal for indoor action subjects, such as sports and cabaret, especially in conjunction with the up-rating and push-processing technique.

BLACK AND WHITE

Far from being ousted by colour film, black and white is not only going strong, but has become a cult medium. You have only to look at the number of CD sleeves now using monochrome photography to realise the tremendous appeal of this medium.

Until recently, films were easily placed in different categories. As with colour, medium speed films of ISO 100-125 have been most popular, as having the most useful balance of grain/sharpness/ gradation. Pictorialists, and photographers seeking even finer technical quality, have used films of ISO 50, such as Ilford's Pan F Plus notable for exceptionally smooth gradation, and giving ultrafine grain.

The coming of new technology saw many newspapers switching from old black and white favourites such as Kodak Tri-X and Ilford HP5 Plus, to colour print films of similar speed. These yield satisfactory monochrome as well as colour prints when needed. Print films such as Fujicolor Super G Plus 400 and 800, and HG 1600, and Kodak's Ektapress 400 and 1600, can be pushed to twice their

Kodak's T-Max 400 film has the fine grain qualities of a slower film, and was ideal for this handheld wide-angle shot, taken at f/11 under an overcast sky.

XP2

This remarkable film from Ilford is based on colour print film technology, and is processed in the same or similar chemistry. It is unusual in two main respects. It has the virtual absence of grain associated with conventional films of ISO 25, but has enormous exposure latitude and can be exposed at ratings between about 250 and 800 without any modification of development.

The gradation and sharpness of XP2 is remarkable. A large, print made from a good negative can hardly be distinguished from a print made from a 5 × 4 in negative. XP2 can be processed at home or by any processing house, in the same C-41 chemistry as print films.

XP2 processing is carried out at a much higher temperature than is used for conventional black and white films, and although processing times are short, preparation takes longer. This is of little importance to most amateurs, as so many processing houses now develop and print XP2 alongside colour print films, and are able to supply good quality black and white or sepia prints. Many amateurs now have their XP2 commercially developed, and do the enlarging at home. Naturally, this is no more difficult than printing from conventional negatives.

Photo: Ron Spillman

T-MAX FILMS

There are three T-Max films, with ISO ratings of 100, 400 and 3200. These three films incorporate Kodak's revolutionary T- grain technology, which gives much finer grain, speed for speed, than other monochrome emulsions of conventional type. The granularity of both T-Max 100 and 400 is claimed to equal that of films which are two stops slower, i.e., ISO 25 and 100. For those wishing to obtain optimum monochrome quality of indoor sport and night action outdoors, the ISO 3200 version is an excellent option. It produces results that were unheard of until recently, and a further advantage is fast and easy processing in D-76 or the special T-Max developer.

The ISO 100 version has become deservedly popular as a sharp and very fine-grained film for general and technical use.

Although pressmen now standardise on fast colour negative film and are satisfied with mono prints of adequate quality, the fast black and white films yield technically superior enlargements, a fact well appreciated by the pictorialist. Also, they can be used to striking effect with contrast filters.

Similar to Kodak's T-Max films are Ilford's 100 Delta and 400 Delta. 100 Delta is claimed to give sharper images than any other black and white film of this speed.

Only a few days before writing this, I was in the company of a local press photographer as he came into the editorial department from his newspaper's darkroom, holding some 10 x 8 in prints of floodlit football, photographed on Fujicolor Super G Plus 400 at ISO 1600 and push processed. This isn't the best way to use this film, but the prints were pinsharp and virtually grainfree. 'We've never had it so good he chuckled.

CHOOSING YOUR FILM

1. If you mainly want pictures to carry about and show friends, for framing, or for club print competitions, colour negative film, commonly called print film, is best and most economical.

2. Although magazines and, journals can reproduce quite well from a glossy colour print, transparencies are still preferred. So if your main aim is publication and slide shows, colour reversal film, commonly known as slide film, is your best choice. Good prints can be rnade from transparencies, but are more expensive than prints made from negatives.

3. You'll probably try several makes of film, Kodak, Fuji, Konica, Agfa, before deciding which you prefer, but today's colour films are all good. Use films of ISO 64-100 for general purposes, as they have the best balance of speed, fineness of grain and richness of colour. ISO 200 colour films are just as good at small degrees of enlargement, and are more useful in dull weather. Save the faster ISO 400 films for action, especially in the winter months, and the ultrafast ISO 1600 films for indoor action or outdoor action at night.

4. Very slow colour print and slide films of ISO 25-50 are best used when a subject calls for rendering of the finest detail and texture. Mostly, the slower shutter speeds mean that a tripod is essential.

5. At one time or another, you will want to try monochrome film. Black and white is best when the strength of a picture lies in bold shapes and strong outlines. In such cases, colour may be superfluous, and even an unwanted distraction. Study the monochrome pictures in this book. Other subject matter can only be photographed successfully in colour. Example: A few red berries among green foliage. In black and white, the berries would not show up. To decide whether you are mainly a colour or monochrome person, ask yourself: "Am I interested mainly in the colour of things, or their shapes?" A tricky question, but it helps. Most advanced workers use each type af film when it is right for the occasion.

6. Where possible, buy your film from a busy dealer, who will not have old stock on his shelves. Ensure that the film is well inside the expiry date on the carton.

Filters

LIGHT BALANCING ● EFFECTS ● GLASS OR RESIN

C amera filters serve three main purposes, plus a fourth which many amateurs consider important, while others do not. First, to modify the colour rendering on slide or print film, for example, adding a touch of warmth under a cold blue sky, or cooling the yellowing effect of late evening sunlight; also, for altering tonal rendering in black and white photography, such as darkening a pale blue sky to dark grey; second, to convert, or balance, daylight colour film for use in tungsten light and vice versa; third, to impart 'effects' to otherwise straightforward images and fourth, simply to protect and keep clean, the surface of the camera lens.

Beset on all sides by clever advertising, the novice may be tempted to buy a large range of filters, when his needs may be met by just two or three. The brochures associated with 'effect' systems in particular, show dozens of so-called creative images, which equally require dozens of filters, and many of these are simply gimmicks of which the serious photographer would grow tired after the first use. This section will help you decide just what filters you need, if any.

LIGHT BALANCING

In the last chapter we saw that no colour film can give natural results in both daylight and artificial light. This is why we have both daylight-type and tungsten-type films. These films are balanced for 5500K and 3200K respectively. 5500K is equivalent to noon sunlight plus skylight, while 3200k is the colour temperature of 500W studio lamps. Under a clear blue sky without clouds, especially in the mountains or on a beach, excess ultraviolet light raises the colour temperature and we get a cold, bluish result. This is usually corrected by fitting a skylight filter over the lens. The original skylight is the Kodak Wratten 1A, but in recent years an independently made 1B filter has become more popular. Both are slightly pinkish, the 1B a little more so than the 1A, but there is no exposure increase needed with either.

At extremely high altitudes even the 1B may not have a sufficiently warming effect, and a pale brown filter may be needed.

A Skylight 1B filter has preserved the rich blue of sky and dress, contrasting well with the warm colour of the timber.

There are five Wratten designations, 81, 81A, 81B, 81C and 81EF. You should need nothing darker than the 81A. In some independent ranges of filters, the Wratten designations are not used, and these filters will be called 'warming'. The palest of these is the most useful.

Towards evening, sunlight becomes very yellow. In general views it is best not to cool the effect. By bringing the colour temperature back to that of noon sunlight and skylight, the charm of the evening light is lost. However, if you are taking close-up portraits in such light, you may decide to use a very pale blue filter, equivalent to a Kodak Wratten 82A.

Both filters may be used to alter the mood of a picture by adding or subtracting warmth.

One German filter catalogue goes so far as to relate the range of warming filters to different altitudes. This is based on the fact that the UV content of light increases at higher altitudes. In fact, this varies enormously with weather conditions, cloud presence, and varying conditions between foreground and background. If you were sufficiently technically minded, you would constantly be using a colour temperature meter to decide on the correct degree of warmth required - by which time conditions could have altered. As suggested, just one brownish and perhaps one bluish will suffice.

EFFECTS

Extravagant effect filters should be used sparingly, if at all. Not all effects appeal to all photographers, and the way-out ones are seldom used professionally. Many amateurs have collected a dozen or more effect filters and, after the initial enthusiasm has worn off, find themselves using just three or four. Every independent maker of effect filters has an illustrated catalogue, and you are strongly advised to study one of these carefully before choosing. Ask yourself how many times you are likely to use a particular effect, how often it may be appropriate, and whether it is in keeping with any of the subjects that interest you.

These effects are sometimes called 'creative' filters. If only it were possible! Creativity is in your mind and eye. You can certainly make use of the less spectacular effects in a creative way, but pictures taken with the more spectacular ones tend to be a mere demonstration of their use. In no way would I dissuade any photographer from experimenting with the hundred or so types available. I merely advise caution against impulse buying. Remember, the pictures that go on holding people's attention, year in, year out, do so because of their beautiful or emotive content, not because the photographer surrounded a lamp standard with a multi-coloured halo. Here are some of the more useful types - in my opinion, of course.

DIFFUSERS

Most ranges have more than one type, each in two or three strengths. Use the catalogue illustrations to decide which type you prefer, such as diffuser or softener. For a start, I suggest you obtain the No.1 only. This is ideal for pictures of children, and for flattering portrayals of adults. A No.2 does a great deal to soften the lines on an aged face, but the No.3 removes too much detail for general picture taking. In the interest of simplicity and rapid choice, I carry a No.1 only.

GRADUATES

We may be entering a heat trough between two ice ages, but our summers still have a preponderance of days without sunshine. This means that we are often confronted with a blank, white sky, or at best a pale blue one, when a rich blue would have worked wonders for our composition. This is where a graduated filter can help. In some ranges there are two strengths of graduate and again I advise the lighter of the two. If there is a little blue in the sky, a grey graduate will darken it in a satisfying way. If the sky is white, a blue graduate will add the necessary colour. There are several other colours of graduates.

The light is diffused but directional, giving both modelling and shadow detail. In such situations, without direct sunlignt, a Skylight filter will add a touch of warmth.

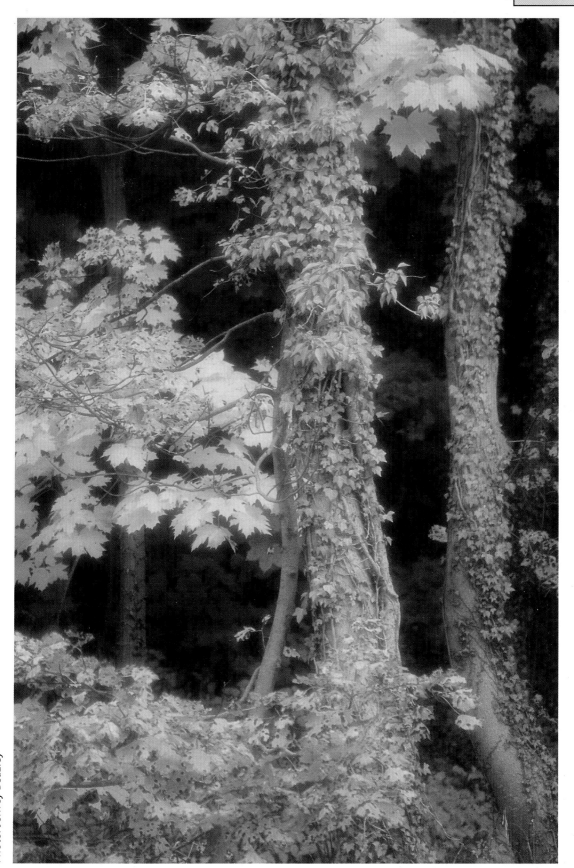

Photo: Jeffrey Beazley

On a cold evening the castle looked bleak and uninviting. Use of a sunset filter has added warmth and a dramatic dimension.

tobacco, or 'tabac'. It is quite warming, and not beyond the bounds of plausibility that it could occur in nature. The other colours are hardly natural, and if they appeal, the darker shades may equally well be chosen.

STARBURSTS

These add a star pattern to any points of bright light, such as reflections of sunlight on water. They come in 2-, 4- and 8-points, and may be turned to rotate the rays at different angles. They are used on many stage settings seen on television, which helps you decide the number of points you prefer.

The foregoing may be considered the more natural of the effect filters, but there are many more. Diffractors and rainbows cast multi-coloured circles and waves across the image. Centre spots give a clear central image with a diffused surround. A speed filter will put a blurred trail behind the sharp image of a stationary car to suggest movement. There are multi-image round and linear filters, giving a cluster of secondary images around, or on either side of, the subject, and even a graded sunset filter to add evening glory when Nature has been remiss. Many of these effects can be had in different colours.

Study the catalogue well, and decide just how few filters you will want to use on a regular basis.

POLARISER

This is perhaps the most useful filter for the colour photographer. It is the only filter that can darken a sky without altering colour in the remainder of the picture. In use, the image is watched in the viewfinder screen while the polariser is rotated, until the desired degree of darkening is achieved. It will lessen reflections at certain angles from water, glass, and other surfaces, with the exception of metallic ones.

Its effect is most pronounced when pointed 90° from the sun, and is least effective when pointed towards, or directly away from, the sun's direction.

There are two types of polarising filter, linear and circular. This refers not to the shape of the filter but to the way it polarises the light rays. With most TTL-metering cameras, a linear type may be used, but certain hi-tech SLRs require the circular type if exposure is to be correct. Refer to the camera's instruction book or, if you are buying a polariser for the first time, get the circular type, which is good for all types of TTL cameras.

Remember, whether of the circular or linear type, the actual shape of the filter may be round (glass) or oblong (resin).

CONVERSION

A dark blue 80A conversion filter is used with daylight colour film in tungsten light, preferably with studio lamps of 3200K. An

A polarising filter has blackened the sky, already darkened as the exposure was for the texture of the white wall. Den Reader used Kodachrome 64 and a 21mm lens on his Olympus OM-1.

Taken on High Speed Ektachrome 160, using only the modelling lights on two Courtenay studio flash units. (a) without, and (b) with, a Hoya screw-in diffuser.

80B is used with overrun photofloods of 3400K. Without the conversion filter, the images would be yellow. This combination of daylight film and blue filter is fine for general interiors, but is not ideal for portraits. Even the film manufacturers suggest that the combination is second best to using a film balanced for tungsten light. Frankly, it all depends on what satisfies each individual.

Amateurs use more daylight than tungsten film, even for studio work, where electronic flash is used. However, tungsten film still has its advocates and many photographers like using it for natural effects in room lighting. Any unused frames may be exposed in daylight by using the amber Wratten 85B filter over the lens. Results are quite good, though blues may be a little on the weak side.

An 80A filter reduces the speed of daylight film by 2 stops, and an 80B by 1⅔ stops. An 85B reduces the speed of tungsten film by ⅔ stop. Naturally, the TTL metering takes care of this.

FL-DAY

This filter is used with daylight colour film under fluorescent tubes. Technically, it should be used with tubes bearing such descriptions as daylight or cold white, whereas an FL-W is advised for de luxe, or warm white, tubes. In many working situations it is not possible to read the description on a tube and, in any

case, this might be a code number only. The FL-W is supplied for these warmer tubes, but over many years of professional practice I have found the FL-D gives very good results every time. Other professionals agree with me.

Fluorescent tubes emit an irregular spectrum, and although this does not matter in general scenes with figures, the combination is not ideal for portraiture.

BLACK AND WHITE

On black and white film, colours are rendered as tones of grey. We can use coloured filters to alter the way the colours of the subject reproduce, and so strengthen or lessen particular grey tones.

The common filters used for this purpose are yellow, orange, red and green. Most black and white film is very sensitive to blue, which comes out lighter than in Nature. Thus, a yellow filter renders a blue sky as a darker shade of grey, showing up any white clouds. The most useful yellow filters have an exposure increase factor of 2 ×. Orange and red filters darken the blue sky progressively, and though exposure increase factors vary,

Sport and Action

PEAK ACTION ● PANNING ● SUBJECT TREATMENT
THE RIGHT SPEED ● FOCUSING ● MIRROR DELAY
INTENTIONAL BLUR ● ACTION LENSES

U sing the fastest shutter speed on your camera is not always the best way to photograph action. Sometimes a shutter speed of 1/1000 sec or faster will stop the action so completely that all sense of movement is destroyed. This is known as freezing the action. The best shutter speed to use depends on the subject. It is surprising to the novice that a good picture of runners on a track may require as fast a shutter speed as some shots of racing cars. This is because the athlete's body may be moving at far less speed than a car, but his arms and legs may be whirling much faster than his body. Racing cars, on the other hand, often slow down when approaching a sharp bend, where some of the best pictures may be taken.

PEAK ACTION

Although a diver may be moving at 30 mph when touching the water, at the peak of some dives, just after leaving the board, he may be almost stationary. Even a relatively slow speed, such as 1/125 sec, may be fast enough to ensure sharpness, though 1/250 sec or faster would make it more of a certainty. This is called catching the peak of the action and, as we shall see, it is one of the most useful tricks in the action photographer's repertoire. On the other hand, a racing dive looks best just after the diver has left the edge and is at full stretch, before touching the water. That calls for a faster shutter speed, and 1/500 sec would be normal for this.

PANNING

Short for panoramic movement, panning is a technique employed by every sports photographer, and is perhaps the most important. It consists of swinging the camera smoothly in order to keep the moving subject centred in the frame. This way, the image of the subject is

A 400mm lens doubled to 800mm with a 2X converter produced this powerful close-up of a skier.

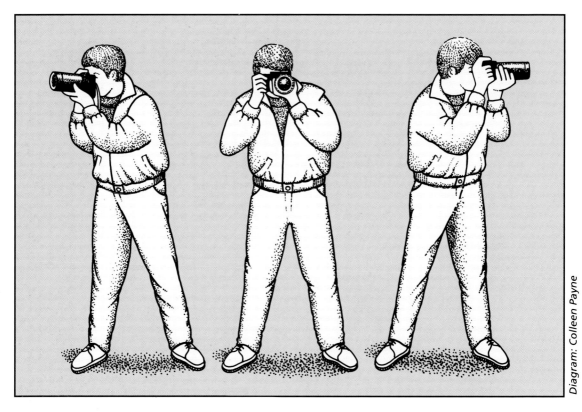

Diagram: Colleen Payne

moving relatively little in relation to the film. With a car moving across the field of view at 200 mph, and a camera fixed on a tripod facing the track, a shutter speed of 1/8000 sec would probably stop the movement, that is, in the unlikely event that the shutter release could be pressed at just the right moment! By panning, even 1/500 sec or slower could render the car sharply.

Just as the image is stationary relative to the film during a panning movement, the background appears to move faster across the field of view. This imparts a degree of horizontal blur to the background, and gives a real sense of movement.

Everyone is familiar with the way people watch a tennis match, heads moving regularly from side to side with the play. The attentive viewer never misses a shot, and with a little practice neither should a photographer. It isn't the eyes of the person watching the tennis match that move back and forth with the play, but his head. The movement of the head keeps the eyes in line with the ball. The movement is easy, comes quite naturally to everyone, and needs no practice. A panning movement of the camera is accomplished in the same way, and almost as easily. Keep the

Panning is the pressman's most important skill. The camera is moved smoothly in an arc, keeping a moving subject centred in the frame. The release is pressed, never jabbed, at just the right moment, without interrupting the swinging movement.

camera firmly pressed against the cheek and brow, which keeps it steady. The eye is looking straight ahead through the viewfinder, and the oncoming subject is kept centred by moving the head, not the eye.

Naturally, some initial practice is called for, and any passing road traffic is a suitable target. A roll of practice film will pay big dividends next time you want to pan in earnest. When you have attained the initial skill, you will sometimes position the subject so that it is not dead centre in the frame, but just approaching it. This is a better composition, with the subject heading into the frame instead of out of it.

The way you release the camera's shutter is part of the follow-through action. Start squeezing the button gently, so the exposure takes place at just the right moment. Never make a sudden jab at it, which will cause camera shake.

SUBJECT TREATMENT

Relate the shutter speed to the subject. That is the first golden rule of action photography; the two others so far discussed being smooth panning action and smooth release of the shutter. The fourth, which is probably the hallmark of every successful sports and news photographer, is anticipation. Looking ahead to the point of peak action, the point of possible impact, the point that will provide the most spectacular picture, and having the finger beginning its pressure on the release button as the psychological moment approaches. This is a skill, or rather a sense, that develops with time. As you become more and more familiar with a sport, you become aware that a certain sequence of events is likely to follow any given situation, and you are therefore more likely to anticipate it.

By way of example, some time ago I had to produce the pictures to illustrate a series of half-pages in a national magazine, on the lives of the star wrestlers who appear on television. The series continued weekly for a year. At the end of three months I knew not only the attitude of each wrestler to life, the universe and everything, but more usefully, exactly what sequence of throws and rollouts, grimaces and fouls, would follow any other, with any given pair of fighters!

The golden rules:
(1) Relate shutter speed to subject.
(2) Smooth panning action.
(3) Smooth shutter release.
(4) Anticipating the action.

THE RIGHT SPEED

A side-on picture of a long jump contestant hurtling above the sand can be caught at 1/250sec with a smooth pan but, light permitting, a professional would choose a faster speed. In the first place, there is little to be gained from a very blurred background in such a shot, where the shape assumed by the athlete, the tension in limbs and face, are sufficient portrayal of action. The classic shot of a long jumper, however, is from the front with a long lens, the movement relative to the camera being far less at this angle than in a broadside shot.

The high jump is a different matter. Most of the athlete's power is expended in getting up there, and this is not the usual time for a picture. This comes as he backs over the bar. In the high jump this is not a still peak, but it is the point of least movement.

Again, 1/250sec or 1/500sec suffices, but light permitting, an even faster shutter speed will produce better sharpness. This is another situation where any panning movement would be quite short and a blurred background of no account, as all the action is implicit in the participant.

The pole vault is somewhat different. A spectacular shot from a low angle can show the athlete just before peak height, with the pole bent back in a spectacular curve, best caught at a high shutter speed. Right at the top, though, there is an almost still instant, which could be caught at a slower speed. In practice a faster speed will ensure sharpness, and most professionals would agree that the slower speeds of 1/250sec or so, should be reserved for creating a little background blur in panning shots. The pole vault is a subject where background blur, even if possible, would be meaningless.

With such subjects as boxing, hockey, football and so on, where there is constant fast action by the participants, but no single subject direction, high speeds are necessary to give adequate sharpness. Unless lighting conditions were poor, 1/1000sec would be standard for this kind of action, and even faster if this did not call for too large an aperture in sports calling for good depth of field.

FOCUSING

Autofocus is a boon to anyone suffering from poor eyesight, and has been accepted by professionals for some, but not all, subjects. For example, when following runners round a track, when you can be sure that someone will always be centred in the frame, and therefore within the focus zone, autofocus is quite safe. In team sports, though, the action is fast-moving, and the best action seldom

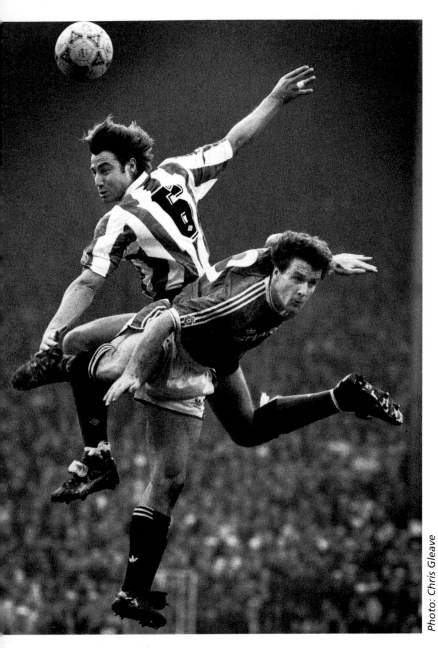

Photo: Chris Gleave

With players moving in different directions, football is one of those sports where a fast shutter speed is always chosen. 1/1000 sec is usually fast enough. Editors of sports magazines know that the readers want to see every detail, so very few intentionally blurred pictures are ever used

A 28mm lens wielded from the prone position produced this eye-catching shot of BMX action.

occurs when one key player is conveniently in the centre of the frame. This has accounted for a number of pictures with the players out of focus, and the crowd on the other side of the field shown sharply between them.

On the whole, sports photographers and pressmen tend to rely on manual focus for most subjects, though in some situations they will use an autofocus camera that has a focus hold facility. Although this enables an off-centre subject to be focused on, and the focus held while recomposing the picture, this is of no use in field games, where the action is

too fast for such a technique.

Some modern SLRs give you a choice of one-step or continuous autofocus. The latter can be a great help for some action, such as following a swimmer approaching along the baths. In the continuous mode, the camera will take care of focus up to the moment of exposure, leaving you free to concentrate on the action.

If you intend to do a great deal of fast action work, it is worth comparing the speeds at which focusing is achieved with various autofocus systems. Minolta, for example,

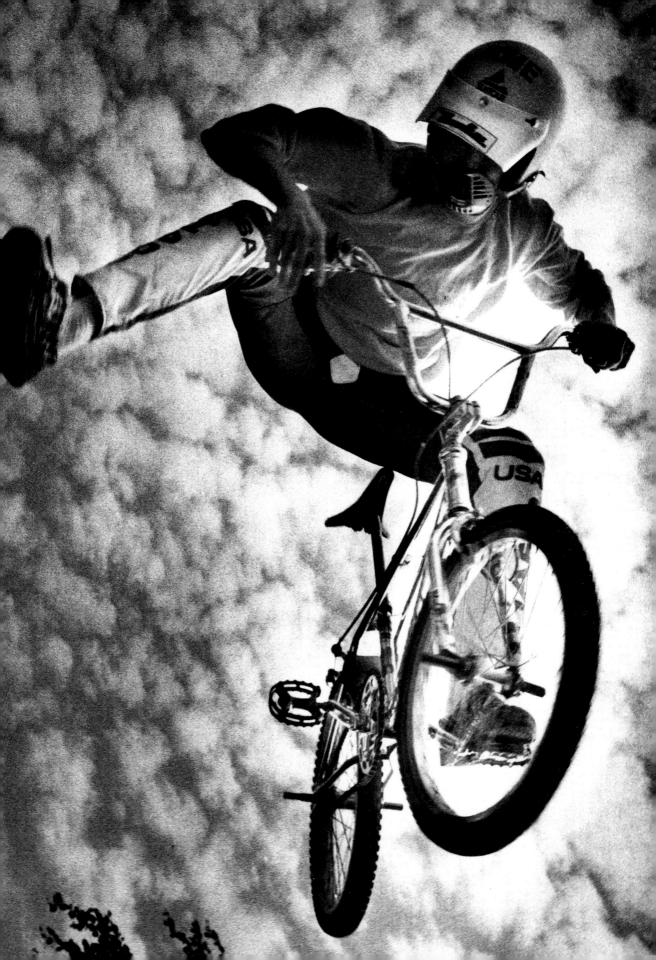

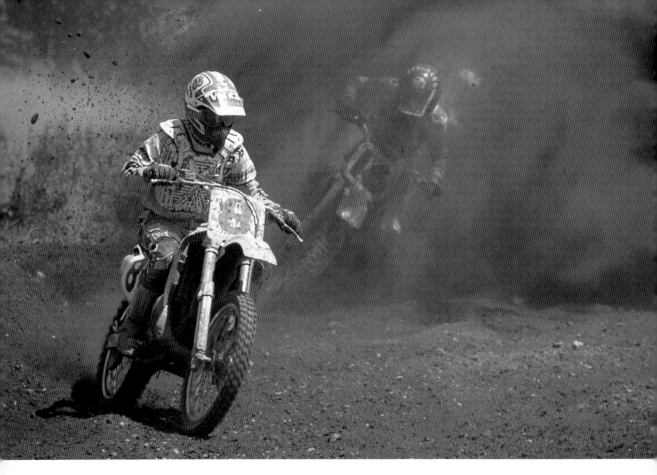

claim the following times for the 7000, depending on the lens in use:

AF Lens	Autofocus speed
28mm f/2.8	1m - Infinity 0.15sec
50mm 1f/1.7	0.45m - Infinity 0.6sec
70-210mm f/4	1m - Infinity 1.2sec

Those figures represent the autofocus speed all the way from the closest focusing distance to infinity, though later lenses have even faster AF mechanisms. Canon EOS lenses, for example, have USM, Ultra Sonic Motors. Normally, the mechanism will be working over a much shorter range. If, for example, you are taking a series of pictures at distances between, say, 6-10m, this represents an extremely short focus adjustment, which could take place in perhaps .07sec or less. The action photographer can make use of this fact by pre-focusing on a spot somewhere near the point at which he expects to be aiming. The lens will stay focused on that

Too fast a shutter speed can freeze not only the action, but the feeling of it. 1/250sec is fast enough for a relatively slowly moving subject. Note the slight blur on the tyre and airborne debris.

point until he shoots, and the autofocus movement, if any, will be virtually instantaneous.

Fast as it may be, or may be made to act, autofocus is of doubtful use for some action work, a good example being the long jumper hurtling towards the camera. Traditionally, the sports photographer has treated this subject with a long lens from a distance, perhaps a 200mm lens at about 13m. At that distance the frontal image of the athlete would be nicely filling the frame. The photographer would have judged a spot where the action would be best, and pre-focused manually on the ground at that point. In theory, it should be possible to prefocus in the autofocus mode, thus reducing any delay to a minimum. It should also be possible to develop a technique of pressing the button early, to allow for autofocus delay. In practice, though, the professional would reduce the possibility

of error by relying on his manual skill.

MIRROR DELAY

As there is a delay of about 1/25 sec before the SLRs mirror has risen and the moment of actual exposure is reached, practice is needed in pressing the release at just the right moment, neither too early nor too late. This is possibly one of the hardest skills to acquire for the amateur, simply because he does not get the continual practice from which the professional benefits. Some cameras actually help you acquire this skill, because the release button has a pressure point beyond which you know the shutter will trip. The few cameras favoured by pressmen, especially the action specialists, have this type of release.

However, the amateur who gets out at weekends and visits sporting events, will soon pick up the technique. At first, the novice is inclined to shoot a fraction too early, hence those pictures of horses jumping fences, with their hind legs still touching the ground, and approaching motorcycles a yard short of the pin sharp gravel on the track.

One of the best horse trials photographers I ever met, confided in me that during his apprenticeship he was so premature with his pictures at the jumps, he despaired of ever improving. In dulcet Irish tones he told me: 'I mastered it purely by chance. I decided to catch horse and rider almost from the front, filling the frame as they hopped over. I was well back, using my 200 mm lens. I could see neither of the devils as they approached the hedge, my first sight being the cap of the rider as they started the jump. I soon learned to press the tit just as his face became visible, and in every picture there they were, beautifully framed, right on top! It worked wonders for my prestige! The first time I did it, I got a lovely shot of a lady rider on a well-known nag, right at the peak of the jump. My editor pointed to the six-inch gap between her bottom and the saddle, and said admiringly, 'How d'you manage to catch it at just that moment?' 'Easy,' I said, 'You watch her expression.' The great thing was, it taught me what I needed to know about mirror delay, and after that I just seemed to get them right from any angle.'

INTENTIONAL BLUR

Amateurs often like to use slow shutter speeds, to introduce directional blur into action shots. Exposures of 1/15 sec and slower are chosen, and the result can be pictorially quite effective. 1/30 sec or 1/60 sec can produce fuzziness rather than blur. Shots like this can be visually quite exciting, and many have won prizes in competitions at camera clubs and in photographic magazines.

If you are thinking of selling your work to sports magazines, you will have to adopt a different approach. Sports enthusiasts are interested in the faces of their heroes, the gear they use and the machines they drive, ride or manipulate. When they buy a magazine that caters to their particular sport, they want to see every detail, and picture sharpness is the order of the day. It is, of course, possible that the picture editor of a sports magazine may decide to include one, exceptionally impressive, blur shot among a number of sharp ones in a spread of pictures, but, and I offer this advice in the light of experience, don't include any blur shots in your portfolio when asking a sporting magazine's picture editor to put you on his freelance list.

Of course, if you have no aspirations to professional employment, intentional blur offers enormous scope for creativity, not just in action work, but in portraiture and many other fields.

ACTION LENSES

Many amateurs who are keen on sports make do with a zoom lens of about 70-210 mm, and with a maximum aperture of f/4 or f/3.5. Some of them write to me, complaining that they sometimes need a longer focal length, and asking whether a 2 × or 3 × extender, or teleconverter, would be an economical solution to the problem, or should they consider buying a lens of longer focal length. I always point out that a 2 × extender reduces light transmission by the equivalent of two stops, and a 3 × converter by three. This reduces the effective maximum aperture of the f/4 lens to f/8 or f/11, and the slightly

faster f/3.5 lens to f/6.3 or f/9.5 (the half-stop settings between f/5.6 and 8, and f/8 and 11).

Not only are such apertures too small to permit really fast shutter speeds except on the brightest days and with fast film, but they give a very dim viewfinder image, which makes fast focusing impossible, and subject to error. Additionally, a converter magnifies any residual aberrations in a lens, and it is usually recommended that the prime lens be stopped down at least one stop when a converter is used. In practical terms, these factors make them useless for sporting purposes.

Standard lenses have apertures of f/1.8 and even f/1.4, ideal for rapid work. Lenses of about 100mm have maximum apertures of f/2.8 or f/2.5 and are relatively inexpensive compared to good zooms. Many 135mm and even 200mm f/2.8 lenses from camera and independent makers abound in the secondhand market at low prices now that zooms are more popular for general photography, and are ideal for the sporting amateur who doesn't want to be 'grounded' when the sun goes in.

Professional sports photographers favour very wide maximum apertures for long focal length work, partly because of shooting speed, but equally because the brighter viewing lends itself to quick appreciation and focusing of the subject. These lenses are easily recognised at sporting events by virtue of their large front diameter, and the usually white barrel. Unfortunately, they cost a great deal of money. Few amateurs could justify paying about £5000 for an f/2 Nikkor IFED, or £3000 for an Olympus Zuiko 350mm f/2.8. On the other hand, the amateur has one great advantage - if conditions are bad, he can put his camera away, go off and enjoy a hot drink, without worrying about his job.

OTHER ACTION

We do not often think of subjects like portraiture and child photography as in the category of action photography, but both subjects qualify. Portraiture is done at close distances, and a sudden laugh or shake of the head can be as fast, in relation to movement on the film, as a racing car at thirty metres.

Similarly, trying to capture good shots of a hyperactive child calls for at least as much skill as a good sports action shot. There are also techniques for action work at night, and all three subjects will be dealt with in later chapters.

SIX QUICK TIPS FOR ACTION

1. ISO 400 is the pressman's choice for daytime action. It permits fast shutter speeds in changeable weather but has fine enough grain to be greatly enlarged if required.

2. The mirror in an SLR takes 1/25sec or less to rise, which means that a vehicle speeding towards you is closer at the moment of exposure than when you pressed the release button. Some hitech SLR's have a predictive autofocus system, which takes account of the discrepancy. With other cameras, you fire just a fraction before the advancing subject reaches the spot you've chosen. This might be a yard or so in the case of a racing car, motorcycle or long jumper.

3. If you intend to specialise in sports photography, consider a system such as that of Canon, which has USM (Ultra Sonic Motor) lenses, for extremely fast autofocusing.

4. Practice panning smoothly. Even with fast action, squeeze the release button, don't jab it.

5. Extremely long sports lenses with large maximum apertures, such as 300mm or 400mm f/2.8, are extremely heavy. Action photographers usually support them with a monopod.

6. With some subjects you'll get sharp pictures at mid-range shutter speeds (1/250sec) by catching the action at its peak. Examples are footballers jumping to head the ball, a pole vaulter going over the bar, a swallow diver just before the descent.

The foreshortening in this photograph shows that a long lens was used, this makes it easy to expose at the moment the horses' heads come into focus.

Photo: Bretislav Marek

Composition

What exactly do we mean when we speak of pictorial photography? Is it some special category? Could not a press picture, a portrait, even a forensic photograph, qualify for this description? Pictorial awards, nevertheless, are the most sought after in camera club competitions, though I think most clubmen would find it difficult to define and classify. A pictorial shot is usually of a still, or fairly still, subject, and if a person is included, he or she is there as part of the composition, and not as a portrait. A pictorial shot often relies on a beautiful lighting effect, and it is obvious that care has been taken with the fine detail as well as the overall composition. It is also the case that the term is used only among amateur photographers. A professional is more likely to refer to a picture, whatever its subject matter and treatment, as striking, exciting or satisfying.

One thing is certain, however. Even though the serious amateur is conscious of composition in every picture he takes, from sport to portraits, from close-ups to abstracts, he is more concerned with it in his treatment of a so-called pictorial subject.

COMPOSITION

Photographers inherited their views on composition from amateur artists. It happened this way. In Victorian times, every genteel miss, and not a few young men, took up watercolour painting as a desirable social accomplishment. They learned the 'rules' of composition from their teachers. These rules were not laid down by the great masters, who understood and applied composition instinctively, but by art teachers. They examined the great paintings and extracted a number of factors that seemed to recur, and from these formulated a series of rules. By their nature they are somewhat arbitrary, whereas true art knows no bounds. The rules are better described as guidelines, and can be quite helpful to a beginnner.

Linear and colour composition combined.
A studied arrangement of straight and angled
lines strengthened by small red accents.

Photo: Ron Spillman

The 6 x 6cm frame is big enough to maintain high quality, even when composition requires that edges are trimmed in favour of an oblong shape

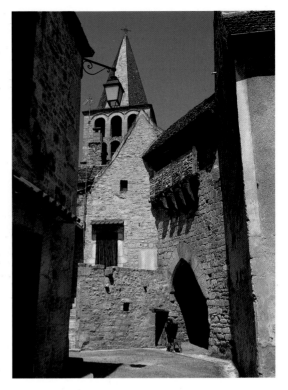

They are:

1. BALANCE
Rather than symmetry.

2. FORMAT
Square is passive. Upright is active. Horizontal is passive, but not as much as square.

3. DIRECTION
Upward movement is more active than horizontal. Diagonal is very active. An off-centre moving subject should aim towards the centre of the frame. If centred, it will be pointing out of the frame. A good composition keeps the eye from straying to the border.

4. PLACEMENT
The commonest aid to composition is The Rule of Thirds. An oblong is divided into nine by two evenly spaced horizontal and vertical lines. In a clockwise direction, the four corners of the centre oblong, A, B, C, D, are strong points. With the main focal point of a view placed ideally on a strong point, it should be balanced by secondary matter on the point diagonally opposite.

5. COLOUR
Warm colours are stronger than cool colours. A small amount of red balances a large area of green or blue. Reds are foreground colours, blues and greens background colours.

6. DETAIL
A few bold masses balancing each other are more satisfying than a mass of irritating detail.

Naturally, there are many subsidiary guidelines, but those are basic. In practice, and when studying the work of good photographers, it becomes obvious that all these guidelines may be successfully ignored. For instance, an upright picture of an old man asleep in a chair is a passive image in spite of the format, and a horizontal shot of a horse and rider taking a fence is active, while a razor sharp picture of a thousand people on a beach can be fascinating rather than

Red and green are complementary colours, and both are enhanced by the dark treetrunk. Being placed centrally, the tree breaks one of the so-called rules of composition, and does it very successfully. Creativity doesn't always follow the 'rules'.

Photo: Bob Green

The Stiperstones, a rocky Shropshire ridge overlooking the Welsh hills. Bold shapes and side lighting are the strength of this picture taken with a 100mm lens from a distance. This has given a good relationship between the two groups of rocks and the hills beyond, FP4 Plus film.

irritating. It is not really a case of rule-breaking. It is simply that the photographer has recognised that art exists between the gaps.

The Victorians, and amateur artists ever since, learned about composition and perspective. The amateur photographer may have attended art classes, but he doesn't have to, as the camera does the drawing for him. In fact, the introduction of the roll-film camera made it possible for many thousands of people, without benefit of art teaching, to indulge in picture-making. This wasn't entirely a good thing, as some appreciation of the building bricks of art help every image maker, whatever the medium, to success.

The important point is that those early photographers did not acquire their sense of composition from teachers who derived rules from the analysis of great photographs. They simply inherited the rules used to guide amateur painters. These have been handed down from generation to generation even though they are not always compatible. The

pictorial photographer needs some different guidelines. He needs a different approach.

CREATIVE CONTROL

Imagine an artist sitting before his subject. Five hundred metres away is a noble tree, and a hundred metres behind that, a house of roughly the same height. At such a distance, tree and house are seen in almost true relationship. For dramatic reasons, the artist chooses to draw the tree taller than the house, and extends one of the boughs to form a frame for the house.

The photographer can achieve the same, or a similar result, by photographic means. By moving closer, and switching to a wide-

angle lens, he can make the tree larger and the house relatively smaller. By moving a little to the left, he can make the bough reach further to the right. By kneeling, he can raise it. This emphasises the importance of viewpoint. You can only control magnification, not perspective effect, by zooming a lens.

At the other extreme, by viewing the tree and house from a great distance, the true relationship is seen. A long focal length lens is then used to fill the frame with the subject, but the impression is entirely different.

This brings us to the relationship between the way we see, and the way the camera sees. Unlike the camera, our eyes are not fitted with lenses of interchangeable focal length. Distant objects appear small, and if they are very distant we cannot see their potential picture value. Look at them through a long lens, however, and relating to each other in unusual ways, and our imagination is stirred. At the other extreme, our eyes cannot cope with a wide-angle effect. If we look across a room and keep our eyes still, a relatively tiny area directly in front will appear sharp.

Although we are not conscious of it, our eyes are constantly wandering around the point of sharp focus to extend our appreciation of that area. The sides of the room are completely blurred at the periphery of our vision and to observe them clearly we have to look sideways. The wide angle lens, of course, can take in the whole view and render it quite sharp at every point.

Both kinds of viewing, the long and the short, are different from our normal vision, but both can open up our minds and introduce a creative element into the way we look at things.

It is interesting that in the early '20s, when Oskar Barnack was experimenting with a small camera to use the only small film then available, 35 mm cine film, he chose a lens of 50 mm focal length, as giving an image close to that we consider normal when viewing from a comfortable distance. Thus, the first Leica cameras of 1924 were equipped with the famous 50 mm Leitz Elmar, originally Elmax (from E. Leitz and the firm's optical expert Max Bereck), and this focal length has been adopted as 'standard' by every lens maker to the present day.

ZOOMING

A good zoom lens speeds up your photography, but it does not necessarily improve it. All too often, a photographer stands before a subject and uses the zoom to fill the frame, when a change of viewpoint would make a better composition. We must remember that viewpoint controls perspective; focal length controls magnification. If you want the best possible picture of a subject rather than a mere record, study it first with your eye, not through the camera. Walk around until you find the best viewpoint. Objects too far apart can be brought closer together by moving round to one side. They can be shown in true relationship by moving farther away, or the difference between them exaggerated by moving closer to one or the other. Only towards the end of this process should you raise the camera to your eye, and begin to confirm or alter your decision by zooming to different focal lengths.

One advantage of having a set of lenses, was that you went to a prejudged distance before attaching the lens you thought might be right for the situation. The lens then gave the right degree of magnification, or did after you changed your distance slightly. A zoom, on the other hand, can control magnification from a fixed viewpoint, and can make a beginner lazy. Its only advantage is that it obviates the need to constantly change from lens to lens.

To sum up: compose with your feet - control image size with the lens.

THE SUBJECT PROPER

A white house stands on a cliff, a few seagulls wheeling in a vast expanse of blue sky overhead. A few wisps of cloud are high on the left, and a tiny wave breaks at the foot of the cliff, down in the right corner. What is the subject proper? Is it the house? If so, it would best be referred to as the central subject, or theme. The subject consists of the picture as finally visualised, consisting of everything you include in the frame, the various objects in relation to each other and including the spaces between them.

Photo: Ron Spillman

Certainly the house is central to the theme, but to call it the subject proper, is to suggest that some of the other objects in the frame are of less importance, and others may have no compositional value at all. In fact, in a perfect composition every element is an essential part of the construction. Remove or displace one, and you detract from the whole. Build your picture only with essential elements. Remove anything that detracts or makes no contribution. This is, of course, a counsel of perfection, and perfection isn't always possible. Nevertheless, you can do a great deal towards achieving it.

By moving the camera a little to left or right, you may be able to get rid of an obtrusive telegraph pole or fence. You can wait a few moments for that wheeling bird to enter the frame top left, and give balance to a strong feature bottom right. By moving a bit lower down a hill, you can shoot under the telegraph wires across the road, instead of having them across the top of the frame. By waiting for the clouds to clear the sun, you can get strong modelling on a subject that would otherwise appear flat. A scrappy skyline can sometimes be eliminated by holding the camera lower and pointing it up a little. This will often give a clear sky background to a portrait. The same irritating

Brass bands are excellent material, provided you home in on the reflections that can be seen in most of the bigger instruments. The black and white buildings of an old town square can be seen in this one. Focus on the brass, but stop well down to get the reflection sharp as well.

Any zoom with macro facility can capture a subject like this. It would seem lifeless without the backlighting on the dew. Early morning is a wonderful time for the observant photographer.

Photo: Ron Spillman

skyline can often be lost by taking a higher viewpoint and looking down, making the ground the background.

Selectivity. 'One wave can depict a whole ocean', a lesson learned from Chinese painting. Similarly, a few ears of wheat can create more atmosphere than a whole field.

SPACE AND WHITE SPACE

I mentioned that not only the objects in a picture, but the spaces between them, all form part of the composition. Those spaces have a strength of their own. They can emphasise distance or diminish it, and in so doing alter the emotional appeal of the picture. In our imagined example a small house is surrounded by vast sea and sky. This emphasises the isolation, the lonely situation, of the house. An old maxim among pressmen is to the effect that if an image isn't strong enough, it wasn't photographed from close enough. The moral is to fill the frame with that 'subject proper'. However, this applies to one kind of picture only, and would be a nonsense if applied to our house. Made large within the frame the sense of isolation

would be lost.

Make full use of space when you compose.

White space is a term used mainly among graphic artists, and refers to the amount of white paper left around an image on the page. The eye is so used to flicking over pages filled with concentrated areas of text and pictorial matter, that an area of white space attracts by its restfulness. In so doing, it can emphasise the picture it surrounds. In photography, we can do the same thing with wide borders, or with a mount. There is no need to accept the ¼ in borders of the usual amateur masking frame. There are frames which can adjust borders up to 2 in, and a 35 mm negative enlarged to 12 × 8 in on 16 × 12 in paper can look far better than enlarging the image to fill the whole sheet.

These fish were seen in a market in Tunisia. The upper crate distracts the eye, and removing it creates a tighter composition.

EMOTIONAL CONTENT

Pictures which evoke an emotional response in the viewer, were probably taken by a photographer with an instinctive response to the subject matter. It is true that you tend to take the best pictures of the things you feel strongly about, or have a great interest in. This is one good reason why those rules of composition are not, in themselves, enough to create worthwhile pictures. I have seen many a picture, and I am sure you have too, where every rule of composition has been applied, and yet the result is eminently forgettable. There has to be an emotional content, something which conveys a sense of beauty, pathos, or what have you.

If we stick to the things we like, rather than those we think the judges will view favourably, we are more likely to impress all concerned. At the same time, we can emphasise our theme by using compositional devices. Think for a moment about some of the terms we use in everyday conversation. To look up to someone suggests respect, courage, importance, and so on. This is why statues of famous people are usually on pedestals, even on horseback. To make us look up to them. We also talk about looking down on somebody, a phrase which suggests inferiority or meanness, rather than small size.

We can increase a person's importance or dignity in a portrait by letting the camera look up at them. The dependance of a small child is stressed by a high viewpoint, emphasising small size. In fact, the effect is best achieved from a slightly high viewpoint, so that the face remains fully visible. It is an error to get right down to the child's level, or the sense of scale is lost. Similarly, clear space around a person suggests a solitary disposition or loneliness, while a small surrounding area packed with business or hobby items indicates a busy person.

Lighting, too, can support an emotional theme. Sunshine or bright surroundings emphasise enthusiasm and pleasure, while deep shadow suggests sorrow or drama. These are all building bricks in picture structuring.

THE OVERLOOK

This does not refer to forgetfulness, but to looking over the entire act of making and taking a picture. One of the first things we all have to learn is to see the whole picture, consisting of everything within the frame, and not just that part of the subject that is of prime interest. One or two examples will make the matter clear.

We are watching someone taking a picture of his girlfriend in the garden. He poses her and focuses carefully, asks for and gets a beautiful smile, presses the shutter release exactly at the right moment. When the pictures come back from the processor, he is dismayed to find the washing line in the next garden coming out of each of his girlfriend's ears, with various articles of clothing flapping on either side. What is more, his camera bag is on the garden path beside her. Not exactly a well arranged composition. Why? Simply because he was so absorbed with his 'subject

The bridge and small area of dappled foliage above it are beautifully balanced by the larger area of sunlit foliage and the reflections at the left. Note that subdued colours are just as effective, sometimes more so, than glaring primaries.

proper' that he didn't see what occupied the rest of the viewfinder. By all means be emotionally involved with your subject. In fact, your pictures would suffer if you were not. At the same time, you must develop the same skill of detachment which every news photographer tries, or should try, to achieve. It means making a practice of treating the viewfinder image not as a glimpse through the lens, but as a flat picture with an oblong margin, just like the picture that will eventually emerge. It takes a little practice, but pays huge dividends in clean and well-constructed images. There is no need to confine the practice to those occasions when you are actually taking pictures. At any spare moment, raise the camera to your eye and examine whatever happens to be nearby.

Arrange an object of central interest, and look around the screen, deciding what can be eliminated or emphasised by a change of viewpoint. It is surprising how quickly you will develop the knack, and how rapidly it then becomes second nature.

Go over the pictures in this section at your leisure taking in a point here and there, and you will soon be applying these principles and guidelines to your own work. We may never be able to give an exact definition to the word 'pictorial', but it - whatever it is - will certainly add strength to your pictures and a keener enjoyment of your photography.

Portraits

INDOORS • **FLASH OR TUNGSTEN** • **HOW MANY LAMPS?**
OUTDOORS • **SUN AND REFLECTOR** • **IN THE SHADE**
POSING • **WEDDINGS** • **CHILDREN**

T his section is divided into two main sections. The first deals with portraiture indoors, the second outdoors, but in either case portraiture falls into two main categories, formal and candid. They are not mutually exclusive. A portrait with a good candid expression may be beautifully lit, and there is no reason why the expression in a formally lit portrait should be confined to the 'Look here, just above the camera, and keep still' variety. Various set-ups, ranging from plain daylight to the use of multiple flash, will be described, and you will find it easy to decide just how far you want to experiment, and how much lighting equipment, if any, you require.

INDOORS

The amateur's studio is usually a room, perhaps with some of the furniture moved out of the way for a portrait session. Few rooms are as large as a professional studio, and where full-length shots are concerned, this limits the number of lighting effects the amateur can employ. In a professional studio there is space to have the model two or three metres from a wide background, and to light the back of the figure as well as the background.

A professional studio is also higher than most rooms, so that top lights on booms may be used, without coming too close to the sitter's head. Perhaps more important, when using a studio-type flash head with a translucent brolly (diffuser) in front, there may be insufficient ceiling height to have the diffuser angled downward at the sitter's face. Nevertheless, an ordinary living room is easily adapted for head-and-shoulder and half-length portraits and, as you can see from the pictures in this section, excellent results can be obtained, even with a minimum of special equipment.

Taken at the long end of a 28-70mm zoom, a close viewpoint and wide aperture have put the background sufficiently out of focus to emphasise the sharpness of the face, but retaining enough of the environment to give a sense of location.

Photo: Phil Dolby

Photo: Ron Spillman

WINDOWS

Even when working professionally, some of my best portraits have been taken with a hand-held camera and the light from a window.

Some rooms are so large and sunny that adequate light is reflected back to the shadow side of the face, and even the wall in the background may be nicely lit. In most rooms, however, the side of the face away from the window is in unrelieved shadow, and the rear wall too dark to give a pleasant feeling of separation from the sitter.

This is where the use of a good reflector comes in. It may be nothing more than a large sheet of white card, perhaps covered with crumpled kitchen foil, or a towel draped over a chair back, though there are advantages to using the commercially-made article. In practice, the reflector is brought closer to the shadow side of the face until the desired amount of fill-in is achieved.

More scope is obtained by adding one artificial light source, either to illuminate the

Naturalist Michael Leach and eagle owl Rocky. The upward glance and low camera angle add a dramatic touch. Colour would have added nothing to this picture.

Lighting a face from below creates a theatrical effect, as if from stage footlights. Here, having the face close to the edge of the frame with a dark area behind, adds a touch of mystery.

background if this is attractive enough not to detract from the portrait, or to use from the rear to give sparkle to the hair, or a rim light to the face. Flash is ideal in colour work, as it has the same colour composition as daylight. Tungsten light may be used, and the yellowness of its light on the background or as a back light on the sitter, can be quite pleasant. It should not be used to lighten the shadow side of the face unless an odd effect is sought. Coloured gels are available with special fittings for the front of some tungsten studio units, and may be combined with a main daylight source to provide a variety of interesting effects.

Photo: Don Maclellan

FLASH OR TUNGSTEN

There are advantages and disadvantages to both forms of lighting. Flash is fast and small apertures are normal, making it ideal for candid or lively portraits. A laugh, or a sudden toss of the head, at a distance of two metres, calls for as fast a shutter speed as a moving car at thirty. The small apertures give enough depth of field to retain sharpness when, with that sudden movement, the head moves back or forward a little. Conversely, the advocate of continuous-source lighting argues that he can obtain differential focusing at wide aperture,

with perhaps just the eyes really sharp, and this is more difficult to achieve with flash. In fact, many studio and even portable flashes have a reduced power switch, allowing larger apertures to be used, which minimises this debatable advantage.

Flashes of either type can be used in conjunction with large brollies or diffusers, again calling for larger apertures.

In one important respect, tungsten studio lamps have a big advantage over the small flashgun as the lighting effect can be studied and arranged down to the last detail. With clip-on flashguns, with or without brollies, some guesswork is involved. Certainly, 500W

Photo: Ron Spillman

studio lamps are far brighter than the 60W lamps which provide a modelling light in amateur studio flashes, but at night, or in a darkened room, the latter are more than adequate, and they do match the effect obtained by the flash. Only in a room with a fair amount of daylight filtering through curtains is it possible that the effect given by the modelling lamps may be modified, usually indicating less contrast than will be given by the flash exposure.

One big advantage of flash, is that a few indoor portraits can be made on the daylight film that is probably in the camera. For tungsten studio lamps you have to switch to the appropriate film or use a bluish conversion filter.

A few top SLRs permit TTL metering of multiple-flash set-ups, provided their own special flash units and leads are used. However, failure often occurs when using a second or third flash with slave unit, to be fired by the TTL flash on the camera. As the slaved units are triggered a fraction of a second after the flash on the camera, the TTL metering will take account only of the first flash. The lighting will be retained, but there will probably be over-exposure. The answer is

A glance over the shoulder gives a sense of spontaneity. Here, the sun provided the rim light and exposure was balanced for the shadow side of the face.

to use a separate flash meter.

HOW MANY LAMPS?

Good portraits may be taken with just one studio light, flash or tungsten, with the aid of a brolly or translucent diffuser, and a reflector. The diffused light will act as modeller, and is best placed in front of the sitter, about 45° to one side, and 45° high. This gives a neat shadow under the nose and bottom lip. Because of the size of the diffused source, there will be no hard-edged shadows on the face, a positive advantage when working with one light only. In fact, the modelling light will also be supplying a partial fill-in to the

Everything about this portrait is right. The diagonal of the body and the tilt of the head. The red shirt emphasising the lip colour, the complementary dark green background, the direct but natural gaze. The coarse grain gives this a painting-like quality.

Photo: Roger Noons

shadows. The reflector may be used, as with the window light, to light-up the shadow side of the face, or it may even be used on the opposite side from the modelling light and partly to the rear, to give modelling to the shadow side of the sitter.

TWO LIGHTS

Using a second light increases the portraitist's scope considerably. It can be used from the rear to backlight the hair and give it sparkle, or on the background to give good separation from the sitter. It is also possible to have one lamp on either side, well to the rear and aimed forward. This gives a strong rim effect on both sides of the face, and the central shadow can be controlled by using the reflector in front. A very striking effect is achieved, often used for actors playing dramatic roles.

Many different effects are possible with

The contrasty black & white technique was ideal for this strong portrait. The photographer used Kodak T-Max 400 film in an Olympus OM-2N with 28mm Zuiko lens. Colour would have lessened the impact of the image, by drawing attention to itself.

two lights and a reflector, but you should always start with just the modelling light, arranging this to best advantage before adding a second light, or even the reflector.

A THIRD LIGHT

With three lamps you can have both a background separation light and a hair light, as well as the main light, but there are two important considerations. In the first place, will you have enough room in a makeshift studio for (a) the sitter with enough separation from the background, (b) yourself and the camera in front, at least two metres

from the sitter if a lens of about 85-100 mm focal length is in use, plus (c) the wide-spreading tripod legs of three lighting stands? In the second place, such a multiple lighting set-up may be good for formal portraiture, where a pose is arranged and usually held, but quite unnecessary for candid shots. In fact, the lighting for candid portraits is best kept simple, to avoid unpredictable, confusing or unpleasant shadows.

I once gave the above advice to a mature student, who considered the matter and then said, with a sparkle in his eye, 'Yes, but I love playing around with all those lights.'

CLASSICAL LIGHTING

There is a classical lighting set-up, used mainly in the past by better class portrait studios, consisting of five lamps. These were as follows: (1) The modelling light, often a huge 1000W lamp, its direct light shielded by a cup in the centre of a dish reflector nearly two metres in diameter. Invariably, this was placed in line with the sitter's face, no matter in which direction it was turned. (2) The fill-in, a smaller lamp in reflector, placed beside the camera, to lighten the shadows. Often, this was a mere 250W. (3) The separation light, used on the background. This was often an adjustable 500W spotlight, and the beam would be widened for full- and half-lengths, and spotted for head-and-shoulder portraits. (4 and 5) Two more adjustable spots, used in various ways, to provide hair and rim lighting from either or both sides. For full-lengths, one of these would sometimes be used on the opposite side from the separation lamp, to help illuminate the background evenly.

Even though the professional studio today might have such a lighting capability, it would probably find only occasional use, as the modern trend in portraiture is towards simplicity, and few amateurs, even where the space and money are available, would enjoy handling such an array of lighting equipment. As for the portraitist with a makeshift, occasional studio at home, where would all that gear be stowed away without causing family upsets?

It is interesting, though, to observe how each lamp contributed something positive to

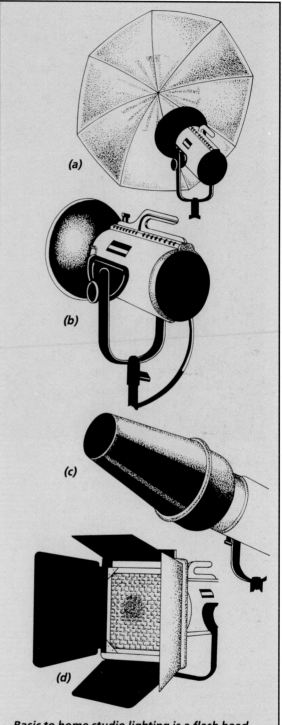

Basic to home studio lighting is a flash head such as this Courtenay unit (a) complete with brolly, to provide a broad diffused light. The ordinary reflector (b), gives sharp shadows, which are confined to a spot area by means of a snoot (c). This silver honeycomb (d) softens shadows and adds a pearly touch to the lighting effect.

Diagram: Colleen Payne

Photo: Ron Spillman

that classical, but now outmoded, form of portrait lighting, and how cleverly our much simpler present-day techniques have been derived from it.

OUTDOORS

It should not be thought that portraits outdoors are in any way inferior to those taken indoors, simply because there are no studio lights or backgrounds. In fact, the great outdoors is also a great natural studio. Learn to use it properly, and it will provide abundant sets and lighting effects. Your entire lighting equipment need consist only of a portable reflector, and perhaps a lighting stand or assistant to support it.

SUN AND REFLECTOR

You cannot move the sun in relation to your sitter, but you can reverse the process by turning the sitter. In this way you can have

This pose is artfully simple. The couple are together, left of centre, but the man is pointing right. The pose has good direction, and was carefully related to the flowers.

anything from frontal lighting with hard, sharp-edged shadows, to backlighting with the face in shadow and a strong light on the hair. In both cases, you might use the reflector in front, either to lighten those sharp shadows, or to reflect light into the shadowed face.

A reflector such as the Variflector folds conveniently to a quarter its size, but springs open taut and ready for use. From a close distance, a reflector can have at least as strong an effect as fill-in flash, especially when it has the sun directly on it, or is of the silvered variety. Move it about, lower or higher, closer or farther from the subject, and it proves to be a very versatile piece of equipment.

If someone is sitting or lying on sand or grass, the reflector can be placed on the

Photo: Neil Humphries

*Let your expression say 'What a lovely child!'
and the parent will usually respond in a
friendly manner. This gives you the
opportunity to take some good dual portraits
as well as close-ups of the child.*

ground, just out of shot, and will reflect back
strongly into facial shadows. On grass it
performs a useful second role, removing the
possibility of a green cast. Although turning
your sitter in relation to the position of the
sun will give many modelling effects, the
change in background has to be considered.
At one point it may be a satisfactorily smooth
area of foliage, at another an irritating view
studded with telegraph poles. Not always will
the best position relative to the sun provide
the best background.

However, experience lightens many loads,
and this also applies to outdoor backgrounds.
After one or two outdoor sessions, you will be
taking note of suitable locations, such as a
courtyard with plain walls on all sides, or a
hillock where a clear sky background is
possible in all or most directions.

IN THE SHADE

On brilliantly sunny days, it is often best to
have your sitter in the shade, especially if light-
coloured walls or other reflective surfaces are
nearby. Some of the quality of the sunlight
then influences the shade, giving a luminosity
to portraits difficult to achieve by other
means. The portable reflector often helps.

A useful trick is to have your sitter in the
shade but with a sunlit background.
By exposing for the sitter, the background
gets a degree of over-exposure. This lightens
it, gets rid of some irritating detail, and gives
good contrast to the outline of the face and
figure. Obvious locations are among trees
bordering a sunlit glade, and on the shadow
side of a sunlit street.

Photo: Martin Pope

Children are most natural when occupied in some pastime, and oblivious of the camera.

POSING

A few basic portrait poses are described here, and it is worth referring to these notes while studying them.

The human frame is divided into sections joined by hinges. The head is connected to the torso by the neck, the chest to the lower trunk by the waist. We also have hinges, or joints, at shoulder, elbows, wrists, knees and ankles. Although rules are made to be broken, limbs never should. We can learn from professional portraitists, who never illtreat a sitter's anatomy! Here are a few guidelines:

CHILDREN

From birth to teenage, child photography is in a class of its own. Sometimes easy, sometimes frustrating, but a successful result is always satisfying. Record the growth, moods and activities of your children over the years and you'll have a priceless set of memories. Here are some essential tips:

BABIES

The great thing about babies is that they don't run around. A touch of wind is fondly interpreted as a smile, and just about any snap pleases the parents. For quality work, though, take more care. If you want a facial close-up with wide eyes, don't have the light source directly in front. The baby will screw up its eyes. Never fire a flash into the eyes, though some folk think it's too fast to have any effect. Eye specialists say the effect of light on our eyes is cumulative, and they wear out like other bodily organs. Bounced flash is far safer.

Photo: Alan Millward

There's an old studio trick to support a baby that is still unsteady when sitting up. A curtain or backdrop is placed immediately behind the baby, and behind this the parent's supportive hands can't be seen.

Babies have beautiful bodies, far more beautiful than the most expensive woollies. Let's produce baby pictures, not catalogue shots of baby clothes!

ACTION CHILD!

What moves faster than an express train or, at least, appears to? Answer: a youngster who's found its legs and is determined to use them! Autofocus will ensure that your active subject is always in focus, but how to keep him or her

Children in most countries love posing for tourists, and their cheeky expressions are among the best shots you bring home. Remember, your best approach is a big smile.

always in frame? Before the child comes into the room or play area put one of its favourite playthings where you want to take the picture. Provided there are no other distractions around, the child will go to this, and have it's attention held long enough for you to take your shots.

TEENS

With some children, the appearance of a camera triggers an instant response - start

123

pulling faces, turn away, express boredom or, worst of all, start posing. A sure way round this parental problem is to photograph the child while intent on one of its favourite occupations, a board or computer game, model construction or reading.

Older teenagers are easier, but pictures of them indulging in some pursuit, anything from flower arranging to aerobics, will avoid that self-conscious expression that kills so many child portraits.

Naturally, when a youngster is old enough to co-operate with you, all the lighting techniques already discussed can be used.

LEISURE PURSUITS

Weddings, birthdays, engagements and family reunions are important occasions. When a professional photographer has been engaged for a wedding he will, or should, be working with a medium format camera. This can produce the very smooth skin tones and very fine dress detail that brides want to see. His rolls of 120 film are usually processed by a laboratory that specialises in weddings and will add diffusion, vignette and other effects, even the bride and groom toasting each other inside a mask shaped like a champagne glass. This professional work is costly, but most couples consider it as important as the reception itself.

The amateur would do well to let the professional get on with his job, and concentrate on the many happy sidelights to the occasion. Outside the church or registry office, a few good shots can be taken of the couple being posed and photographed. At the reception the official photography will tend to follow a pattern, and the results will be a bit posed. This is where the guest with a camera can score, by taking a number of happy and candid pictures, of people at their tables, dancing, chatting, or congratulating the newly weds. A set of pictures like this will be treasured by them, and will often give as much or more enjoyment over the ensuing years than the wedding album itself.

This candid approach to weddings and other family functions does not call for a great deal of equipment. Unless you intend to do some close-up portraits of the couple, you will not need a long lens. Most half-lengths and small groups will be taken with a standard lens, though a wide-angle of 35 mm or perhaps 28 mm will help with groups. The necessary focal lengths may be included in just one zoom, which is really all you need. Mobility is all-important for this kind of photography and, if close-up portraits are not needed, even a good compact camera will suffice.

FLASH AND RED EYE

A problem encountered regularly when taking flash pictures of people in dimly lit interiors is red eye. It is caused by the flash being very close to the axis of the lens. In the dim light people's eyes tend to be dilated. The flash reflects from the blood vessels inside the eye, and the resulting pictures show red spots where the pupils should be. Many flashguns now have a pre-flash feature. A small flash is fired first, which contracts the pupils of the eyes just before the main flash is fired, thus minimising the possibility of red eye. A flash clipped on to a camera is further from the lens than the inbuilt flash of a compact, and a flash mounted on a bracket beside the camera is farther away still. This reduces the incidence of red eye, but the danger increases the farther the subject is from the camera, as the separation between flash and lens will be relatively less. The matter is a little more complicated by the fact that the blood vessels are all round the interior of the eye, not just at the back, so red eye may also occur, though to a lesser degree, when people are not looking directly into the lens.

The ideal way to avoid red eye is to have the flash aimed upwards in the bounce mode or, if the ceiling is too high, off the camera, but connected to it by means of a short lead. Special leads are available for most hi-tech cameras, which retain the dedication. The camera is held to the eye with one hand, the flash raised above the head by the other. If camera and flash are not dedicated, a quick

Every portrait doesn't have to be a close-up. Here, three 'portraits' form one touchingly beautiful composition.

glance upward just before the exposure, will ensure that the flashgun's sensor is aimed properly at the subject.

However, let us not exaggerate this. Red eye doesn't always occur, especially if photography is mainly of couples and half-length groups, with the flash on a bracket. At greater distances, it is far less likely if people are not looking directly into the lens. Best of all, if you are able, take the people you are photographing to a brighter part of the hall. This causes the pupils to contract, and minimises the risk of flash reflection. However, bounce flash is best of all.

WEDDING FILM

Amateurs often ask me if it will be satisfactory to use a very fast print film, of ISO 1000 or 1600, for a wedding. As far as exposure is concerned, flash becomes unnecessary, red eye is avoided, and mobility increased. If the coverage is to be purely candid, there is no reason why not. There may be a problem in getting a fast enough shutter speed and small enough aperture if the sun is shining outside the church, so a slower film may be used at that part of the proceedings.

In artificial light indoors the colour balance will be wrong, but this can be partly corrected in printing. In theory, the best thing to do would be to use an 80B blue filter. This will reduce effective film speed by 1⅔ stops, so a film of ISO 1600 would be equivalent to one of ISO 500, but that could well be fast enough. In practice, though, a paler blue light balancing filter such as the Kodak Wratten 82 or 82A, can be used. There is only ⅓ stop light loss (ISO 1600 to 1250) and filtration at the enlarging stage will correct any residual yellowness.

If a reception is held in the daytime, and the hall is illuminated by both tungsten and daylight, a daylight colour film can be used without a filter, provided the people to be photographed are somewhere near a window, with the daylight on one side, the artificial light on the other. This will give quite pleasing results. A frontal mixture of both light sources should be avoided.

A useful trick when taking a flash shot of several people at a table, is to stand on a chair,

looking down at them at an angle. Not only does this ensure that those at the back are not hidden, it also evens out the exposure and avoids having those at the front over-exposed, and those at the back under-exposed.

CHIEF PHOTOGRAPHER

Getting married is an expensive affair, and it is common for people to spend hundreds of pounds on wedding albums and framed prints. To save money, a couple may decide to dispense with a professional, and ask a knowledgeable amateur friend or relation, to photograph the wedding. If you find yourself selected for this onerous task, make your preparations in advance. The following tips are useful:

1. If there is the slightest risk that your camera may malfunction, or has an erratic fault, get it seen to. If it is battery operated, change the battery rather than take a chance. If you have both SLR and compact, take both.

2. Have fresh batteries in your flashgun, and at least one spare set.

3. Use an ISO 100 print film to ensure smooth skin tones and good detail in the main pictures. Preferably, use the film you know. Carry plenty of it. Think about adding two or three rolls of ISO 400 or faster film, which can be used without flash for candids, in conjunction with the pale blue 82 or 82A filter already mentioned.

4. If you are using a new camera/flash, read the instructions carefully, and see at least one set of results beforehand. It is amazing how many people spoil interior shots by working in the wrong program mode.

A delightful smile and a natural pose. Note how the slightly soft focus adds a romantic touch without losing the all-important detail in the bridal dress.

An intimate moment or a careful pose? Every wedding photographer should capture or contrive such radiant moments.

And here is a list of the essential pictures in any wedding album:

ESSENTIAL WEDDING PHOTOGRAPHS

1. **Half-length, bride alone.**
2. **Full-length, bride alone.**
3. **Half-length, bride and groom.**
4. **Full-length, bride and groom.**
5. **Now add the bridesmaids and page boy.**
6. **Now add immediate family.**
7. **Now add all family and friends .**
8. **Full-length, bride and groom looking over shoulders as they approach the car.**
9. **In the car.**
10. **Receiving guests at reception, ask bride who she wants.**
11. **All speeches and reading the telegrams.**
12. **Cutting cake (make sure knife blade is not fully edge-on to camera, or it will not be seen).**
13. **Bride and groom taking floor for first dance.**
14. **In street clothes, going away.**

There are several other standard shots in professional wedding albums. These include the best man adjusting the groom's buttonhole outside the church, bridesmaids and various groups arriving, bride and groom chatting with friends at reception, groups at tables, close-up of bride and groom toasting each other with arms intertwined. Some professionals visit the home of the bride beforehand to photograph her having head-dress adjusted by mother, putting on the traditional something old and something blue (a garter usually plays a part here).
The amateur wedding photographer's maxim should be: There's safety in preparation. Naturally, many of the tips given also apply to other functions, but it can be seen that a large bagful of equipment is neither necessary nor advisable.

TEN GOLDEN RULES FOR PORTRAITS

1 Traditionally, portraits are head, head-and-shoulders, half-length and full-length, treating each part of the body as a unit. Don't cut off in the middle of a hinge.

2 Don't cut into limbs, hands or feet. In a half-length, fold the arms or bring them up into the frame so that they, and the hands, are seen whole. Kneeling, hugging the knees, or lying down, don't cut off the feet.

3 The standing figure occupies only a thin central section of the oblong frame, and its features are therefore small They can be made larger within the frame, as can the whole figure, by having the sitter seated, even more so, with legs tucked up on a chair or couch.

4 Give movement to your portraits by having the head turned towards the camera over a shoulder, or the upper half of the body swivelled at the waist. This, together with a low angle, dramatises.

5 Use either a plain background, or one that is in keeping with the sitter. Writers feel most at home with their books or word processors, children with their games or studies, cooks in their kitchens.

6 Be careful to have a catchlight in the eyes, reflected from a light source. No catchlight, no bright eyes. A slight lift of the chin can help.

7 Hands must look natural. Self conscious hands can be corrected either by giving them something to do, like clasping each other or arranging flowers, or by asking the sitter to bend the fingers a little, and tap the arm of the chair.

8 A long nose is corrected by a low angle, close-set eyes by a profile or three-quarter pose, short legs by a low angle or disguised by kneeling, extreme height by a high angle, or having the person seated.

9 Full studio make-up, with foundations and lip liners, are seldom used nowadays outside the theatre or film studio. Let your female sitters apply their own make-up, perhaps a bit softer-edged than usual. An Erace stick can be kept handy for camouflaging red spots and unsightly veins.

10 A golden rule for the amateur studio. The photographer may be very interested in equipment and techniques, but shouldn't presume that the sitter is impressed with anything other than the results. Have everything ready before the start of a session, so that you can devote your energies to putting the sitter at ease and capturing good expressions.

Wildlife

LONG SHOTS ● HIDDEN POSITIONS ● SEASONS

W ildlife isn't always wild. Creatures which must be approached with caution in the wilds, or reveal themselves for a few moments only, are easy targets when photographed in zoos. In such situations, your usual optical equipment will cope, and the popular 70-210mm zoom is long enough for most shots. In fact, in wildlife parks you can take shots identical with those taken on photographic safaris across the savannahs of Africa, India and South America.

LONG SHOTS

What is the most useful single lens for wildlife photography? In the opinion of many experts it is a prime 400mm lens, preferably with a maximum aperture no smaller that f/5.6. There is good reason for this. First, the long end of a 70-210mm zoom seems to give all the magnification the novice can imagine - until he or she tries to use it for wildlife. Deer are almost, but not quite, large enough in the viewfinder, and more timid creatures begin to wander off just when a few steps closer would have made all the difference.

Add a 2× converter to the 70-210mm zoom and you get 420mm, but you suffer a loss of transmitted light equal to two full stops. But beware you may also see a noticeable loss of quality depending on the quality of the zoom lens and the extender. Most zooms of 70-210mm have a variable aperture, smaller at the long end. So, if the apertures are f/3.5-4.5 (f/4.5 at the long end), the light loss caused by a 2× converter will leave an effective aperture equal to f/8-11. This gives a poor viewfinder image, difficult for manual focusing. With practically all hitech cameras the autofocus will not operate as the transmitted light is too low. Even more important, just when you need a fast shutter speed to overcome subject movement and camera shake, you'll be confined to slower speeds. Not a disastrous situation if you are confronting a fairly still

A 300mm lens isolates this yawning cheetah (or has he just been stung by a bee?) from a completely out-of-focus background. A perfect example of differential focusing.

Most cats respond to a friendly approach, though a cat that doesn't know you is likely to turn away if a camera is suddenly aimed at it. Raise the camera slowly and keep up the friendly overtures while taking.

You can't always get close to your subject at zoos, but the problem is solved by a long focal length lens. The picture below was taken with a 100-300 mm zoom.

Photo: Paul Mount

The light is usually bright on safaris, so fast shutter speeds are possible even with medium speed films. Some photographers would expose a picture like this at 1/250 sec, panning the camera with the animal to keep it sharp. This would impart a degree of horizontal blur to the grass, which could increase the impression of speed. As both animal and grass are sharp in this picture, it suggests that a shutter speed of 1/1000 sec or faster was used.

subject and using a tripod, but hand-holding will be a risky business at best.

The 400 mm will be the first choice of many specialists, but the occasional wildlife photographer can still take excellent pictures without it. A tripod or monopod will overcome camera shake, and on a bright day an adequately fast shutter speed will be possible.

There are a number of intermediate autofocus zooms on the market, with focal lengths of about 60-300 mm or 75-300 mm, and although the maximum aperture at the long end is usually no greater than f/5.6, they will bring an animal into sharp focus in a fraction of a second. f/5.6 is also large enough to permit action-stopping shutter speeds,

HIDDEN POSITIONS

Most amateurs want to enjoy their photography, and don't take kindly to heavy tripods and portable hides. It's no use relying on luck, though. In some situations, great shots are only possible if you are prepared to carry this extra equipment and sit patiently and quietly for hours on end. This is particularly the case with nesting birds and small mammals such as badgers, otters, rabbits and weasels.

Any dealer can show you hides of different sizes and weights in his catalogues. They are always green, brown or camouflaged, with an opening for the lens, an air vent (essential) and enough space for a stool and an open camera bag.

A strong ball-and-socket tripod head is much quicker in use than a two- or three-way tilt tripod head. This can make all the difference if a bird lands six inches to one side of the spot you are focused on - as they usually do. With the ball-and-socket partially loosened you can re-compose swiftly and fire without having to lock the ball again. Your hands and the tripod will give all the steadiness you need.

A great wildlife picture is a combination of artistry, technical skill, patience, and observation. The last factor is the most important. Only when you observe your subject over a period do you learn its habits and movements, and the time of year when it is active, looks its best, and most important - puts in an appearance! Read about your chosen wildlife, look at good photographs to see how the experts have approached the subject, get to know the habitat and sort out the most likely vantage points.

This doesn't always mean setting up a hide. Some animals are less timid than others and accept the presence of an occasional human being. With a herd of deer, for example, you'll soon discover how close you can get to that invisible circle without disturbing the animals. Step across that line and the deer begin to be nervous. Don't make any sudden movements but, equally, don't freeze and start inching forward. It's a surefire way of letting the deer know you are up to no good! If you are with a companion you don't have to stay silent. An unhurried flow of conversation lets the animals know you aren't stalking them.

All animals are territorial creatures. That applies to your domestic cat as well as to lions, buffalo and elephant. A kingfisher will select a bough or a stanchion above a spot in the stream where small fish are still for a moment, then constantly dive from that spot. Otters and badgers seldom deviate from their runs to and from the water. A bird bringing food for fledglings will always perch on the same twig until its mate leaves the nest to forage. In the wilds, animals visit waterholes at the same time each day, and usually at the same spot. Observe until you know these places, focus on them, and have patience.

Photo: Roger Reynolds

At protected areas along the coast you can get within a yard or two of many bird colonies, so every bird picture does not have to be taken with a long lens.

Photo: Mike Hollist

"Why's he dangling that lamb chop?" Mike
Hollist certainly captured the attention of these
cubs with Tri-X and a 180mm lens on his
Nikon F2.

Outdoor Photography

BUYING A BAG ● **LEISURE PURSUITS** ● **FLASH AND RED EYE**
VACATIONS ● **FILMS ABROAD**

Many an amateur buys a camera bag big enough to take his whole outfit, which may include two camera bodies, a couple of zooms and a converter, a wide-angle lens, exposure meter, two flashguns, one with a slave unit, a compendium of effect filters, copying device, extension tubes, and more. With Velcro'd compartments carefully adjusted, and everything neatly stowed, the outfit looks most impressive, and the owner can close the flap with satisfaction. The satisfaction lasts until that huge outfit is lifted on to a shoulder, and the Compleat Photographer sets out for a photographic location.

This is when he or she comes up against the dreaded complaint known to, and avoided like the plague by, all experienced photographers, namely, shoulder sag. After the first half hour or so, depending on your muscles, you are so occupied by your aching shoulder that you cannot concentrate on the pictorial possibilities that surround you.

The trick is to divide your outfit according to the job in hand. The complete range of equipment can be kept in a large case, or even a cupboard, at home. Many experienced photographers keep it in a large but portable case in the boot of the car. From this is drawn only what you will be needing for the occasion, and this smaller selection is then carried comfortably in a shoulder bag.

BUYING A BAG

The actual size of a shoulder bag should depend on how little, not how much, gear you need for a particular job or outing. It is far too easy to choose something bigger just in case you might need extras. Choice should be made after reading sections 1-4, especially 4. Do you need an extra camera body? An extra lens? Many an amateur will think an extra camera body important, on the grounds that this permits alternate choices of colour or black and white, or colour slide and

Wherever you go, in town or country, you will find traditional crafts being practised. Note how the soft background emphasises the sharp detail of the woodturner and his work.

Photo: Ron Spillman

Provided you get a good window seat on an aircraft, all you need is the moderately wide-angle lens of a compact camera. Wipe the inside of the window, and keep the lens as close to it as possible. This prevents reflections.

black and white, or colour slide and colour print, without having to remove a film and reload. In practice, as has been stated in Section 11, it is not wise to try to switch your thinking from monochrome to colour and back again, in the course of one session of photography. Each medium calls for a different approach and a different pre-visualisation of finished results.

All creative professionals and advanced amateurs recognise this fact. Similarly with lenses. Various combinations are suggested in Chapter 4 , and there are few occasions in general photography where a pair of zooms, say, 28-85mm and 70-210mm, will not serve. Naturally, final choice of this limited outfit will depend on your own approach to the subjects

that interest you, but the principle is the same - travel light. In my early professional days I remember worrying myself, in the presence of a famous photojournalist, as to whether I needed one extra telephoto, or two. 'If you can't take a saleable picture with what you've got', he said bluntly, 'no amount of glassware will help you'.

There are, however, more aspects to buying the right bag than mere size. Some bags are hard, and tend to roll on your hip. Others are unnecessarily cumbersome because of the padding. Unpadded, or very lightly padded bags, usually bend to take the shape of the hip and may be considered more comfortable.

When comparing bags, study the shoulder strap as well as the interior. The strap can make all the difference between comfort and nagging annoyance. Is it wide enough, and what sort of non-slip provision has been made? Some straps are provided with a slip-on or button-on foam pad. These are sometimes too thick to be stable, or are too smooth to prevent slipping. One firm even makes an enormously thick accessory shoulder pad 'ergonomically designed' but not very practical. The best kind of strap has a stitched on or woven in series of rubber strips. These hug tight to the shoulder, and stay there.

VACATIONS

Are you going on a photographic expedition, or a holiday with a camera? They are two different things, and the wrong approach can spoil your enjoyment and that of the people you are travelling with. A professional on location may need two or more cameras and quite a few lenses, as well as a heavy tripod and other items. He will have portable reflectors for outdoor work with models, possibly a multi-flash outfit, and perhaps twenty or more effect filters. Just as much to the point, he may also be equipped with an assistant to carry and load for him.

His trip will have been planned with the sole purpose of photography. He may be required to photograph models in exotic locations in which case he will be part of a team including models, a dresser, make-up artist and an art director. Even if he is

producing landscapes to illustrate a magazine article on a certain area, every stage of the trip will have been planned in advance, probably with the assistance of the local tourist board, and transport arranged. He may even wait a day or more just to get a particular view by dawn light or sunset.

Naturally, the photographer on vacation can seldom go to such lengths. If he is on a package holiday, he will probably be relying on day trips for a change of scene and, if it is a package tour, other members of the party will almost certainly be cluttering up the scene just when he had hoped for a deserted view! We have all suffered from it. All the same, it is amazing how many good shots you can get by travelling on the edge of the crowd, as it were, and being alert to pictorial opportunities as they occur.

This is one good reason for not weighing yourself down with a mass of equipment you are unlikely to be able to use. Better to be

Extreme sharpness is essential in a picture which depends on fine detail. Especially in a shadowed location, a portable tripod is worth its weight in successful results.

prepared for the good pictures that are always there for a seeing eye and a ready camera. On a personal note, for holiday colour photography I have learned to carry an SLR with 28-80 mm zoom on my chest, with a polariser on the lens. In a shoulder bag I have a 70-210 mm zoom, also with polariser, plus a matched 2 × converter and plenty of film. Although I could find use for a 24 mm wide-angle lens, I leave this behind in the interests of lightness and a quicker choice of lenses. For the same reasons, I do not have skylight filters on the lenses. In any case, the lenses have a UV absorbing element, as do the polarising filters.

FILMS ABROAD

Film bought abroad is usually more costly than at home. Though it will be fresh if bought from a store with a good turnover, in out-of-the-way resorts it may have been stored on a hot shelf and be very close to the expiry date. This is why the wise photographer will carry plenty of film with him, all bought at the same time and preferably with the same batch number on the cartons.

This brings us to the thorny problem of X-ray scanners at airports and other ports of entry. X-rays can fog your films, but there are precautions you can take to avoid this. In the first place most, but not all, resort countries have agreed on a ceiling dosage of X-rays. At most customs points you will see a notice by the scanner: 'Safe for films up to ISO 1000'. What they do not tell you is that the effect of X-rays is cumulative, so your ultra fast films need go through only two scans to be at severe risk. This is one good reason for carrying only ISO 100 film.

While we are still on the bad news,

Don't put the camera away in bad weather. This was taken in squally rain and gusting wind, with the camera supported on the sea wall. The exposure was around 1/30 sec with the lens at full aperture.

although you can always ask for your film to be examined by hand, a busy official is not always prepared to do this. If you insist, you may be asked to remove every cassette of film from its carton. Special bags incorporating a thin lead layer are sold to protect films from X-rays, but experiments cast doubt on their usefulness. In recent U.K. and U.S. studies it has been found that even using a full range of film speeds up to 3200 there is no X-ray damage even in the case of repeated X-ray inspections. It is also good practice not to load the camera until you are on plane or ship.

If you are using print film you can avoid X-ray damage to your films on the way home, simply by having them processed at a minilab. Minilabs are common in most resort towns, and once the film is processed it can come to no harm. Processing is more costly abroad, but you may consider it a justifiable expense.

Photo: Lewis Woodhouse

As the sun moves across the sky the modelling on the rocks changes. This was taken at the right time of day to show the contours and textures of the tree and rocks. When touring, it isn't always possible to wait for hours, but the professional or advanced amateur knows that pictorial excellence often means playing the waiting game.

Close-Up

**CLOSE-UP LENSES ● EXTENSION TUBES ● MACRO LENSES
BELLOWS UNITS**

The closest focusing distance of most SLR standard lenses is about 0.4m, which gives an image about one-seventh lifesize. In other words, an object 7cm long will be 1cm on the film. This is called an image ratio of 1:7. Note that the first number refers to the image size, the second to the subject size. An easy way to remember this, is to read it as a fraction, in this case 1/7th. Magnifications larger than life-size are sometimes expressed differently. For example, ten times life-size may still be written 10:1, but more often as $10 \times$. A true macro lens will reproduce the image life-size (1:1) or half-size (1:2). By attaching supplementary close-up lenses or extension tubes to the ordinary camera lens, image ratios down to 1:1 and beyond can be achieved. For even greater magnification we can insert bellows between camera body and lens, obtaining 3:1 (three times life-size) or more. The greatest magnifications call for the use of a microscope.

Most photographers refer to any kind of close-up work as macro, an abbreviation of photomacrography. The term macro does not in practice have a strict definition, however most dictionaries refer to macro as 1:1. Anything closer than the normal closest focusing distance of the lens can be called close-up, whether or not supplementary devices are used. For convenience, we can say that macro is from one-third life-size to about twenty times (1:3 to $20 \times$), at which point photomicrography takes over.

In practice, most amateurs are content if they can get close enough to photograph a single bloom, a page from a book, and occasionally a 1:1 picture of a postage stamp. Many zoom lenses have a macro setting, and though this may go down only to 1:4 or thereabouts, it is enough for most purposes.

CLOSE-UP LENSES

Supplementary close-up lenses are the easiest way to get closer to your subject. They are small and light, occupying very little space in a

Taken with a 55mm macro lens, this could have been a plain record shot of a snail. The creative photographer lit the large green leaf from behind, and was rewarded with a brilliant eye-catching study.

Photo: George Rhodes

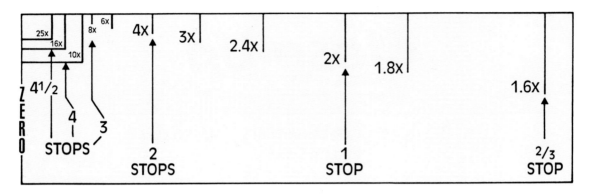

ZERO

0 STOPS
25x 16x 10x
6x 8x
4x 3x 2.4x
4¹/₂
4
3

STOPS

2
STOPS

2x 1.8x
1
STOP

1.6x
2/₃
STOP

Put the scale in the subject plane. It must be aligned with the camera, horizontal or vertical, with the zero line touching the short edge of viewfinder image. At the opposite edge, read off the exposure increase factor.

camera bag, and are quickly attached to the front of the camera lens, just like a filter. They are also cheaper than other close-up devices. They come in different strengths, or dioptres. Some makers call them simply No.1, No.2, No.3 and so on, and provide a leaflet informing you of the degree of magnification, or just show a series of illustrations of a subject taken without, and then with, the various lenses. The numbers, however, are usually the same as the dioptres, which other makers express as +1, +2, +3 and so on. The German filter makers B+W designate their supplementaries as NL1 etc, the letters standing for nahe linse (near, or close-up, lens).

The easiest possible way to decide which close-up supplementaries will suit you best, is to visit a camera store and try them out on your camera. There's nothing like hands-on, or in this case eye-on, experience. The thing to remember is that when the close-up lens is fitted to your camera lens, with the latter set at infinity, focus will be sharp at a distance equal to the focal length of the close-up lens. This holds good whatever the focal length of the camera lens. It is quite easy to determine. Simply divide 100 by the dioptres of the close-up lens, and you know the correct distance

Supplementary close-up lenses and extension tubes give all the magnification most photographers need, but for optimum quality in extreme close-up work, there are bellows units and special lenses corrected for given ranges of magnification.

between the subject and the lens on your camera in centimetres. Thus:

+2 = 100cm ÷ 2 = 50cm
+3 = 100cm ÷ 3 = 33.3cm

This is particularly handy if you have a compact camera that can be focused manually. All you do is tie two knots in a length of string, the distance between them being the focal length of the close-up lens. Use a thumb to hold one knot under the front surface of the lens. Frame the subject in the viewfinder, and extend the other knot to the important point of focus on the subject. Drop the string and fire.

A great advantage of supplementary close-up lenses is that, unlike extension tubes or bellows, they do not lessen the brightness of the image reaching the film, so no exposure increase is necessary. True, TTL metering automatically adjusts the exposure time (aperture priority mode) or lens aperture (shutter priority mode), but neither are desirable in close-up photography. At very close range, the slightest movement of either

Subject-to-lens distance in cm	Focal length in cm	Depth of field in cm at an aperture of:					
		f/5.6	8	11	16	22	32
90	3.5	82-99	79-103	76-110	71-122	66-141	59-190
	5-7 5	85-96	83-99	80-103	76-110	72-120	66-141
	10.5	86-94	85-96	83-98	80-103	77-108	73-119
	15	76-65	76-87	75 986	69-30	70-94	66-102
80	3.5	75-87	72-91	69-95	65-105	61-118	55-150
	5-7 5	76-85	74-87	72-90	69-95	66-103	61-117
	10.5	77-83	76-84	75-86	73-90	70-94	66-102
	15	78-82	77-83	76-84	75-86	73-89	70-93
70	3.5	65-75	63-78	61-81	58-88	55-97	50-117
	5-7 5	67-74	65-75	64-77	61-81	59-86	55-97
	10.5	68-72	62-73	66-75	64-77	62-80	59-85
	15	68-72	68-72	67-73	66-74	65-76	63-79
60	3.5	57-64	55-66	53-68	51-73	48-79	45-92
	5-7 5	58-63	57-64	55-65	54-68	52-72	49-79
	10.5	58-62	58-62	57-63	56-65	54-67	52-71
	15	59-61	59-61	58-62	57-63	56-64	55-67
50	3.5	48-53	47-54	46-55	44-58	42-62	39-70
	5-7 5	49-52	48-53	47-54	46-55	44-58	42-62
	10.5	49-51	49-52	48-53	47-54	46-55	45-57
	15	49-51	49-51	49-51	48-52	48-53	47-54
40	3.5	39-42	38-42	37-43	36-45	36-45	33-51
	5-7 5	39-41	39-42	38-42	37-43	35-47	35-47
	10.5	39.4-40.3	39.2-41	38.8-41.4	38.3-42	37.7-42.7	36.7-44
	15	39.8-40.2	39.7-40.25	39.5-40.7	39-41.2	38.8-41.5	38-42.2
30	3.5	29-31	29-31	28-32	28-32	27-34	26-34
	5-7 5	29.5-30.8	29.2-30.9	29-31.2	28.5-31.7	28-32.4	27.3-33.7
	10.5	29.7-30.3	29.6-30.5	29.4-30.8	29.3-31	28.8-31.3	28.3-32
	15	29.8-30.2	29.7-30.3	29.6-30.4	29.5-30.5	29.3-30.7	29.1-31
20	3.5	19.7-20.4	19.5-20.5	19.3-20.7	19-21	18.7-21.5	18.3-22.2
	5-7 5	19.9-20.2	19.7-20.4	19.5-20.6	19.3-20.7	19.2-20.9	18.8-21.4
	10.5	19.9-20.1	19.9-20.2	19.8-20.3	19.7-20.4	19.6-20.4	19.4-20.6
	15	19.9-20.1	19.9-20.1	19.9-20.1	19.9-20.1	19.9-20.2	19.8-20.2

the camera or the subject can spoil the picture, so a faster shutter speed is advisable. Also, depth of field is extremely shallow, so the smallest lens aperture is safest.

People often argue about the difference in optical quality that can be obtained with supplementary close-up lenses and extension tubes. In fact, an ordinary camera lens, whether of single focal length or a zoom, is computed to give its optimum performance at infinity. With all but the most expensive, the closer they are focused the less well corrected the residual aberrations become. The actual loss of quality is very small, and only has any significance at very close range, and even then most people would not detect any lack of sharpness. It has been pointed out that a supplementary alters the lens design, so some deterioration is to be expected, while extension tubes, which fit between the camera and the lens, merely extend the lens, and therefore have no effect on optical performance. However, lenses are designed for minimum subject distances of several focal lengths and some loss of image quality is likely.

In fact, the loss of correction with the lens extended is roughly equal to that caused by the supplementary lens. Neither can equal the superb quality obtained with a true macro lens, but with the camera lens stopped down to about f/8 or f/11, both are quite satisfactory for all but the most technical photography. Perhaps the greatest advantage of close-up lenses is that they still work with autofocus camera lenses.

A supplementary close-up lens is quite simple to grind and polish, so there can be little difference in performance between the best-known makes. The very best, such as those supplied by Canon and one or two other top camera makers, consist of a cemented doublet rather than a single element and give significantly better quality.

Above left; with a standard lens at its closest focusing distance. Above right; with Cokin 101, and right; 102 supplementary close-up lenses added.

EXTENSION TUBES

These are usually bought as a set of three, in three lengths, though sets of four are available. One or more is fitted between lens and camera, and the greater the extension the closer the focus. Used alone, the shortest tube will give a magnification of about 1:3, up to 1:1, or life-size, when all three are used together. Three types of extension tube sets are available. The simplest are non-auto, so you have to set the lens aperture by hand for each exposure. Next come auto tubes, which transmit aperture stop down signals to the lens. Finally, supplied by the makers of hi-tech, fully programmed cameras for use with specific models and lenses, are fully dedicated extension tubes. If you are buying for the first time, ask a knowledgeable dealer for advice on choosing the right tubes for your own camera. At the time of writing, extension tubes giving a bright enough image with autofocus lenses are still on the drawing board, so focusing has to be done manually.

As the distance between lens and camera body increases, the inverse square law comes into effect, calling for a proportional increase in exposure. At 1:1, for example, where the lens is at twice its focal length, four times the exposure is required, that is, two stops wider or two shutter speeds slower. A TTL metering camera will allow for this automatically, but with non-TTL cameras an exposure increase factor is required. This is given in the instruction leaflets supplied with the tubes. If you do not have this, then rather than refer to tables, simply set up the camera, compose and focus the subject with the extension tube or tubes in place, then place the scale chart in the subject plane. It must be aligned with the camera, horizontal or vertical, and the zero line must touch the left-hand edge of the viewfinder image. At the right-hand side you can read off the exposure increase factor required.

As you can see from the depth of field chart, the zone of sharp focus is tiny with extreme close-ups, so it will usually be better to increase the exposure time rather than use a larger aperture. First, determine the exposure with a hand-held meter. Obviously, a $6 \times$ factor applied to 1sec would be 6sec, but with faster speeds, simply multiply the speed by the increase factor. Thus, $6 \times 1/125$ sec = 6/125 or 1/20sec. If the exposure is being made by flash, you can open the shutter on B or T in a darkened room, fire the flash the requisite number of times, then close the shutter.

Photo: Mike Travers

MACRO LENSES

A true macro lens, like a good enlarging lens, is computed to give its optimum performance at close distances, but it is only necessary to add one to your kit if you require the utmost in optical correction. For close-ups of flowers, any kind of creative work, or copying the occasional page of type, stopping the camera lens well down and using a supplementary close-up lens or extension tube is quite satisfactory.

To obtain optimum sharpness in close-ups, a genuine macro lens is best. On a 35mm camera, a macro lens of 90mm, 100mm or 105mm will give the same magnification as a 50mm lens, but from twice the distance, so the subject is less likely to be disturbed. This picture of a male Brimstone butterfly was taken, in fact, with a 135mm macro lens and extension tubes on a 6 x 7cm camera.

Macro lenses for 35 mm SLRs are normally 50 mm or 100 mm, will focus down to 1:2 or half life-size, or 1:1 with the addition of a specially matched optical component. If you have the opportunity, examine the image with both focal lengths before choosing. Most natural history photographers prefer the 100 mm macro. This gives the same image size as the 50 mm, but from twice the distance. There are two great advantages. The perspective will not be so acute, and the lens, being at a greater distance, is less likely to scare away the bee you have been focusing on.

The better macro lenses incorporate a moving group generally known as a floating element, which moves as the lens is focused. This keeps residual aberrations at their lowest, whatever distance is focused on, so distant shots are as sharp as when photographed through a normal lens. Such a macro lens can be used with confidence to replace a lens of similar focal length but conventional design for general photography. A good macro costs a fair amount of money, so before buying it is worth asking whether a floating element is

A 135 mm lens with supplementary close-up attachment on a 35 mm SLR filled the frame with this dandelion clock. Was the escaping seed natural or contrived? Whichever, it provides added interest and combines with the backlighting to produce a fine composition as well as a good example of textural rendering. An obliging helper holding a coat as a windbreak will overcome movement caused by the slightest breeze.

incorporated. If the dealer doesn't know, the manufacturer or importer will.

BELLOWS UNITS

This is a bellows running on a track, and like extension tubes, fits between camera body and lens. Greater magnifications can be achieved than with supplementary lenses or tubes. Bellows units vary enormously in their degree of sophistication. With the simplest, the lens will have to be stopped down manually, but the more sophisticated will work automatically, with the appropriate camera, transmitting stop-down and other signals to the lens.

Photo: Jonathan Plant

Extension of 150 mm is normal, and magnifications up to about 2 × using a standard lens. As a normal camera lens performs least well (but adequately) at extremely short distances, the user is often advised to use it in a reversed position, for which special adaptors are available. However, in the reversed position, the stop-down mechanism of the lens cannot be operated through the bellows unit. Either the lens has to be stopped down manually after focusing, or, in some cases, a special twin cable release can be used. A single pressure will stop down the lens to the pre-set aperture, then fire the shutter.

When working with the lens a few inches from the subject, focus is affected by the slightest movement, and sharp focus can be lost simply by tightening a locking knob on a cheaply machined bellows unit. This is one area where it pays to pay more. Also, it can be maddeningly difficult, if not impossible, to vary the distance between subject and lens by a few millimetres, by shifting the legs of a tripod. The answer is to use a focusing stage. This is incorporated in the best bellows units,

The frog was taken from a distance with a 135mm lens, extension tube and flash. The lighting is flat but every tiny detail shows.

but for others can be purchased separately. It fits under the bellows rail, providing a rack-and-pinion bed along which the camera and bellows can be moved smoothly back and forth, adjusting the focus as desired.

Focusing can sometimes be a problem when using bellows fully extended indoors in ordinary lighting, and a powerful torch or other light source placed close to the subject can be a great help. If your bellows/camera combination is such that TTL exposure can only be achieved in the stop-down mode, it may not function at the small apertures necessary for extreme close-ups. For that eventuality, the bellows unit has a scale showing the exposure increase factors at various amounts of extension, with the focal length lens you are using.

For the best possible definition, makers of the top cameras provide special lenses for use on their bellows units, but these are extremely expensive.

Photo: Peter Watson

An 85mm lens with extension tube was used on an Olympus OM-1 to capture this Indian Moonmoth larva.

Backlight enlivens this shot of a sawfly larva in alarmed posture, while the shadowed background strengthens the outline of the subject. For these reasons, it is sometimes best to shoot against the light, using a reflector or reduced power flash to fill in at the front.

Photo: Richard Revels

Photography at Night

EXPOSURE METERING ● COLOUR ● RICH BLUE SKIES

The latest fast films have made it possible to take handheld pictures at night, but for certain kinds of picture a tripod and a longer exposure are still necessary. Obviously, at a brightly lit circus or tattoo, the fast film enables you to shoot at speeds fast enough to stop the action, and every detail of the performers should be visible. At the other end of the scale, a moonlit landscape calls for a tripod as exposures can run into a minute or more. For some night shots TTL metering, or the use of a separate exposure meter, will ensure correct exposures, but in other cases it is safer to use an exposure table, such as the Kodak one printed here.

EXPOSURE METERING

As described earlier, even the most sophisticated meter cannot think. It can merely average the various brightnesses in the subject and give an exposure that will be right for a mid-tone. This is fine if the subject contains a fairly even distribution of light and dark areas. If the important part of the subject is quite small, and dark, against a large, bright background, the meter would indicate too brief an exposure, and in the resulting picture the subject would be too dark. Conversely, if the important part of the subject is small but bright, against a large, dark background, the meter would indicate too long an exposure, and the subject would be over-exposed.

The latest hi-tech cameras have metering systems designed to overcome such problems. The evaluative metering which Canon introduced with the EOS range recognises the difference in brightness between the main subject and the surrounding areas and makes suitable compensation. It is geared to the principle that, more often than not, correct exposure is needed in the part of the scene you want in focus. The matrix metering introduced in Nikon's

To obtain a velvety dark blue sky, wait until the sky is almost, but not quite, black. The long exposure needed for the foreground will be sufficient to lighten the sky slightly. Note the streaked car headlights caused by the long exposure.

Photo: Keith Vaughan

remarkable F801s takes account of frontal, side or backlighting, feeds this information to its memory banks, then decides (a) where the main subject is in the frame, and (b) whether it occupies more than one position, after which it balances all the data. The F801s in fact, is the exception to what has been said about using an exposure table. Not only can it take flash fill-in into account, but in extreme situations, such as a few lights showing across water, or a moonlit landscape, it will ignore those inky shadows which are, in any case, beyond the ability of the film to record.

With some night scenes, which include a few brightly-lit areas near streetlamps, and larger areas which are much dimmer, spot or partial metering aimed midway between the brighter and darker areas would be best. Average metering could be over-influenced by the darker areas, and give too much exposure. Typically, the night atmosphere is lost, and the scene looks as though some daylight or other general illumination were present.

With the sun hidden, a straight meter reading has produced a sunset with deeply saturated colours. Taken with a 28-70mm zoom on a Canon A1. Fujichrome Velvia film.

The advantage of a good exposure table is that the indicated exposures have been arrived at in practice, and will retain the atmosphere natural to the subject. The table overleaf gives thorough definitions of the various lighting levels, but these will inevitably differ a little from venue to venue. Although the indicated exposures will ensure a result, some photographers will decide to bracket certain shots, i.e., take one at the indicated exposure, then two more, one at half a stop less, the other half a stop more.

COLOUR

Colour slide films are made in two types, one balanced for daylight and electronic flash, the other for tungsten lighting. Outdoors at night, the tungsten film will give a natural colour rendering. Daylight film will give a

Photo: Martin Langer

Exposure was metered for the darkening sky, but flash on an extension cord was used from the left to put detail into the scarecrow's dark clothing.

much yellower image, which is fine for the lights themselves, buildings, shop fronts and so on, but if faces are prominent in the frame, these will appear quite reddish. One advantage of daylight film, however, is that flash can be used to illuminate people in the foreground.

Slide films such as Fujichrome Provia 1600 and Kodak Panther 1600 give yellowish, but acceptable, results for night photography of moving subjects. As far as print films are concerned, the fast films of ISO 1000, 1600 and 3200 are all balanced for daylight. If people are prominent in the pictures, a pale blue 82A filter (KB 1,5, Cokin 025) can be used. This calls for only a small increase in exposure of one-third. It is certainly to be recommended when shooting with print film at indoor shows, and will later help the printer achieve a satisfying colour print.

RICH BLUE SKIES

If the sky is to be included in a night scene, especially in a city, a dark, rich blue is preferable to unrelieved blackness. The trick here, is to wait half an hour or so after sunset, until the light in the sky has almost, but not quite, gone. It will then have just enough strength to register as dark blue. Your eye will tell you when the right moment for the exposure has arrived, but do not be misled into shooting too soon. Nothing looks worse than a night shot which is properly exposed from the horizon down, but with a light sky. However, for street scenes where the sky is excluded, it can be an advantage to shoot before the light in the sky has fully faded. The main illumination, and therefore the atmosphere, will be provided by the street lighting, but there will be a useful trace of fill-in from the remaining daylight.

GUIDE TO NIGHT EXPOSURES

	SUBJECT	FILM SPEED
		ISO 64/19° to ISO 100/21°
AT HOME	• Home interiors at night: Areas with average lighting	1/4 s f/2.8
	Areas with bright lighting	1/15 s f/2
	• Candle-lit close-ups	1/4 s f/2
	‡ Indoor Christmas lights and Christmas trees	1 s f/4
OUTDOORS AT NIGHT	‡ Outdoor Christmas lights and Christmas trees	1/30 s f/2
	‡ Brightly-lit city street scenes (wet streets and interesting reflections)	1/30 s f/2
	‡ Neon signs and other lighted signs	1/30 s f/4
	‡ Shop windows	1/30 s f/2.8
	‡ Subjects lit by street lights *	1/4 s f/2
	‡ Floodlit buildings, fountains, monuments	1 s f/4
	‡ Brightly-lit illuminations	1/30 s f/2.8
	‡ Skyline - distance view of buildings with lit windows at night	4 s f/2.8
	‡ Skyline - 10 minutes after sunset	1/30 s f/4
	‡ Skyline - just after sunset	1/60 s f/4
	‡ Moving traffic on motorways, bridges, flyovers, etc - light patterns	20 s f/16
	‡ Fairs, amusement parks, illuminations	1/15 s f/2
	‡ Fireworks - displays on the ground	1/30 s f/2.8
	‡ Fireworks - aerial displays (keep shutter open on B for several bursts)	f/8
	‡ Lightning (keep shutter open on B for one or two streaks of lightning)	f/5.6
	‡ Campfires, bonfires, etc.	1/30 s f/2.8
	‡ Subjects lit by campfires, bonfires	1/8 s f/2
	• Night football, night tennis, speedway, greyhound stadiums *	1/30 s f/2.8
	‡ Moonlit landscapes *	30 s f/2
	‡ Moonlit snowscenes **	15 s f/2
INDOORS IN PUBLIC PLACES	• Bowling, show jumping, ice hockey	1/30 s f/2
	• Boxing, wrestling	1/60 s f/2
	• Circuses, stage shows, ice shows: floodlit acts	1/30 s f/2
	‡ Well lit art galleries and museums	1/8 s f/2
	† Interiors with bright fluorescent light	1/30 s f/2.8
	• School performances - stage and auditorium	–
	• Swimming pool - tungsten light indoors (above water)	1/15 s f/2
	• Hospital nurseries/delivery rooms	1/30 s f/2
	• Church interiors - tungsten light	1 s f/5.6
	† Stained glass windows, daytime - photographed from inside	Use 3 stops more
	† Glassware in windows, daytime - photographed from inside	Use 1 stop more

ISO 125/22° to ISO 200/24°	ISO 250/25° to ISO 400/27°	ISO 500/28° to ISO 800/30°	ISO 1000/31° to ISO 1600/33°
1/15 s f/2	1/30 s f/2	1/30 s f/2.8	1/30 s f/4
1/30 s f/2	1/30 s f/2.8	1/30 s f/4	1/30 s f/5.6
1/8 s f/2	1/15 s f/2	1/30 s f/2	1/30 s f/2.8
1 s f/5.6	1/15 s f/2	1/30 s f/2	1/30 s f/2.8
1/30 s f/2.8	1/60 s f/2.8	1/60 s f/4	1/60 s f/5.6
1/30 s f/2.8	1/60 s f/2.8	1/60 s f/4	1/60 s f/5.6
1/60 s f/4	1/125 s f/4	1/125 s f/5.6	1/125 s f/8
1/30 s f/4	1/60 s f/4	1/60 s f/5.6	1/125 s f/5.6
1/8 s f/2	1/15 s f/2	1/30 s f/2	1/30 s f/2.8
1/2 s f/4	1/15 s f/2	1/30 s f/2	1/30 s f/2.8
1/30 s f/4	1/60 s f/4	1/125 s f/4	1/125 s f/5.6
1 s f/2	1 s f/2.8	1 s f/4	1 s f/5.6
1/60 s f/4	1/60 s f/5.6	1/125 s f/5.6	1/125 s f/8
1/60 s f/5.6	1/125 s f/5.6	1/125 s f/8	1/125 s f/11
10 s f/16	10 s f/22	10 s f/32	5 s f/32
1/30 s f/2	1/30 s f/2.8	1/60 s f/2.8	1/125 s f/2.8
1/30 s f/4	1/30 s f/5.6	1/60 s f/5.6	1/125 s f/5.6
f/11	f/16	f/22	f/32
f/8	f/11	f/16	f/22
1/30 s f/4	1/60 s f/4	1/60 s f/5.6	1/125 s f/5.6
1/15 s f/2	1/30 s f/2	1/30 s f/2.8	1/60 s f/2.8
1/60 s f/2.8	1/125 s f/2.8	1/250 s f/2.8	1/250 s f/4
15 s f/2	8 s f/2	4 s f/2	4 s f/2.8
8 s f/2	4 s f/2	4 s f/2.8	4 s f/4
1/60 s f/2	1/125 s f/2	1/125 s f/2.8	1/250 s f/2.8
1/125 s f/2	1/250 s f/2	1/250 s f/2.8	1/250 s f/4
1/30 s f/2.8	1/60 s f/2.8	1/125 s f/2.8	1/250 s f/2.8
1/15 s f/2	1/30 s f/2	1/30 s f/2.8	1/60 s f/2.8
1/30 s f/4	1/60 s f/4	1/60 s f/5.6	1/60 s f/8
1/15 s f/2	1/30 s f/2	1/30 s f/2.8	1/60 s f/2.8
1/30 s f/2	1/60 s f/2	1/60 s f/2.8	1/125 s f/2.8
1/30 s f/2.8	1/60 s f/2.8	1/60 s f/4	1/60 s f/5.6
1/15 s f/2	1/30 s f/2	1/30 s f/2.8	1/30 s f/4

xposure than for the outdoor lighting conditions

xposure than for the outdoor lighting conditions

General Note:
Always use a tripod or other firm support for shutter speeds slower than 1/30 second.

***** *When the lighting provided is mercury-vapour lamps, you will get the best results by using Daylight type film for colour slides. However, the slides will appear greenish. Use an FL-D filter.*

****** *For scenes lit by the unobscured full moon to show full detail in the surroundings. Do not include the moon in the picture, since it will move appreciably during the exposure.*

• *For colour slides of these scenes, use Tungsten type film for the most natural colour rendering. Daylight colour film can also be used, but slides will look yellow-red.*

† *For colour slides of these scenes use Daylight type film. Tungsten type film can also be used with a No. 85B filter over the camera lens. When using this filter give 1 stop more exposure than that recommended for Daylight type film in the table .*

‡ *For colour slides of these scenes, you can either use Daylight or Tungsten type film. Daylight type film will produce slides with a warm, yellowish look. Tungsten type film will produce slides with a cold, bluish appearance.*

Technical Section

THE DARKROOM ● BLACK & WHITE PROCESSING
COLOUR PROCESSING ● DUPLICATES & NEGATIVES
PRESENTING PICTURES ● SELLING PICTURES
FILE FOR THE FUTURE

Every amateur's ambition is to have a fully equipped darkroom with running water, and used for no other purpose. A spare room, even a small boxroom no larger than 2 x 3 m will serve, but in many cases the room just isn't available, and he has to be content with occasional use of the bathroom or the bedroom. I have worked in all sorts of darkrooms, from the aforementioned bathroom to professional Fleet Street labs and know that, with care and proper equipment, just as good prints can be made in the former as in the latter. The three advantages the professional enjoys are the space to make big prints, easy temperature control, and more rapid drying and finishing. There are two essentials which even the most skilled amateur does not always achieve. These are total darkness, and good ventilation.

LAYOUT

Ideally, a darkroom should have separate dry and wet benches. That is, one side for the enlarger, frames, printing papers and all printing accessories, the other for chemicals, dishes and tanks, and washing facilities. However, many a maker of superb prints carries the prints in a dish of water from bedroom to bathroom or kitchen for washing and drying.

If films only are to be processed, then a darkroom is not necessary. The film can be loaded into the tank inside a light-tight changing bag, after which processing may be carried out in room lighting. Even easier is to use a Jobo daylight developing tank. The film cassette is dropped into a central shaft and the film leader attached to a clip. With a cover in place, the film is wound into the spiral, the film end cut off internally, and the cassette dropped out.

The impact of some monochrome subjects is increased by making a contrasty print.

Photo: Chris Haynes

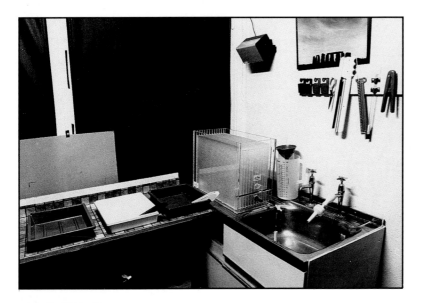

Where space allows, keep the wet working area (wet bench) separate from the dry area. Here, 8 x 10in trays are shown, but there is just room for 16 x 20s. The Nova washing tank will take up to 10 prints 12 x 16in, without cross-contamination as each one is added. This means that the first can be removed for drying as soon as the last print leaves the fixer. There is an Ilford Multigrade safelight on the wall at each end of the bench.

EQUIPMENT

Here are two lists of equipment, one for film processing, the other for making prints. The essentials come first, after which there is a list of extras which most professionals and advanced amateurs would consider essential. Chemicals will be dealt with later.

FILM PROCESSING (BASIC)

Developing tank. There are several makes, the most popular being Jobo and Paterson. Both have adjustable spirals, so that films of different sizes can be accommodated.

Thermometer. This should be of the best photographic quality, with a clearly visible scale. Where possible, black and white processing should be carried out at 20°C, and colour printing at 38°C. A thermometer that covers the range 10-50°C would be ideal.

Film squeegee, or tongs. These have rubber lips and are used to wipe down the film, so that it dries without drop marks on the emulsion. Provided the processing conditions, the wash water and the wiper are all clean, this is the best way to remove surplus water from the film before drying. In areas where water is free from chalk and lime deposits, films may be given a final

rinse in dilute wetting agent, shaken and hung to dry.

Film clips. These come in pairs, and have needles or claws to grip the film. One goes at the top to hang the film while drying, with another one at the bottom to keep the film taut.

Funnel. For pouring stop bath and fixer back into their respective storage bottles.

Drying Cabinet. A film drying cabinet, with impeller fan and air filter. Nowadays, this usually has the fan/heater in the top compartment, the 'cabinet' being of tough transparent plastic, clipped on and suspended from it. Not only does this speed up drying, but protects the film from floating dust and hairs that could adhere to it while wet.

PRINTING (BASIC)

Enlarger. There are no bad modern enlargers, but you do get what you pay for. The important features are rigidity, plane parallelism between negative carrier stage, lens and baseboard, perfectly even illumination, and a good lens. There are efficient but quite economical instruments such as the Czechoslovak Meopta range imported by Photax Limited, but if your money runs to it, get one of the more

expensive models typified by Durst and LPL. Whatever price you pay for an enlarger, do not stint on the lens. A poor lens cannot reproduce the fine detail recorded by your high quality camera lens. For colour printing the enlarger should be fitted with a colour head. This contains the dial-in filters, yellow, magenta, cyan, needed to control the colour balance of the prints. The colour head can also be used to control the contrast of variable contrast black and white printing papers such as Ilford Multigrade.

Masking frame. This is used to hold the printing paper flat on the enlarger baseboard, usually fitted with adjustable arms for different paper sizes, and giving a narrow white border. More expensive types are available giving borders up to 5 cm wide.

Dishes. For black and white paper, three are needed. For ease of handling, these should be slightly larger than the maximum paper size for which they are intended. A ridged bottom prevents paper adhering, making it easier to lift out, and one corner should be shaped for pouring.

Print tongs. These enable you to lift the paper from dish to dish. One for taking the print from the developer to the stop bath (without immersing the tongs themselves in the latter), the other for use between stop bath and fixer, and fixer to wash.

Drum. This is used for developing colour prints. The exposed paper is loaded in the dark, after which processing can be carried out in room lighting. The tank takes a very small amount of solution, and is rolled back and forth on a level surface. It may also be placed on a thermostatically controlled rotary print processor

Safelight. These can be quite bright, as long as the colour is correct for the printing paper in use. Ensure that you are buying the right type, by reading the leaflet packed with every safelight, or where suitability is mentioned in advertisements.

The Leica V-35 enlarger maintains pinpoint autofocus at any degree of enlargement between 3 x and 16 x . Separate modules can be slipped in for colour, conventional black and white, and variable contrast papers. Expensive, but the Rolls Royce of 35 mm enlargers.

EXTRAS

Print wiper. A large pair of rubber-lipped tongs, used to wipe excess water from prints, prior to drying.

Print dryer. Resin coated (RC) papers can be wiped of surplus water and left to dry in a simple rack, something like those used to store dinnerplates in an upright position. There are also RC print dryers in which the sheets are held on racks over which heated air is blown. Fibre-based prints are best dried on a heated flatbed dryer, held taut by an apron to prevent curling. Professionals use an infrared dryer with a rapid throughput, such as the Ilford Ilfospeed 5250 for all RC papers, black and white and colour.

With the enlarger head raised to the top of the column, it may need a metre or more space above the bench. In most rooms this will present no problem, but where ceiling height is restricted, bench height will have to be decided with this in mind. The average desk top is about 75cm from the floor, and this enables people of average height to sit comfortably without bending forward. You may be spending considerable periods at the enlarger, and back strain is no inducement to good printing. Development of prints, on the other hand, whether in dishes or a drum, is usually carried out standing, so the wet bench height should ideally be higher.

Never was the old saw about cleanliness being next to godliness truer than in darkroom work. Ordinary dust and hairs, as well as floating particles of dried-out chemicals, can cause havoc. Dirt will adhere to negatives and cause spots on prints. Keep everything clean, wash all dishes and tanks thoroughly after use, and remember that the only thing that should ever dampen a darkroom towel is clean water. Real cleanliness in a darkroom cannot be achieved with a lightning blitz every few weeks.

This merely re-distributes the dirt. Brush down shelves and wipe benches regularly, and vacuum clean weekly. Keep a cover over the enlarger.

One aspect of amateur darkroom work that gets too little attention is ventilation. It isn't only continual exposure to chemical fumes that can cause headaches and even ill health, but constantly breathing stale air. When a darkroom is in regular use, a proper light-tight Ventaxia fan should be installed where possible or, failing that, a light trapped 'tongue and groove' ventilator box put through the door. However, in a temporary darkroom, where such an installation might be out of place, or not allowed, the usual procedure is to fan the door to and fro a few times every half hour or so. It works, and is certainly better than nothing!

Whole books have been devoted to darkroom layout, but the foregoing will provide a useful outline for the newcomer to darkrooms and their equipment. For more detailed information, advice is always available from the makers of equipment. Venues and meeting times of your nearest camera club or photographic society can be obtained at your local library, and the more experienced members are usually very happy to advise on individual requirements.

This Durst DES 100CA colour analyser is used on the enlarger baseboard and indicates the correct filtration for the print.

BLACK & WHITE PROCESSING

The characteristics of black and white films were dealt with in Section 8. There are many differences but most are based on light-sensitive silver halide emulsion. When the lens projects an image of the scene on to the film, the crystals are affected, more or less, by the amount of light reaching them. The greatest effect is in a highlight area, such as a sky, the smallest effect in the shadow areas. This is called the latent image, as there is not so far any visible effect on the film. In fact, if it were to be taken from the camera at this stage and exposed to light, the film would fog. That is, all parts would be equally affected, and on development the film would be completely black.

The developer blackens the affected silver halide grains, while the fixer removes the unaffected ones. This leaves a negative image of the scene, light areas reproduced dark and vice versa.

PROCESSING FILMS

Black and white film has more latitude than colour film, and that applies to processing as well as exposure. This is mainly because at the printing stage we can use papers with different degrees of contrast to compensate for low or high contrast in the negative. It is also due to the fact that the time and temperature of processing can be varied by several degrees without affecting the result. As in every stage of picture-making, however, it pays to be precise.

The processing operation is quite simple. The film is loaded into the tank in darkness, care being taken to handle the film by the edges only. With the tank lid in place, processing can then be carried out in the light. The three solutions are developer, stop bath and fixer, all made up by dilution with water, as described in the instructions packed with the chemicals. The standard temperature is 20°C (68°F). First, the developer is poured in and the cap sealed. Normally, agitation consists of turning the tank upside down two or three times in five seconds, once a minute until development is complete. The developer

After wiping down, films should be hung to dry in a dust-free atmosphere, which usually means the bathroom, as it contains less dust-gathering materials. Best of all is a proper drying cabinet with heated, filtered air and a fan. Both Durst and Jobo make cabinets suitable for amateur and semi-professional use.

is poured out, so that the stop bath can be poured in just as the development time is up. Half a minute or so in the stop bath, which is then poured out and the fixer introduced. Most fixers are now of the rapid variety, with fixation complete in a minute or so. This is followed by a wash, fifteen minutes in running water being sufficient with modern films. The film is then hung to dry.

Some photographers simply give a water wash between developer and fixer. A stop bath is far better. It arrests development immediately instead of slowing it, neutralises the alkaline developer, and prevents carry-over which will shorten the life of the fixer. It will be appreciated that the slowing down of development by using a water wash is less important when development time is long. Half a minute before fixation, after twelve

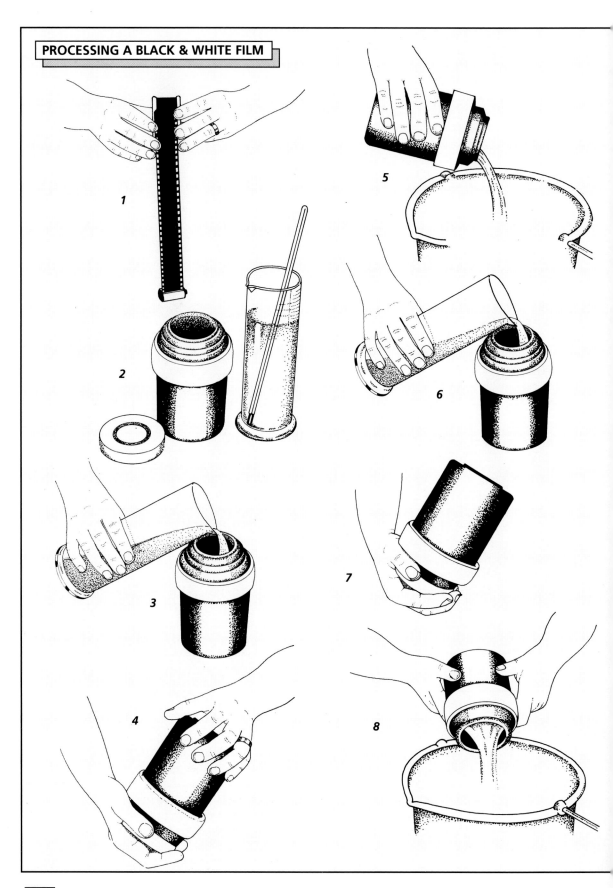

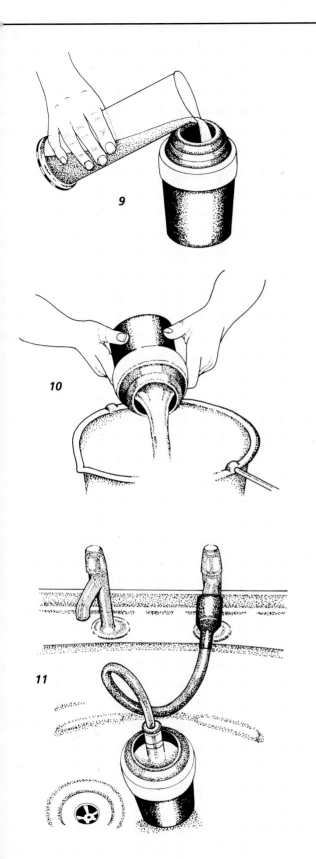

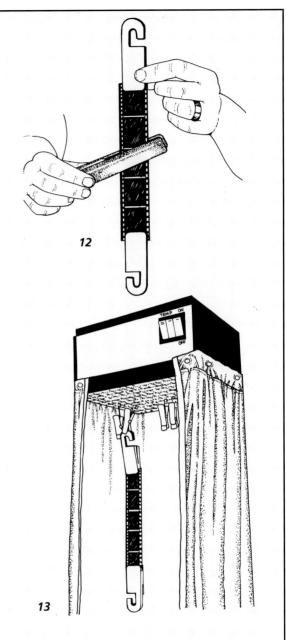

(1) Load film in spiral and close tank. (2) Check temperature of developer. (3) Pour in developer, push on watertight cap. (4) Inversion agitation 10 sec initially, then 5 sec per minute, or as instructions. * (5) Pour out developer. (6) Pour in stop bath just as development time expires. (7) Agitate once or twice during 1 min. (8) Pour out stop bath. (9) Pour in fixer and agitate three or four times during fixing period. (10) Pour out fixer. (11) Wash 10 min. (12) Wipe film. (13) Hang to dry in dust-free atmosphere. *Check film sheet instructions for specific agitation patterns.

Diagram: Colleen Payne

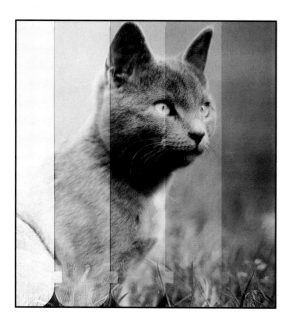

An enlarging exposure meter can be used, but it is quite simple to make a test strip. This was exposed successively at 2, 4, 6, 8 and 10sec. The choice is between 6-8sec.

minutes development is not much, but after five minutes there would be an unwelcome increase in both density and contrast.

DEVELOPERS

The standard developer for small films is Ilford's ID.11 or Kodak's D.76, which are the same formula. For small films it is usually recommended that the full-strength developer is diluted 1 + 1 with water. The developer gives a favourable balance between fineness of grain, the nominal ISO speed of the film as marked on the carton, and good gradation of tones. It does, however, have to be mixed from powders. Some developers are supplied as liquid concentrates, and may be preferred for various reasons.

Ilford's Perceptol gives extra fine grain, reduces negative contrast, but calls for an increase in exposure. Paterson's Acutol also lowers contrast, gives a sharp 'edge effect', but increases film speed slightly. Kodak's Microdol-X is a true fine grain developer which does not affect tonal gradation, but lowers film speed. Paterson's Acuspeed increases film speed two to three times and gives a pronounced but sharp grain structure.

A favourite with many professionals for use with medium speed film such as FP4 Plus, is Ilford Ilfotec LC29 or Kodak HC-110, a concentrate that gives a very sharp image with good gradation and normal film speed.

Kodak's T-Max and Ilford's Delta films give images with finer grain than is normally associated with their ISO ratings. They may be developed in D.76, though it is claimed that T-Max films give best results in Kodak's special T-Max developer.

Ilford's almost grainless XP2 has high speed and great latitude, and may be processed in the standard C-41 process used for colour negative films. Even really big enlargements show no appreciable grain.

The keen photographer will want to try out different film/developer combinations, but a word of advice is called for. Start with just one or two combinations and stay with them until you know exactly what results you can expect in different situations. You might, for instance, settle on FP4 Plus/Ilfotec for general work, and HP5 Plus/ID .11 for speed. Whatever you do, never experiment on an important subject.

Two aids to spotlessly clean negatives, that will print without dust spots or hair lines, are film tongs and a drying cabinet, which were described in Section 18. The tongs are cheap enough, but a proper drying cabinet is costly, and in any case may take up more room than you have at your disposal. If this is so, hang the film to dry where there is no furniture to harbour dust, and where people are not constantly walking about. This usually means the bathroom.

ENLARGING PAPERS

There are two basic types of enlarging papers. One is available in different grades of contrast, usually numbered from 0-5. The other is variable contrast paper. With this, any grade of contrast is obtained by altering the filtration while enlarging. This may be done with the built-in filters on a colour enlarger, or by using a set of special filters supplied by the paper manufacturers. Kodak's variable contrast papers are Polycontrast II RC (resin coated) and Polyfiber (fibre based). Ilford's are both Multigrade, either RC or FB.

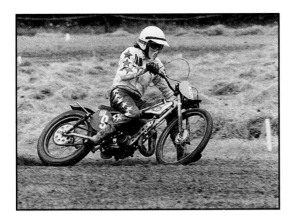

A straight print from an Ilford HP5 Plus negative, exposed at 1/500sec, using the panning technique shown in Section 10.

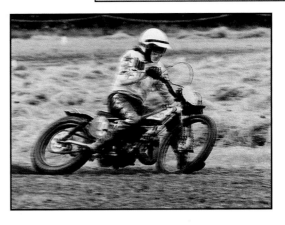

The same negative, but the masking frame was moved three times, about 0.5cm each time, along a straight line, during exposure.

Resin coated papers absorb chemicals more rapidly, and can therefore be processed more quickly. They are also washed and dried more quickly, do not curl up when left to air dry, and the glossy variety will dry to an unblemished sheen without having to be glazed. Fibre-based papers take a little longer to process, considerably longer to wash, and for perfect flatness should be dried in a heated flatbed drier. Some photographers say that fibre-based papers look better when viewed direct, as in an exhibition, though not everyone agrees. For reproduction, glossy RC is the order of the day.

THE PERFECT PRINT

To yield a full range of tones from white to black in the finished print, a negative of average contrast should be printed on normal paper, also called Grade 2. It should be fully developed before being fixed, as only in this way can a full, rich black be obtained. This means that enlarging exposure has to be just right. A second or so too much exposure and the image will darken too rapidly. The novice will often give too long an exposure, then 'snatch' the print before the full development time has expired. This is bad practice, and leads to a 'good enough' attitude.

A good exercise for the beginner, and useful refresher for the more skilled printer, is as follows:

1. Enlarge a negative on normal paper and develop fully. Repeat with more or less exposure if necessary, to obtain the best possible print.

2. If you think more contrast would have a greater appeal, repeat the process with a more contrasty paper, Grade 3 or 4.

3. If you think a softer image more desirable, repeat the process on Grade 1 or 0.

Always develop fully, adjusting exposure where necessary. This exercise will show that good printing does not mean trying to obtain a print of average tone every time. Controlling the degree of contrast can have a powerful aesthetic effect.

SAFELIGHTING

The safelight has to be right for the paper in use. Most red and orange safelight filters are safe with most enlarging papers, but not necessarily for the variable contrast types. A test that is often suggested is to place a coin on a piece of the paper you are using, leave it for a few minutes under the safelight, then develop. If the coin area stays white while the remainder goes slightly grey, you have an unsafelight.

A print may fog slightly, even though the borders, which were protected by the

A good negative, but taken in soft lighting.
Grade 2 Multigrade gives too soft a print.
Changing to grade 3½ gives far better contrast

masking frame, remain white. This is because the protected border has received no light at all, and has remained unaffected. The answer is to carry out a preliminary coin test.

PAPER HANDLING

Bear in mind that safelights, in practice, are only relatively safe, so printing paper should not be exposed to their light any longer than is necessary. Leave it covered in the box or packet until the image has been focused and composed, the lens stopped down and the exposure decided, then put it in the masking frame and make the exposure. Then, slide the paper face down under the developer, lift once to break up any air bubbles, and slide under again. Rock the dish gently. Turn the paper face up after 30-40 seconds. Until then there is not much to see.

Handle paper carefully by the edges. A finger nail, or the edge of the printing frame brushed across its surface may leave a mark. If washing several sheets under running water in a dish, bring the bottom one to the top every minute, to ensure that all are washed equally.

DODGING & BURNING

Dodgers are used in printing to lighten or darken selected areas of the image, by 'holding back' or 'burning in'. A set of dodgers consists of small pieces of black card held on thin wire handles, and the sheets of card from which they were cut. By way of example, if one side of a face is heavily shadowed but retains a trace of detail, a small piece of card is held midway between the enlarger lens and the paper for part of the exposure, with its shadow falling on the bright shadow area. The card is moved slightly during the exposure, to disguise the edges of the shadow and eliminate that of the thin wire. Conversely, where a dense highlight would otherwise print without detail, a card with a hole in it is used. The image is given an overall exposure, then the main part masked off while the dense part receives extra exposure through the hole. Again, the card is moved a little during the burning in, to avoid obvious edges.

MAKING A BLACK & WHITE PRINT

(1) Brush negative to ensure clean print. (2) Focus, compose, expose. (3) Rock dish for even development. (4) Lift with tongs, drain and (5) transfer to stop bath. Repeat process into fixing bath. (6) Wash print.

Diagram: Colleen Payne

COLOUR PROCESSING

Colour printing and processing are not much more complicated than black and white. One step that causes a problem for some darkroom workers, is obtaining the right filtration when colour printing. As you will see, this can quite easily be overcome, even without a costly analysing instrument. As regards processing, it is necessary to maintain a considerably higher temperature than for black and white. Again, this can be done without expensive temperature controlled equipment, but extra care is needed.

Before describing the various procedures and processes involved, let us consider the economics of colour processing. A question I am asked constantly is 'Which is cheaper, home processing or sending it away?' The answer is sending it away, but it does not take into consideration the pleasure that can be derived from doing it yourself.

PRINTS FROM NEGATIVES

As with black and white enlarging, the correct exposure has to be found, but it is also necessary to determine which filters must be put in the light path to obtain satisfactory colour balance in the print. Most modern enlargers have a colour head incorporating dichroic filters of three colours, yellow,

magenta and cyan. By inserting them progressively into the white light path, the colour can be altered from weak to strong and for convenience the various strengths are given value numbers. Most enlargers use Kodak values, though Durst values are slightly different, 170 on the Durst scale being equivalent to 225 CC Kodak.

Enlargers can be bought for black and white only, without the special colour head, though often this can be added later as a special accessory. Older enlargers, and most new ones, have a filter drawer. Packs of YMC filters are available and can be put in the drawer, and the required combination of values in each case is known as the filter pack. Printing from negatives is commonly referred to as the neg-pos process, and only Y and M filtration is normally necessary.

There are three ways to determine the correct filter pack, or combination of values. These are (1) Using an electronic analyser, (2) using a mosaic device such as the Unicube or Duocube and (3) using a standard filter pack and your own judgment.

Electronic analyser. This instrument measures the density of each colour layer in the negative, compares them with a reference in its memory, and indicates the correct filter pack to be used. The instrument needs to be pre-programmed, or calibrated, for each make and type of film, and each make and batch of paper. In the latter case, re-

COMPARATIVE PROCESSING TIMES AND STEPS AT 38°C FOR PRINT FILM, PRINT, SLIDE AND XP2

Step	Print Film	Print	Slide Film	XP2
Pre-Bath ‡	–	–	1 min*	–
1st Dev.	3¼ min	2 min	6 min 30 sec	3 min 45 sec
Rinse	30 sec	30 sec	–	30 sec
Wash	–	–	2 min	
Colour Dev.	–	–	6 min	
Wash	–	–	2 min	
Bleach-Fix †	4 min 30 sec	1 min 30 sec	9 min	6 min
Wash †	4 min	4 min	4 min	2 min

* Pre-wash or water jacket at 40°C. Remaining steps at 38°C.

† See instructions packed with kits for times and temperature range.

‡ Thermo-tank instructions may suggest alternative pre-heating of tank.

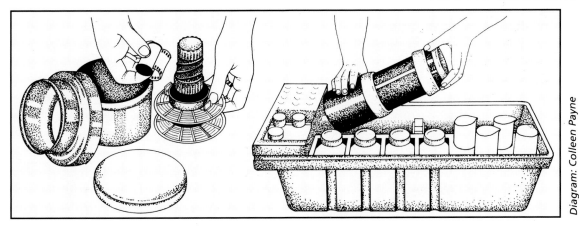

Diagram: Colleen Payne

A film can be loaded in daylight into this special Jobo daylight processing tank. It is wound on the spiral internally, cut off, and the empty cassette ejected before processing

This Jobo CPE-2 processor simplifies colour print (or film) processing. The thermostatically controlled water jacket keeps the chemicals, and the drum or tank, at the right temperature. The drum is automatically rotated with two-way action.

calibration is sometimes, but not always necessary, when starting a new batch of paper. This is because slight colour differences may exist from batch to batch, but nowadays such differences are often small enough to be ignored. The method of calibrating is described in the instructions for individual analysers. Far less programming is needed if you use just one type of film and paper, the only variable then being the lighting conditions when the pictures were taken.

The Unicube. This device costs much less than an electronic analyser. Basically, it consists of a small mosaic pattern of transparent yellow, magenta and cyan patches. With the image composed and focused on the paper mask, the enlarger lamp is switched off and a diffuser placed beneath the lens. The mosaic is placed over a 5 × 4in piece of paper laid on the mask, and a standard exposure given. When the paper is developed and dried, you pick the patch nearest to neutral grey. Reference to a chart tells you which filter combination you need to make a good print, as well as the correct exposure. The Unicube works extremely well and there is minimal wastage, provided your colour discernment is good enough to distinguish the patch nearest to grey.

Standard filtration. This works extremely well if you use one type of film and paper. With any neg-pos printing it will be found that one combination of yellow and magenta

filter values will give an acceptable, if not the best possible colour print. A good starting point is the value 50Y + 50M and, if using a filter drawer you must add a UV absorbing filter. The dried test print is examined in good light, and with the aid of a ring-around, which will be described shortly, you decide (a) whether there is an unwanted colour cast, and (b) what strength (value) of which colour is needed to remove it. In neg-pos printing the rule is: add the same colour as the cast, or remove the complementary colour. Thus:

If print is too	Add	Remove
Yellow	Y	M and C
Magenta	M	Y and C
Cyan	C	Y and M
Blue	M and C	Y
Green	Y and C	M
Red	Y and M	C

In the case of a print made on reversal paper from a colour slide, filtration is easier. Not only can you see the colours unreversed while focusing and composing on the masking board but correction is easier when looking at a test print. You simply reduce the same colour as the unwanted cast, in any degree you think appropriate. See the section Colour Judgment, that follows.

Naturally, if all the negatives on a film, or a

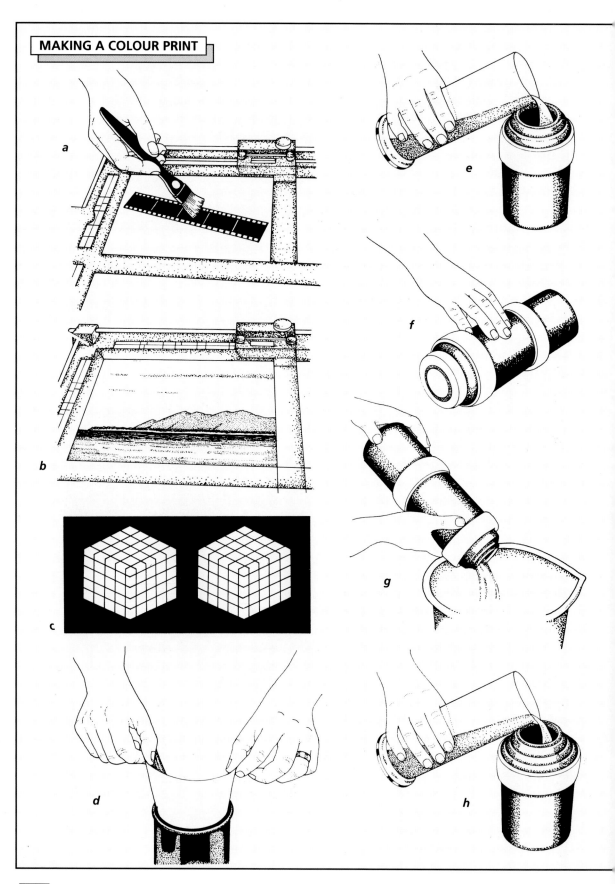

MAKING A COLOUR PRINT

(a) Brush negative and insert in carrier.
(b) Focus and compose image on baseboard.
(c) Use a colour analyser, or less costly matrix such as this Unicolor Duocube, for a test print, to determine filtration and exposure.
(d) Expose final print and place in drum.
(e) Pour in developer. (f) Roll drum back and forth on level bench. (g) Start pouring out 15 sec before end of development time.
(h) Start pouring in bleach-fix just as development time is.finished.
(i) Pour out bleach-fix. (j) Pour in first of several changes of water. (k) roll drum between each change of water. (l) remove print from drum.
(m) Wipe off excess moisture, and dry.

Diagram: Colleen Payne

particular sequence, are made under the same lighting conditions, a single test print will serve for all.

A CONTACT SHEET

Up to 36 negatives, or a whole film, can be printed in strips on a single sheet of 10 × 8 in colour paper, and as individual negatives may call for a different filter pack, the sheet is best exposed to a standard 50Y-50M or whatever you find by experience to be best. A contact printing frame, such as the easily obtainable Paterson proof printer, holds the strips neatly and facilitates the job. From the finished contact print you can decide what changes in filtration, if any, are required for different negatives.

COLOUR JUDGMENT

In schools of photography, the student spends a day or so making what is known as a ring-around. This has a picture, invariably a portrait because skin tone is so important, with good colour, placed centrally. Radiating from it are rows of the same picture, in progressively stronger casts of magenta, green, cyan, red, yellow and blue. Beneath each picture is printed the degree of filtration necessary to get rid of the cast. None but the keenest amateur colour printer, though, will want to undertake this laborious exercise, and most make use of the ready-made ring-arounds that are seen in many textbooks.

The trouble with such ring-arounds is twofold. First, the individual pictures are usually so tiny that realistic evaluation is all but impossible. Second, however good the originals from which the ring-around is printed, the depth and even colour of the printing inks may vary. Because of this, I make two recommendations. One is the extremely well printed Kodak Colour Printing Aid, single copies of which are available free from Customer Services, Kodak Limited.
This applies to UK residents. The other is the Kodak Color Print Viewing Kit R-25, used for evaluating the colour balance of both neg-pos and reversal papers. The kit features Kodak Colour Printing filters mounted in six cards,

An alternative to a drum, is this thermostatically-controlled print processor from Nova. Developer and bleach-fix can be left in their compartments, with rollers on top to keep out dust and prevent oxidation.

each containing densities of 0.10, 0.20 and 0.40 in the colours red, green, blue, cyan, magenta and yellow. By placing the various filter foils over the dry test print and viewing in good light, it is easy to determine the necessary filtration. These filters, by the way, are for viewing only.

PROCESSING

The various chemical and wash stages for processing:

(a) Colour negatives
(b) Prints from negatives
(c) Prints from slides

are given on page 172. Detailed instructions for mixing chemicals, the temperatures to be used, processing times and capacities are given in the instruction sheets included with the various kits, so there is little point in repeating them all. However, the sequence drawings will show what is involved in the various processes, and some advice on general aspects of colour processing routines should be helpful.

SAFELIGHTING

Most popular safelights can be fitted with a filter that is reasonably safe for use with colour papers, though not with films. Visually, such a safelight filter appears amber in shade, so dark that when you first switch off the room lighting there appears to be no light at all. However, within a minute or so, even with the safelight turned up to reflect off the ceiling, you will be able to see well enough to find the paper box and other essentials. After a few minutes, you will wonder if the light isn't too bright! Be careful not to exceed the recommended closest distance, and the recommended wattage for the safelight lamp.

PAPER

Read and follow carefully the instructions packed with the paper you use, especially as regards detecting the emulsion side in the dark. Ilfochrome, for example, is dark brown on the emulsion side, which is a little disconcerting the first time you expose a sheet, as the projected image is not as bright as when you composed on a white surface.

CLEANLINESS

Drums, spirals, chemical containers and measures must be washed thoroughly after use. A single drop of errant solution, dry or wet, can cause a colour cast or coloured spots on the next print or film. This aspect of colour processing cannot be over-stressed.

TEMPERATURE

This is of paramount importance in colour processing, there being practically no tolerance. Success depends on maintaining the stated temperatures. In some processes, the temperature may be altered, provided the time is modified in keeping with a chart given in the instructions. Some neg-pos kits permit paper to be processed at room temperature. This may seem like a boon to the amateur who doesn't want to buy a temperature-controlled processor but experience shows that print colour is less good at lower temperatures, and best when closest to 38°C or so.

It is possible to stand the various containers of solutions in a water jacket, such as a large washing-up bowl, and maintain temperature with frequent additions from a kettle and reference to a thermometer. Some people become adept at this, and have no problems at all, while others cannot fully control fluctuations, and can never be sure of the results they achieve.

The easiest method is to use a temperature-controlled processor, such as the Jobo CPE-2 shown on page 173. This keeps all the chemistry and the tank or drum at any required temperature and gives regular 2-way rotation to the latter. An extra cost, it is true, but worth its weight in constantly successful results.

MAKING DUPLICATES & COPY NEGATIVES

Photographic magazines carry advertisements by firms offering a slide duplicating service. Because they make so many, and because there is no wastage, excellent duplicates are offered very cheaply. To do the job at home, you need a duplicator and time, and it will only work out cheaper if you intend to make fair numbers of duplicates on a regular basis. This section will detail the equipment, materials and techniques involved.

DUPLICATORS

Also called slide copiers, these provide the easiest method of duplicating. The camera lens is replaced by the duplicator, which is basically a tube containing its own lens, and with a holder at one end for the original. Common makes are Ohnar and Panagor. There are also copying attachments to fit on bellows units supplied by the best SLR manufacturers.

A zoom slide copier, or duplicator, which will give same-size duplicates, or enlarge a section of the original up to 2.5 × This model can be used with most SLRs. It has three carriers for 35mm frames mounted in 2 × 2in mounts, filmstrips, and 110 transparencies.

OPTICAL QUALITY

Lenses computed specifically for extreme close-up work (copying, macro, enlarging) are best if a bellows unit is to be used. However good a normal camera lens may be, its performance is least good for close work, though this is a matter of degree. However, if used in the reversed position by means of an adapter, and/or stopped down to f/11 or so, results are very good. Although the lens in a duplicator is of simple construction, it is designed for the job, and these instruments give excellent results.

LIGHTING

Instructions packed with duplicators suggest that all you have to do is insert the slide that is to be copied, ensure accurate focus, aim at the sky, and let the camera make the

exposure automatically. Unfortunately, the colour temperature of the sky is subject to continual and dramatic change, so the results are often hit-and-miss. Flash, or tungsten light, removes this variable, and is much to be preferred.

An SLR fitted with a zoom slide duplicator, mounted on a copying stand. The four tungsten lamps are not being used. Instead, a flashgun is set at a measured distance from a 45° white card. The light is reflected upwards. As the light is perfectly even, the duplicator's diffuser panel is held out of the way by a rubber band. Two of the lamps are switched on to brighten the image while focusing.

CONTRAST

A duplicate slide made with a general purpose camera film will be more contrasty than the original slide. Special low-contrast duplicating film is available, and is used in all commercial processing houses, but this requires careful filtration and much experiment, a costly process for the amateur, and one that often ends in failure and frustration. There are, however, two much easier methods, using ordinary film, which will have more appeal to the amateur.

METHOD 1

Use a slide film balanced for tungsten light, such as Fujichrome 64T. Expose by tungsten

light, giving twice the indicated exposure, i.e., rating the film at only half its speed, in this case ISO 32. Have the processor PULL, not PUSH, the first developer time by one stop. This reduces contrast while maintaining correct density. You can also use daylight film with flash, again down-rating the film and reducing developing time. If you process your own film, instructions for modified E6 processing will be supplied free from Customer Relations, Kodak Limited. Similar instructions are packed with E6 type chemistry from other suppliers, such as Photo Technology's Chrome-Six. Naturally, the whole film has to be exposed the same way

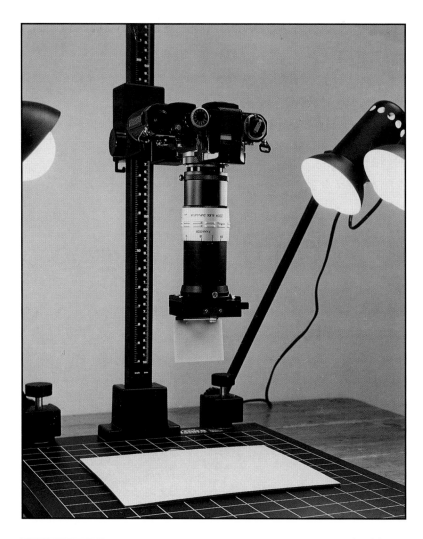

Slide duplicating or copying can be carried out by tungsten light. Here, the lights of the copying stand are aimed at a white card and reflected up to the duplicator. Note that the diffuser panel is hanging loose, as it is not required.

METHOD 2

This method is more convenient, and economical, for the photographer who wants to make only an occasional duplicate using the film already in the camera. It reduces the contrast, but without affecting the ISO rating or processing of the other pictures on the film. An exposure is made in the slide copier, using flash. The original is then removed from the holder, and replaced by a neutral density filter that passes only one-hundredth of the light. Ideally, a Kodak 2.0 ND filter (every 0.1 log is equivalent to one-third of a stop). You can order this gelatine filter through your dealer, and cut a piece to fit a 35mm slide mount. Now, another identical flash exposure is made on the same frame of film, which has the effect of reducing contrast. This procedure is possible only on cameras which

permit double exposures to be made. Where a multiple exposure device is not incorporated, and on suitable cameras, try winding on with the rewind button pressed. This will re-set the shutter without winding on the film. Register may not be precise between the two exposures, but for a duplicate this does not matter.

COPYING SET-UP

Various means can be devised to ascertain the correct exposure when using a duplicator. My own method is perhaps simplest, and lends itself to several variations. I have the camera/duplicator mounted on a proper copying stand, with four tungsten lamps aimed at white copying paper on the baseboard. The diffuser panel of the duplicator is not used, and the shutter time is determined by the camera. Tungsten

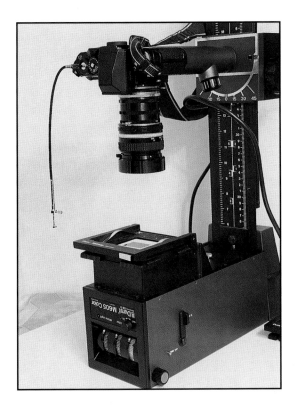

The slide to be duplicated can be held in the enlarger carrier on top of the reversed colour head. This way, very fine or creative colour control can be introduced. In this set-up, extension tubes are fitted between lens and camera. The image fills the frame at 1:1 ratio, and exposure is determined by TTL metering. Extra exposure is given to correct a too-dense slide, less exposure to add density to a weak one.

film is used.

It is possible to use dedicated flash, where this facility exists, by means of a special dedicated extension cord but I have yet to meet anyone who has consistently made good duplicates by this method. It is best to use the flash in the manual mode, and carry out a once-only test. Take a series of exposures, starting with the flash just 230 mm from the diffuser of the duplicator, then more exposures at 300-380-450-530-600 mm, followed by a further six at 750-900-1050-1200-1400-1700 mm.

This would be best with an ISO 100 film, again using the technique of reduced film speed and shorter processing time.

With a very powerful flash, repeat the whole sequence at half-power, which will fill a 24-exposure film. When processed, pick out the best duplicate, and you will then know the best flash-to-diffuser distance for later use. If you are later copying a slide denser or lighter than the one used for the tests, make extra exposures with the flash at lesser or greater distances.

SLIDES FROM NEGATIVES

For home processing, use Kodak Vericolor

Slide Film SO-279 (catalogue No. 162 2364) supplied in 36-exposure cassettes. This is stocked by mail order firms. This uses Process C-41 (Paterson equivalent is 2NA) as for ordinary colour negative films. If SO-279 is sent away, it should be marked 'ORDINARY C-41 PROCESS', just in case a young laboratory technician fails to pick up this information from the cassette. There is no need to reduce contrast with this film. Kodak Customer Relations will send you a copy of their leaflet E-24 'Using Kodak Vericolor Slide and Print Film.'

BLACK & WHITE NEGATIVES FROM SLIDES

Load the camera with a sharp, medium speed film. Ilford FP4 Plus is recommended. Develop normally, but preferably in Ilford Perceptol developer. Contrast can be fully controlled by choice of printing paper.

COLOUR NEGATIVES FROM SLIDES

This can be done with normal colour negative film and flash. Increased contrast can be avoided by using the ND filter technique, as in Method 2.

PRESENTING PICTURES

Good pictures look even better if they are well presented. Even your best 6 x 4in prints are more impressive if displayed in a neat flip album. This short chapter gives an account of the most popular ways to present your work, and some useful sources of supply.

SLIDES

Small illuminated viewers are available, and quite useful for examining individual slides, but something bigger is required if they are being shown to other people. Some projectors have a useful screen attachment showing pictures about 10 x 8in, and you change slides in the usual way. A slide sorting desk merely provides an illuminated panel on which a number of slides can be arranged, but for detailed viewing a magnifier is necessary. Beware the cheaper kinds of sorting desk, containing ordinary tungsten lamps. These get very hot and slides should not be left on them too long. Better sorting desks, or slide display panels, have cold fluorescent tubes.

Slides are best seen when projected on a big screen. The projector you buy depends really on your pocket, but many excellent models can be had around the hundred pound mark. The standard lens for use in average rooms is 85mm, and the most popular screen is of the 4-5ft spring-loaded roller type attached to a folding stand. With a screen to projector distance of about 8-10ft, the picture can be seen comfortably by ten or so people.

Silver screen material gives the brightest image when viewed from almost directly in front, but the brightness falls off quickly as the viewing angle increases, so people on the end of a row can see least well. Glass beaded screens, and those of plain white material are more popular for this reason.

If you use mainly slide films, and find yourself enjoying the job of giving a slide show with commentary, you may want to move up to a twin-lens AV projector such as the Rollei, or possibly a full audio-visual set-up, including two projectors, dissolve unit, recorder, amplifier and speakers.

MOUNTING

At one time, club photographers mounted their exhibition photographs on quite elaborate boards, which were sold in all photo stores. A typical mount would be cream or buff, with a sunk and bevelled central area of different tone surrounded by thin lines of gold or brown. Sometimes the photograph was even attached to a central layer of tissue that formed an additional border.

Today, plain mounts are preferred, either leaving a broad plain border around the print, or flush mounted. Many photo stores stock such mounts in various sizes, and these are usually white on one side, cream on the other.

Mounting can be a bit of a problem. Shops selling artists' materials usually stock Scotch Spray Mountant. This gives a moderate bond, and prints can be carefully lifted and repositioned. It works well with smaller prints, but larger ones tend to curl away from the mount in a warm atmosphere.

A permanent bond is obtained with the water-based Foto-Bond. This has to be brushed thinly on the back of the print, which is then rolled down and smoothed flat on the mount, which is then left under pressure for half an hour. Foto-Bond works just as well on resin-coated as on fibre-based papers, but the trick is to apply it thinly and evenly without ridges, which would show through the mounted print.

These wet mountants sometimes cause the print to shrink a little, causing an inward curl to the mount. With good, hard mounting board, and the print left under pressure until quite dry, this should not happen. A trick with softer boards is to mount two back to back, which will counteract any tendency for the print to curl.

POSITIVE MOUNTING

Professionals sometimes use dry mounting tissue, placed between print and mount, which are then pressed tightly together in a heated dry mounting press. Such a press is far too expensive for amateur use, and though the job can be done with a cool domestic iron and an overlay of special paper, it is quite

tricky and takes plenty of practice. Far better to use one of the two self-adhesive methods now popular. One is the lightweight foam-core Polyboard. You peel off the covering, a little at a time, bringing the print down into contact with the exposed surface. Bonding is immediate and permanent, so positioning has to be accurate. In spite of its light weight, Polyboard will not curl, and a quantity of large mounted prints can be carried without strain. Mounting does, however, have to be flush to the edges, without borders.

Another method is to use Ademco Double-Sided pressure sensitive mounting film. This again, has an adhesive surface with peel-back covering, and comes in rolls. It is extremely easy to use, and has the advantage that it can be applied to the print only, and thus positioned in the centre of a mount, leaving a border.

Photobition and Ademco deal almost entirely with professionals, and the smallest available quantities may be more than you need for immediate purposes. However, on a print-by-print basis the materials are quite cost effective, and the prices are not beyond the amateur's pocket.

TITLES

A discreet pencilled signature is in order on a mount, but do be careful about titles. They are still seen on some exhibition prints at some camera clubs, but are hardly ever used by professionals except as a straightforward statement of the location or event. In modern exhibitions it is more usual to number prints and leave the titles, if any, to the catalogue.

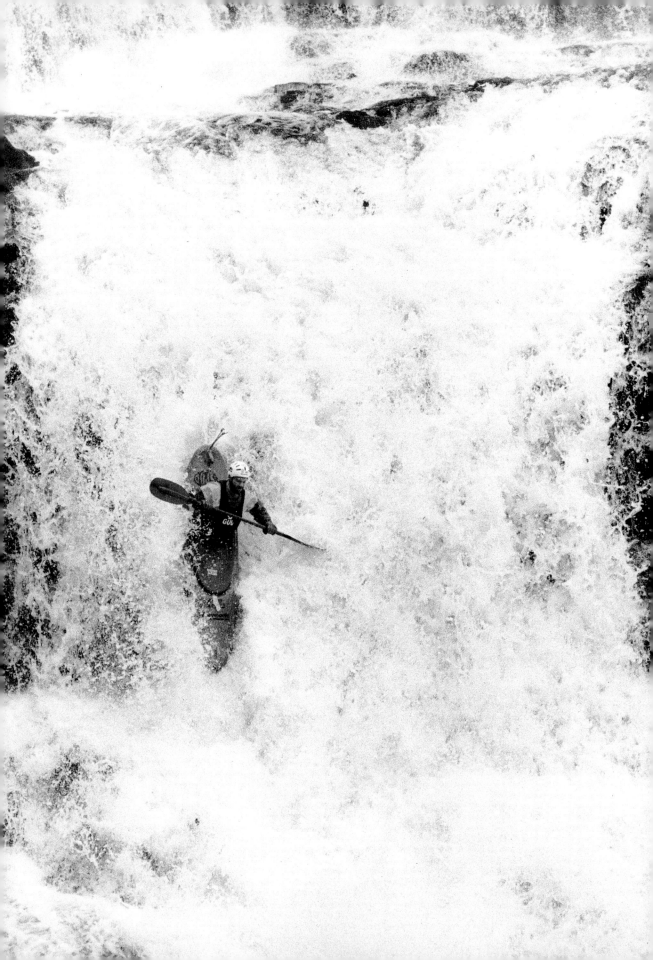

SELLING PICTURES

Most amateur photographers would like to make some money from their hobby. Not necessarily enough to make a living as a full-time freelance, but enough to defray expense of materials, and possibly even cover the cost of equipment. It can certainly be done. As in every field of endeavour, success comes to the person who studies the subject first. There is no magic about editorial sales. A good photographic technique and appreciation of a worthwhile picture are the first requirements, but after that a businesslike approach is the most important factor.

I have worked both as a staff photographer and a freelance servicing top international magazines, and I know the subject. This section will tell you what is possible and what isn't, where your endeavours should lie and where you would be wasting time and materials, and how to approach the various markets and outlets. Selling pictures to the press is a vast subject, but here are the outlines. The motivation is with you.

SUITABILITY

Every day, editors of national newspapers receive colour slides of landscapes and portraits, submitted in the fond hope that the editor will find them appealing. He may, but (a) doesn't use colour, and (b) the pictures would be of scant appeal to his readers. They are sent back with a polite note of thanks. The photographer shrugs, and thinks 'Better luck next time.' Unconsciously, he has pinpointed the cause of failure. Luck has absolutely nothing to do with it.

He may be an excellent landscape photographer, or have a penchant for taking appealing pictures of babies, but unless he studies his prospective markets he will get nowhere. The best possible advice to the amateur who wants to profit from his hobby is this:

A picture that would always be welcome in the files of a magazine specialising in climbing, canoeing, touring, the countryside, or photography. Such pictures are in constant demand to illustrate articles.

Photo: Ian Ball

Concentrate on the subjects that interest you most, as this is what you will be best at. Study the magazines that use your kind of pictures. Don't submit copies of what has already been printed, but new pictures that should appeal to the particular readership.

There it is in a nutshell. The formal name for suitability is market analysis. The suitable markets are in the magazine racks at any big newsagent. Photography Yearbook, published annually, contains a representative selection of the world's best pictures. You can submit your best pictures. If accepted you will earn a fee from this prestigious publication.

Don't waste time trying to compete with the professionals at sports and other events. They are covering for a particular magazine or client, and will have their stuff on the editor's desk well before you could do so. That does not mean you have no way into such markets. A keen amateur sports photographer, for example, could put together a dozen of his best action shots taken over a period, send them to the picture editor of a relevant magazine, with a note stating simply 'A few samples of my work. Please put me on your freelance list. I am available to cover at any time.' One busy day the editor may be short of a staffer or a regular freelance, and your telephone will ring. Do the job well, and other commissions will follow.

SUBMISSIONS

Editors are busy people. When they open an envelope, they hope to see useful pictures, properly captioned. Don't submit transparencies in glazed mounts, which are easily broken and can damage a secretary's fingers as well as the picture itself. Card or plastic mounts should be in individual transparent envelopes, preferably clear on one side, frosted on the other. The envelope should have a name and address label on it. If a number of slides are submitted, each envelope can be spot numbered and related to a numbered sheet of captions. Another method of presentation is to have the unmounted frame in a black mask transparency sleeve

Colour prints of high quality on glossy paper are now acceptable in some magazines,

but transparency material is preferred by all. Black and white prints should also be glossy. There is no regulation size, and anywhere around 10 × 8 in will do. Prints should be unmounted with a small name and address sticker on the back, in one corner.

Pictures and text are best packed in a card-backed envelope with a 'PHOTOGRAPHS DO NOT BEND' sticker on the front.

CAPTIONS

Only when submitting to photographic magazines is it worth including details of film, camera, lens, exposure and so on. To the editor of a consumer magazine, such information merely suggests that the person submitting does not know the market. All they want from you is full details. Every professional caption writer needs to know the six musts: Who, What, Why, When, Where and How. Use full names for people, with first names, not initials.

FEES

Every reputable national and most regional magazines pay according to a scale of fees, extra for merit, and it is not normally necessary to send an invoice, unless this is asked for. There are still a few smaller and local magazines and newspapers which consider a credit to the photographer is sufficient recompense. It is up to you whether you submit to such publications, but if in doubt confirm beforehand that a fee will be paid.

There is a big difference in the fees paid for exclusive and non-exclusive usage of pictures, the former being much higher. Bear in mind, though, that exclusive rights would be asked for only by an editor who thought a particular picture, or set of pictures, would boost his circulation against that of his rivals. Exclusiveness applies to important news and feature pictures that you may be lucky enough to take when no professionals happened to be around.

Whatever you do, never submit the same topical pictures to two rival editors at the same time. If they both publish, neither will ever accept further work from you.

You would perhaps be surprised to learn that some dedicated photographers, who started as amateurs, are now receiving a useful income from pictures sent to magazines 'For Your Files' over a period of years. Landscapes full of atmosphere, well-known stately homes photographed in some unusual manner, appealing pictures of children and animals, all sorts of oddities, with a name and address and caption stuck on the back or Sellotaped to fold. These go into editorial files, and occasionally are taken out and used, sometimes repeatedly, often to illustrate articles. The fee will be paid automatically after reproduction.

LIBRARIES AND AGENTS

Some libraries specialise in travel, sport or other themes, while some are of a more general nature. Such libraries are constantly asked for particular subjects, either for direct reproduction, or for what is known as artist's reference. That is, when an artist needs a visual aid for an illustration.

If you regularly send your work to a limited number of magazines, which covers the extent of your work, a library may be of no benefit to you. On the other hand, a library's files are constantly in use, whereas your own may not be.

Agents differ from libraries in one important respect, or should do so. That is, they seek out markets for your work. Their sales staff constantly visit publications to show work, and pictures are often sent to those overseas agents with whom they have reciprocal business. Fees may be 50-50 at home, while your share of overseas sales may be as little as twenty per cent. A good agent really earns his money, making duplicates and prints for multiple distribution, as well as marketing and ridding you of the work of book-keeping.

Success in freelancing depends partly on talent, and partly on a businesslike approach. There is no magic get-rich-quick formula, and any organisation that suggests there is should be avoided. The money will be better spent on film.

Photo: Peter Siviter

However serious you are about freelancing, remember the old advice 'Don't scorn the corn'! Pictures that raise a smile will also raise your income from editorial successes.

FILE FOR THE FUTURE

Most photographers start to think about a proper filing system only when they begin to have trouble locating particular negatives or slides. Long before a state of muddle can occur, the wise photographer will have started a sensible filing and retrieval system.

EXISTING STOCKS

If you already have a large number of processed negatives, prints and slides, the first job is to cull them. Go through them slowly and thoroughly, with the aid of a magnifier in good light. In most cases you will find just one frame worth keeping on any given strip or sequence.

The question you should ask yourself when examining each frame, is 'Will I ever want to make a print, or have one made, from this negative?' or 'Will I ever want to show this slide?' Keep any negative strip that contains one or more frames worth keeping, and discard all others. This is a time to be ruthless. If you find half a dozen similar, or repeats, of the same subject, on different strips, keep the best and discard the rest.

Now let us consider sensible and efficient methods of negative and slide filing, and then an easily maintained reference and retrieval system.

NEGATIVE STORAGE

The easiest and most space saving way to store negatives is in a special album. Each page will hold up to seven strips of six negatives, and can be faced with a sheet of contact prints for easy reference. If you do not process your own, look through the advertising columns of photographic magazines, for processors who will supply a contact sheet, colour or black and white, with each film processed.

There are two advantages to the type of pages which are clear on both sides. They allow negatives to be examined closely without removal from the sleeves, and the contact sheet can be made in the same way.

Albums should be stored upright, and not tightly packed, never laid one upon the other. The best position is between two shelves, the top one limiting the entry of dust.

There is no reason why colour and black and white negatives should not be stored in the same albums. For convenience, the home processor can make black and white contact sheets from colour negatives as well. Multigrade paper is best for this, as it has a better response to colour than ordinary papers.

SLIDES

Special clear filing pages are available for use in albums, each page holding twenty or so

Negatives and related contact sheets filed in an album. Albums are best stored upright, not pressing down on each other.

mounted slides in pockets. These are excellent for viewing and retrieval, but rather costly if large numbers of slides are produced. Individual file pages with flapdown dust covers, each holding twenty-four mounted slides, are available for hanging files. These can be used in existing file cabinets, or in special ones made for the purpose.

WHERE IS IT?

A practical filing and retrieval system can be based on a job book and a card index, though the owner of a home computer may use the same system to put everything on floppy discs. In fact, several ready-made filing systems are already available in disc form. Names and types can be found in the advertising columns of photo and computer software magazines and catalogues.

The job book is simply a chronological list of entries, the date followed by a very brief description of the pictures taken. A one-line entry is enough to jog the memory. A third column gives the location of the negatives or slides. Example:

A/17/5/3 = Album A, sheet 17, strip 5, neg. no.3

An entry for a slide in a hanging file might be simply:

HF12/15 = File sheet 12, pocket 15.

The job book will serve to trace negatives and slides until you have made fifty or so entries,

after which a more precise method of retrieval may be desirable. A deep card index serves well, but the normal set of A-Z divider cards is useless. You will find that most of your work ends up being indexed under just a few letters, such as L for landscape, H for holidays, and P for portraits. It is more useful to make up a set of dividers to cover the types of work you do, adding further ones when and if they become necessary. A good starter set would be:

ANIMALS - ARCHITECTURE - CANDID - CHILDREN - FAMILY OCCASIONS - FAMOUS PLACES - HOLIDAYS - LANDSCAPE - NIGHT - OUTINGS - PEOPLE (BY NAME) - PORTRAITS - SPORT

A specialist would alter or extend this list. If, for example, your main interest was in sporting events, Sport would be too wide a category, and you might substitute Athletics, Cars, Hang gliding, Motorcycles, Skiing.

Within each category, subject cards should be arranged alphabetically, with the album or hanging file location in the top corner. This combination of job book and card index, plus your memory, should enable you to find what you want fairly quickly. A refinement that pays dividends, is to put in a marker each time a negative or slide leaves the system. This could be a small removable sticker, obtainable at all stationers, stating the date of removal and the location (Gone to Such-and-Such Laboratories for reprinting, etc).

Every ten minutes spent filing and indexing will save hours of retrieval time.